PICTURING THE COSMOS

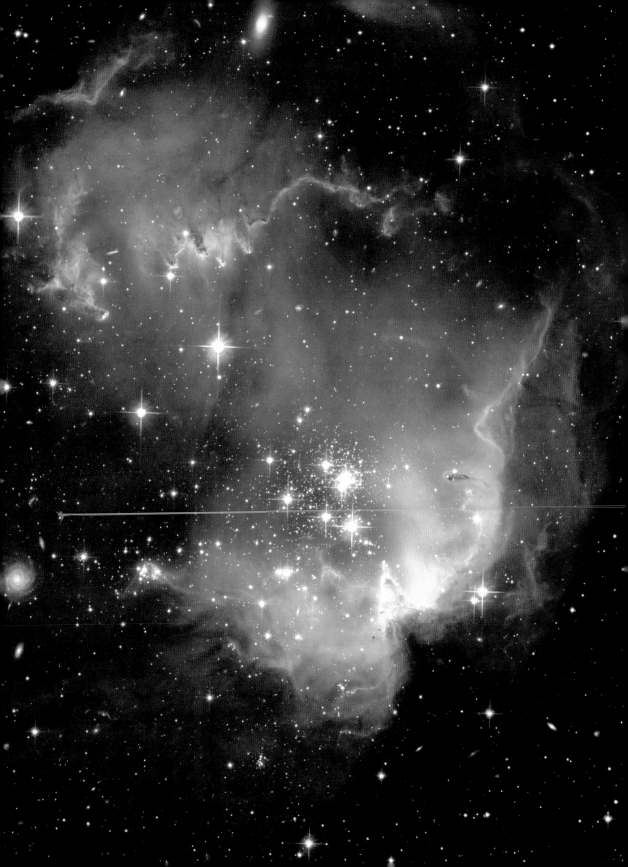

Elizabeth A. Kessler

PICTURING THE COSMOS

HUBBLE SPACE TELESCOPE IMAGES
AND THE ASTRONOMICAL SUBLIME

UNIVERSITY OF MINNESOTA PRESS MINNEAPOLIS · LONDON

The University of Minnesota Press gratefully acknowledges funding provided
for the publication of this book from the Margaret S. Harding Memorial Endowment,
honoring the first director of the University of Minnesota Press.

Frontispiece: View of a supernova remnant in the Large Megallanic Cloud, designated
N49, as crafted by members of the Hubble Heritage Project. July 3, 2003; WFPC2.
Courtesy of NASA and The Hubble Heritage Team (STScl/AURA)

Published by the University of Minnesota Press
111 Third Avenue South, Suite 290
Minneapolis, MN 55401-2520
http://www.upress.umn.edu

Library of Congress Cataloging-in-Publication Data
Kessler, Elizabeth A.
Picturing the cosmos : Hubble Space Telescope images
and the astronomical sublime / Elizabeth A. Kessler.
pages cm
Includes bibliographical references and index.
ISBN 978-0-8166-7956-0 (hardback)—ISBN 978-0-8166-7957-7 (paperback)
1. Galaxies—Pictorial works. 2. Stars—Pictorial works.
3. Sublime, The, in art. 4. Hubble Space Telescope (Spacecraft). I. Title.
QB857.K47 2012
520—dc23 2012020744

Printed in China on acid-free paper

The University of Minnesota is an equal-opportunity educator and employer.

19 18 17 16 15 14 13 12 10 9 8 7 6 5 4 3 2 1

CONTENTS

ABBREVIATIONS

AAS	American Astronomical Society
ACS	Advanced Camera for Surveys
ASU	Arizona State University
AURA	Association of Universities for Research in Astronomy
CCDs	charge-coupled devices
COSTAR	Corrective Optics Space Telescope Axial Replacement
EGGs	evaporating gaseous globules
EROs	early release observations
ESA	European Space Agency
ESO	European Southern Observatory
FITS	Flexible Image Transport System
IDL	Interactive Data Language
IRAF	Image Reduction and Analysis Facility
JHU	Johns Hopkins University
JPL	Jet Propulsion Laboratory
LST	Large Space Telescope
MAST	Multimission Archive at the Space Telescope Science Institute
NASA	National Aeronautics and Space Administration
NICMOS	Near-Infrared Camera and Multi-Object Spectrometer
NOAO	National Optical Astronomy Observatories
STIS	Space Telescope Imaging Spectrograph
STScI	Space Telescope Science Institute
STSDAS	Space Telescope Science Data Analysis System
UCSC/LO	University of California, Santa Cruz/Lick Observatory
WFC	Wide Field Camera
WFC3	Wide Field Camera 3
WFPC	Wide Field Planetary Camera
WFPC2	Wide Field Planetary Camera 2

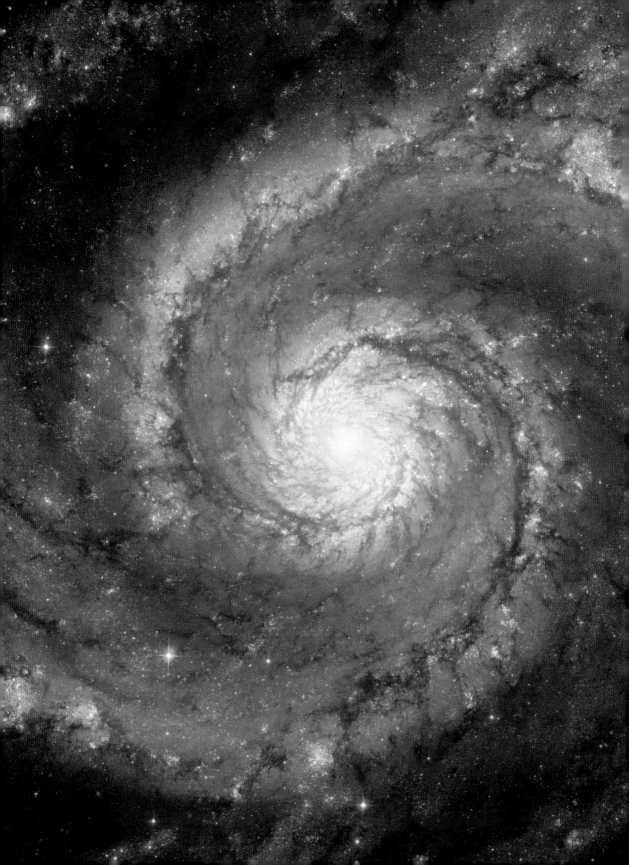

ASTRONOMY'S ROMANTIC LANDSCAPES

Hubble Images and Aesthetics

A dark cloud against a background of orange and blue reaches upward, stretching nearly to the top of the frame that contains it. Brightly backlit at its top and outlined throughout with a soft glow, the majesty and grace of the sinuous shape claim the viewer's attention (Figure 1). But the closer one looks, the more difficult it becomes to classify what is pictured. Because of its wispy outline and top-heavy proportions, it appears that the form must be composed of something airy, something gaseous and insubstantial; however, its elongated profile resembles none of the clouds seen above the earth, and its blackness surpasses that of even the most threatening storm. Its color and assertive vertical orientation instead suggest a gravity-defying geological formation carved into a twisting pillar by unknown forces and silhouetted against a bright sky. The object almost oscillates before the viewer: cloud and landscape, familiar and alien.

The image is one of the many compelling views of the cosmos credited to the Hubble Space Telescope since its launch in April 1990. The National Aeronautics and Space Administration (NASA) and the Space Telescope Science Institute (STScI), the research center that manages the instrument, released the image of the Eagle Nebula, along with one of the Whirlpool Galaxy (Figure 2), to celebrate the orbiting telescope's fifteenth anniversary in April 2005.[1] The view of the Whirlpool is less ambiguous than that of the Eagle; its distinctive spiral shape is iconic, the recognizable sign of a star system akin to the Milky Way. It is, however, no less powerful an image than the representation of the Eagle Nebula. The dynamic whirl pulls the

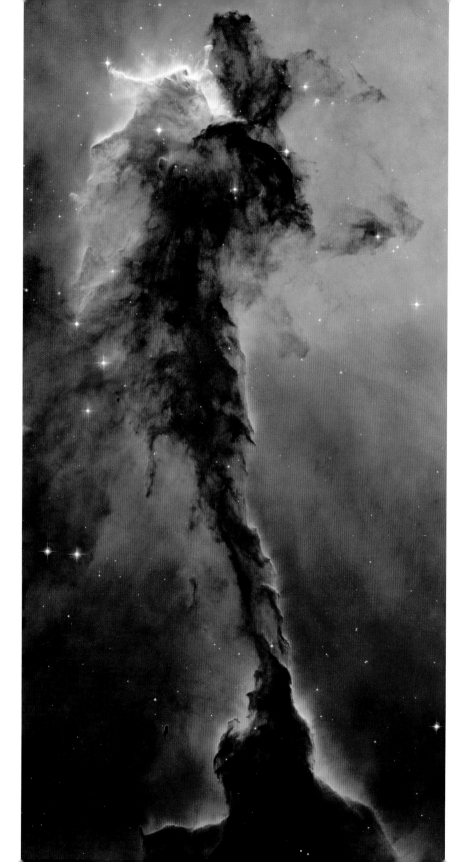

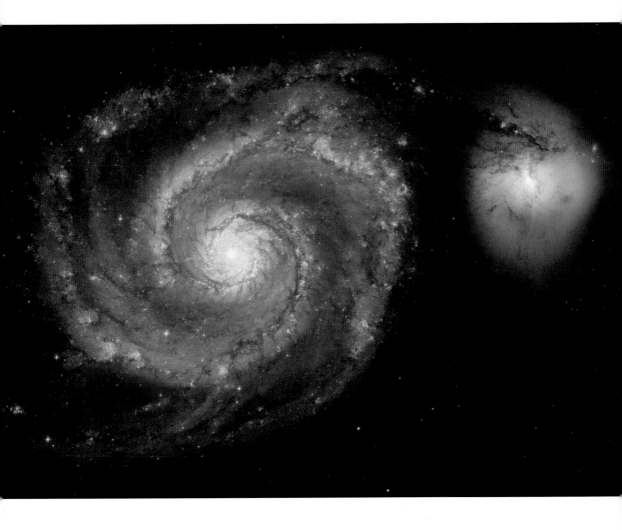

Figure 1. (opposite) This view of the Eagle Nebula was released by NASA and the Space Telescope Science Institute in celebration of the Hubble Space Telescope's fifteenth anniversary. April 25, 2005; ACS/WFC. Courtesy of NASA, ESA, and The Hubble Heritage Team (STScI/AURA).

Figure 2. A view of the Whirlpool Galaxy was also released to mark the telescope's fifteenth anniversary. April 25, 2005; ACS/WFC. Courtesy of NASA, ESA, S. Beckwith, and The Hubble Heritage Team (STScI/AURA).

eye along pathways dotted by red stars into the galaxy's brilliant yellow center. The subtle blues of its arms contrast with the warmer yellows and reds of the stars. As with the Eagle Nebula, the celestial object nearly fills the frame, conveying a sense of its vast size and scale. And for both images, the most highly resolved versions reveal incredible, even overwhelming, levels of detail. The glowing regions along the spiral arms become individual light sources. Each dot of light, even those almost too faint to discern in an image of lesser quality, gains color, a degree of intensity, and sometimes even shape.

This book takes Hubble images like these as its subject: their appearance, their production, and their position within the history of scientific and artistic representations. From its orbit above our globe, the Hubble Space Telescope has provided a revolutionary view of the cosmos. Freed from the obscuring atmosphere of the earth, the instrument has allowed astronomers to observe with new clarity, thereby enabling an improvement in seeing that is often compared to Galileo's first use of a telescope in the seventeenth century. Because the Hubble holds a seminal place within contemporary astronomy and its images have circulated widely—to near-universal acclaim—its views of the cosmos have become models for images delivered from other telescopes, including those produced in the service of science at world-class observatories as well as those taken by amateurs with backyard telescopes. Hubble images have also shaped depictions of the universe in popular culture, and it is common in science fiction films, TV shows, and video games to see spaceships fly through Hubble-inspired scenery.

In the more than twenty years since NASA released the first blurry, black-and-white Hubble image, astronomers have developed representational conventions and an aesthetic style, and the archive of Hubble images demonstrates that scientists have come to favor saturated colors, high contrast, and rich detail as well as majestic compositions and dramatic lighting. The vividly colored, exquisitely detailed, and brilliantly lit Hubble Space Telescope images now define how we visualize the cosmos. They do not look like older photographs of the stars, nor are they anything like what can be seen in the sky on a dark night. Yet they appear to present the universe as one *might* see it, thus previewing what we imagine space explorers and tourists may experience when manned space travel extends humanity's reach beyond the earth's orbit. Improved technology, a telescope orbiting high above the earth's atmosphere and

equipped with sensitive digital cameras, can seem like an adequate explanation for the brilliant hues and sharp resolution. But there is more behind the images than just the workings of advanced instruments. The appearance of the Hubble images depends on the careful choices of astronomers who assigned colors, adjusted contrast, and composed the images. Although attentive to the data that lie behind the images, through their decisions astronomers encourage a particular way of seeing the cosmos.

As with the Eagle Nebula, many of the Hubble images bear a striking resemblance to earthly geological and meteorological formations, especially as depicted in Romantic landscapes of the American West. In the late nineteenth century, the painters Thomas Moran and Albert Bierstadt as well as the photographers William Henry Jackson, Timothy O'Sullivan, and others portrayed the awe-inspiring and unfamiliar western scenery in the visual language of the sublime. The formal similarities between these two sets of pictures situate the Hubble images within a visual tradition, and the reference to the sublime also has philosophical relevance. As defined by Edmund Burke and Immanuel Kant, the sublime describes an extreme aesthetic experience, one that threatens to overwhelm even as it affirms humanity's potential. For Kant, the sublime arises out of a tension between the senses and reason, and each faculty must be engaged to experience such an intense response. Through a reprisal of Romantic tropes, the Hubble images once again invoke the sublime and they encourage the viewer to experience the cosmos visually *and* rationally, to see the universe as simultaneously beyond humanity's grasp and within reach of our systems of knowledge. The tension that begins with the appearance of the Hubble images extends to the relationship between the images and the celestial objects they represent; their reliance on digital data and imaging, which brings together numeric and pictorial representations; and the symbolic significance of the landscape reference with its evocation of the frontier. By repeatedly making use of this tension, a fundamental attribute of the sublime experience, the Hubble images make claims not only about what we know of the cosmos but how we gain knowledge and insights.

Typically, interest in a scientific mission lasts for only a brief period—the duration of a mission or a few weeks of excitement after a new discovery—but decades after the telescope's launch the Hubble images still made headlines and circulated widely online and in print. They achieved an almost unparalleled popularity within the his-

tory of astronomical images, even within the history of all scientific images. Many of the best-known Hubble images were made in an effort to reach those who are not scientists, and those involved with their production and distribution, from astronomers to public relations officials at STScI to administrators at NASA, acknowledged that they hoped the eye-catching images would encourage continued financial support for the Hubble Space Telescope, NASA, astronomy, and even scientific research more generally. As a result, some dismiss the aesthetically developed Hubble images and their evocation of the sublime as little more than hype and visual hyperbole, and consider them nothing more than crass attempts to curry public favor.

Aesthetics can seem secondary at best and often unnecessary to the scientific project. If science strives to master with precision and exactitude the physical processes at work in the universe, if it ultimately seeks to enhance the human condition through improving and extending life, aesthetics can seem a messy distraction from its larger goals. At times, astronomers have argued against dedicating significant resources to making attractive pictures, suggesting that images might be valuable public relations tools, but data—unambiguous numeric values and measurements that could be logically analyzed, compared with other data, and lead to carefully reasoned conclusions—were the intended output of the Hubble Space Telescope. If "pretty pictures," a phrase often used by astronomers, do not forward the quest of science in the purest sense, if they cannot be used as sufficient evidence to make claims about the physical makeup of the cosmos, the production of such images was little better than a diversion.

Those who study the visual culture of science have also entered into the debates around scientific images. The art historian James Elkins, who has written extensively on the relationship between art and science, has been emphatic in his dismissal of scientific images made for public display, seeing such pictures as contributing to what he calls "astronomy's bad reputation" for producing flashy but scientifically uninteresting images.[2] Elkins rejects images made for display because he sees them as a distraction from what he considers to be far more interesting astronomical images, namely those that scientists use only for the acquisition of knowledge. Elkins is correct that scholars of visual culture often ignore the blurry, black-and white-images that show a distant celestial object in only a few pixels. But he too quickly pushes aside the colorful views that reach a larger audience and too strongly judges them as

lacking in value. To regard them as little more than overwrought marketing material ignores the depths of their connections to the practice of science as well as how profoundly the images shape our cultural imagination.

The astronomers who develop Hubble images attempt to balance the often contradictory demands and interests of an audience that ranges from fellow astronomers to schoolchildren. As they craft the images, translating sometimes invisible attributes of the data into visible form, they strive to make the images scientifically valid *and* aesthetically compelling.[3] The resulting Hubble images have served multiple functions: they document and record data; aid scientists in their effort to understand their observations; influence decisions about support for science; and inspire aesthetic responses from a variety of different audiences. To understand the complexity of these images requires a careful study of the visual culture of astronomy, one that considers the decisions astronomers make when composing the scenes and choosing contrast and color, the institutions and groups involved in the making of images, and the relationship of the images to the culture that surrounds them.

The Eagle Nebula and the Whirlpool Galaxy images were crafted by members of the Hubble Heritage Project, a group of astronomers and image processing specialists at STScI that took as its purpose the development of aesthetically attractive images. Since its formation in 1997, the Heritage Project has released a new image almost every month, and its work has resulted in an archive of vividly colored and dramatically detailed views of nebulae, galaxies, and other celestial phenomena. The collection supplements and expands the body of images astronomers produced as part of their research programs or those developed for NASA press releases. As a result, the Heritage Project has played a significant role in defining how Hubble images "should" look. And as the name suggests, the group also looked toward the future by shaping not only the perception of the Hubble Space Telescope and the universe for viewers today but also how they will be seen by later generations.

The Heritage Project's mission is in large measure educational, and the group documented its methods for crafting images in publications that reach both those within the astronomical community and those outside of it. Such accounts tell part of the story, often focusing closely on how to make an image. To gain greater insight into what motivates their choices and what they want the images to communicate,

I conducted oral histories with several astronomers and image specialists (a title for those who specialize in crafting data into images) involved with the project as well as astronomers who have had a significant role in shaping the appearance and distribution of Hubble images. These interviews revealed the profound commitment of astronomers to conveying the awe they feel when observing the cosmos. Although not a programmatic choice, the reference to the sublime landscape so evident in the Hubble images ensures that we too view the distant reaches of the universe with a sense of wonder and a sense of familiarity, which suggests that we know how to explore these places.

The members of the Heritage Project are the characters who have the leading roles in the story of the Hubble images, but others play significant parts: administrators and scientists at NASA, the engineers who built and designed the instruments aboard the telescope, the larger community of astronomers who support images (or at times reject them). The status of the Hubble Space Telescope, the promise that it would improve our view of the cosmos by several orders of magnitude, ensured that its history was carefully documented. Many of those who participated in its early development were interviewed multiple times by the historian Robert W. Smith, and returning to these older oral histories demonstrates the depth and complexity of astronomy's relationship to images.[4] The history of the Hubble Space Telescope remains a touchstone throughout this book, and it will receive the most attention when it shapes the images or aids in interpreting them. Other sources offer more complete discussions of the instrument's history. Smith ably documents the telescope's planning and construction within the institution of NASA, and Robert Zimmerman's *The Universe in a Mirror* offers an extension of that history through the present. Neither author ignores images, but they do not focus extensively on them. This book, on the other hand, is very much about the Hubble images.

Astronomy often serves as the poster child for science by displaying the wonder of exploration and discovery in a nearly visceral manner and without the ethical conflicts that accompany scientific advances in other fields, such as genetics. In many ways, astronomy is about the pleasure of looking. And the engagement of scientists with ways of seeing and presenting the universe testifies to the essential place of aesthetics within any attempt to comprehend the cosmos, understood in

the broadest sense of the term as an ordered and harmonious system. To return to Elkins's quibble with scientific images made for an aesthetic purpose, he does acknowledge and accept the possibility that they have led scientists to ask new questions and explore different avenues of research.[5] He seems, however, to want to rely primarily on scientists' accounts of how they use images. Such descriptions are of great value; my choice to conduct oral history interviews was motivated by a desire to better understand how astronomers think about their relationship to images. But it is not sufficient to rely solely on these first-person accounts.

Astronomers may not always be fully aware of how profoundly images shape their thinking. The hallways of observatories and university astronomy departments are filled with brightly colored images made from Hubble data as well as other sources. The prominence of images attests not only to their importance within the discipline but also suggests that they have an inescapable influence on how astronomers imagine the cosmos. No matter what astronomers may do at their desks with numbers and calculations, the conversations with colleagues about their research take place against a backdrop of dramatic views. It seems inevitable that such representations of the cosmos filter back into their approach to the data, to the questions they ask, to the interpretations they posit.

Similarly, the colorful views of the cosmos have shaped how those outside of astronomy imagine the universe. Perhaps more significantly, it is often through the wider circulation of images that one finds an exploration of the cultural implications of newly acquired knowledge and understanding.[6] The images made to illustrate evolution are one such case, as the historian of science Constance Clark has shown in her study of the evolution debates in the United Sates in the 1920s. Beginning with Charles Darwin's example in *On the Origin of Species*, tree diagrams of various sorts were an important means to communicate the taxonomic relationship between living things. Scientists read them according to the conventions established within biology. In one typical textbook illustration that featured in the Scopes trial, humans were not listed separately but were instead included as part of a small circle labeled "mammals." For scientists, neither the failure to call out the human species nor the small size of the circle was problematic because it accurately represented the place of humans within the accepted classification system as well as the comparatively

small number of mammal species. While not unaware of the political and religious implications of evolutionary theory, they understood the images as "maintain[ing] silence on questions of religious or political significance." Within the context of the Scopes trial, the very same image gained a different valence. As Clark writes, "For scientists this illustration was a version of a familiar branching diagram depicting natural relationships. From [William Jennings] Bryan's point of view it seemed to mock traditional verities about human significance. It was the human place in nature that was at stake."[7]

This example helps to demonstrate that focusing solely on how scientists use images and ignoring their efforts to communicate with a larger audience can overlook what's at stake in the acquisition of new knowledge. Attending to the images that move beyond the laboratory or a scientist's computer screen makes evident the trenchant questions and issues raised through the pursuit of scientific understanding. And in the case of the Hubble images, what could be more significant than how we imagine the universe and our place within it?

For the Hubble images, a reference to a familiar visual iconography, that of nineteenth-century landscape of the American West, threads through efforts to reach a broad audience. The comparison of Hubble images and Romantic landscapes begins with their shared features, similarities in appearance that link two sets of images made more than a century apart. Historically, scholars have often used formal resemblance, an interest in patterns, or a concern with structure as bridges between art and science.[8] And although carrying different names—morphological versus formal analysis—the ability to look closely and carefully at representations is an important skill in both art history and astronomy. The purpose of such visual examination differs in each field, of course, with astronomers interested in understanding the physical processes at work in a galaxy or nebula and art historians intent on understanding the image itself: how it was made, how it encourages a viewer to respond, and how it interacts with other images and the culture more broadly.

As the relationship to nineteenth-century landscapes and paintings demonstrates, astronomers did not create their views of nebulae, galaxies, and star fields in a vacuum of objectivity. The social conditions that surround the creation of scientific images make evident some of what motivates this relationship between two sets of

historically distant pictures. A rich and ideologically complex culture informed scientists' efforts to translate data into images. Rather than creating something entirely new, astronomers, who were working in a period of great technological change as digital imaging transformed the production and distribution of images, extended an existing mode of visualization and representation, one associated with exploration, to a new phase of discovery. The mythos of the American frontier functioned as the framework through which a new frontier was seen.

Although closely studied, scientific images are not typically scrutinized in the same manner as those produced for artistic purposes. The Hubble images, though, deserve just this kind of attention. Not only do those made for public consumption make aesthetic claims, they are part of what W. J. T. Mitchell has called "a visual turn," a cultural fascination with and an embrace of images that fuel our visually saturated world.[9] Despite their omnipresence, our love of images is accompanied by a pervasive uncertainty about their validity and trustworthiness.[10] This ambivalence surrounds the Hubble images, as I will explore in future chapters. It is also made manifest in our failure to give images the attention they are due: to recognize the power that they hold; to acknowledge their ability to move, to persuade, to inform, to inspire; and to interrogate them fully, to excavate the sources of their meanings and, especially in the case of the Hubble images, the reasons behind their popularity. In contrast to this uncertainty, visual evidence is central to this book. The images do not simply illustrate; they are the very material through which I make arguments about science and aesthetics, about the history of the Hubble Space Telescope, and about its significance in American culture at the end of the twentieth century and the beginning of the twenty-first.

To give the images their due, to understand them fully, requires a broad, interdisciplinary study that synthesizes the history of science and technology, philosophy, and art history. As might be expected from such an approach, the result is a series of nested and sometimes tangled arguments that draws on disciplines sometimes seen as in opposition to one another. And yet, this tension is exactly what Kant finds productive about the sublime. Multiple arguments thread through the chapters in this book, which are linked together through their relevance for understanding the Hubble images and, perhaps even more significantly, for understanding how late twentieth-century Americans saw the universe and their place within it.

Celebrating an Anniversary: The Eagle Nebula and the Whirlpool Galaxy

In many ways, the two images that I discussed in the opening paragraphs above demonstrate the necessity of using multiple lenses in order to fully understand the Hubble images. Although captivating for their appearance alone, the views of the Eagle Nebula and Whirlpool Galaxy are more than impressive visualizations of scientific observations. They exemplify the ways in which the Hubble images circulate and function in the world.

The Eagle and Whirlpool images also resonate with the history of the Hubble Space Telescope and the longer history of astronomical observing. An earlier image of the Eagle Nebula, often called the Pillars of Creation, was released nearly ten years before the anniversary image. It focuses on a different region of the nebula that features a set of ambiguous columns also resembling both clouds and landscape formations. Perhaps more than any other Hubble image, that first dramatic view of the Eagle Nebula revived the telescope's reputation after the devastating discovery of its flawed optics, and it remains widely admired.[11] Although observed with a different camera and exhibiting subtle visual differences, the later Hubble image of the Eagle Nebula pays homage to the first.

The view of the Whirlpool Galaxy looks further back into the history of astronomy and alludes to images that recorded the discovery of the distinctive shape of galaxies. In the 1840s, Lord Rosse, a wealthy amateur astronomer and engineer, built a giant six-foot telescope, aptly dubbed the Leviathan, on his Irish estate. The largest instrument of its day, the audacious structure was a landmark in a long tradition of building ever more impressive instruments to collect light from the distant reaches of the universe. The cloudy nights of Ireland limited the use of the Leviathan, but Rosse and his assistants made one extremely valuable discovery when they observed that the glowing cloud known as M51 had a spiral shape, a form that they also found in some other nebulae. Drawings and engravings of the newly dubbed "Great Spiral" circulated widely, and the revised perception of the universe made it possible for astronomers to imagine that the Milky Way did not comprise the entire universe but was one among many similar star systems.[12] By revisiting the object that was pivotal in advancing science's notion of the cosmos, the Hubble's image of the Whirlpool underlines the value of building ever better instruments for observing. The engi-

neering feats of launching and repeatedly returning to an orbiting telescope make the Hubble Space Telescope a contemporary example of Rosse's audacity with even greater potential to forward scientific understanding.

As much as the Hubble's anniversary images point to the past, at the time of their release they also looked ahead to the future of the orbiting observatory. In January 2004, in response to the space shuttle *Columbia* accident of the preceding year, NASA canceled all future repair missions to the Hubble Space Telescope. The possibility of returning to the observatory for periodic servicing missions was one of its key features. During four previous visits, astronauts had replaced and repaired cameras, spectrographs, and other instruments, including critical and highly temperamental gyroscopes. The Hubble relies on three gyroscopes to guide its pointing mechanism and to remain stable in its orbit. At the time of NASA's announcement, it had only one gyroscope in reserve because two of the six on board had malfunctioned.[13] Canceling the repair mission meant additional failures would render the Hubble useless, transforming it into just another expensive piece of space junk. The scientific community and, more remarkably, a great number of people outside of the community responded immediately and passionately to NASA's decision. Online petitions, newspaper editorials, and letters to NASA argued that the instrument remained a valuable scientific tool and one that NASA should not abandon. With all the public support for the Hubble, it is not surprising that the campaign to reinstate a final Hubble servicing mission succeeded, and a crew of space shuttle astronauts visited the orbiting telescope for the last time in May 2009.

The Eagle Nebula and Whirlpool Galaxy images, however, were planned and crafted when the Hubble's future was uncertain. As such they not only represented two well-known celestial phenomena but also made a plea for the continued support of the instrument by displaying its capabilities in brilliant color and exquisite detail. Most people without advanced degrees in astronomy are hard-pressed to identify exactly how the Hubble Space Telescope has changed and enhanced humanity's understanding of the cosmos. They have, however, seen many examples of the Hubble's dramatic pictures, images that NASA showcases on its Web sites and that also appear on calendars and coffee mugs, album covers and art museum walls. Such pictures serve as visible evidence of the Hubble's success. More than any notion of what

astronomers do with the Hubble's data, the stunning images account for the public's support and affection for the telescope.

When releasing the Eagle Nebula and Whirlpool Galaxy observations, astronomers, image specialists, and the STScI press office went to exceptional lengths to reach different audiences. New images and announcements of scientific discoveries are regularly posted by STScI and NASA on their Web sites. For the anniversary images, the STScI press office also distributed more than one hundred large prints, four feet by six feet for the Whirlpool Galaxy and three feet by six feet for the Eagle Nebula, to planetariums and science museums throughout the United States.[14] These institutions already exhibited numerous Hubble images, but such large examples display the observations to their best effect. Not only does the size emphasize the immensity of the subject matter but it also makes visible fine details not readily apparent in a smaller image or on a computer screen.

In anticipation of any questions that might be raised about using an oversubscribed instrument with a limited lifespan to make pictures for museum walls, the data for the Whirlpool Galaxy were also released in a format that made it readily usable by researchers. Because of its large size and relative proximity to the earth, observing the entire galaxy required six separate pointings of the telescope, and at each pointing several observations were made with four different filters. The total data set included ninety-six distinct exposures that were pieced together to create the image. Typically, astronomers must do the work of generating a composite for any observations they oversee. By providing the processed data, STScI saved scientists the time and effort they would need to expend before they could begin to analyze the data, to say nothing of the time put into submitting a proposal to use the Hubble. As well as making the task of scientists easier, STScI invited them to publish research papers on the Whirlpool Galaxy.[15] With the public release of the dramatic view, the invitation was initially issued as a remarkably resolved and dramatic image that promised data to match.

The existence of these distinct modes of representing the Whirlpool Galaxy points toward a fundamental duality within every Hubble image, even the prettiest ones. Each image is expressed first as data and then translated into pictorial form. Hubble images are mediated several times over. Their appearance depends on the

THE ASTRONOMICAL SUBLIME
AND THE AMERICAN WEST

The Astronomical Sublime

For much of human history the visual experience of the heavens remained the same, dependent entirely on naked perception. Although light pollution has dimmed the brilliance of the stars, a look upward on a dark night reenacts this ancient and unmediated vision in which one sees white dots against a black sky, "lights in the firmament of the heavens" (Genesis 1:14), that offer few clues as to their distance, makeup, or relationship to the earth. When Galileo turned his telescope to the heavens in the seventeenth century he introduced another possible experience: a technologically mediated view. In the centuries since, humanity has followed his lead, thereby further extending vision. Astronomers have not only designed and built increasingly more powerful telescopes they have also sought out locations conducive to clear seeing and adopted sensitive technologies for recording and representing light, first photography and then digital arrays. Orbiting high above the earth's obscuring atmosphere, the Hubble Space Telescope stretches humanity's vision beyond what Galileo ever imagined.

Galileo made drawings of his moon observations in which he carefully rendered it in precise perspective and shaded its cratered surface. His drawings reflected his historical moment, embracing naturalism and Renaissance standards for achieving it.[1] Such ways of depicting the world were well established when Galileo made his drawings; they had revolutionized the art of his native Florence a century and a half earlier. Hubble images reflect their historical moment as well. Like Galileo's

drawings, they do not invent a new way of seeing and representing but adopt a familiar and culturally resonant mode of representation: the Romantic sublime.

This chapter begins by establishing the characteristics of the Hubble images that distinguish them from older astronomical images. The distinctive attributes of Hubble images, especially the framing of the astronomical objects and their color schemes, invite a comparison to late nineteenth-century paintings and photographs of the American West by the artists Thomas Moran and Albert Bierstadt as well as the photographers William Henry Jackson and Timothy O'Sullivan. The relationship between the two sets of images goes deeper, however; the paintings and photographs I discuss here speak to ideas about scientific exploration and the frontier, and I return to their cultural context and its significance for the Hubble images in the last chapter. But the appearance of the Hubble images, as well as the response that astronomers and image specialists hoped it would elicit, is the focus of this chapter. An extended comparison of the Hubble images and the Romantic landscapes enables a sustained engagement with how these twenty-first-century vistas represent the cosmos.

The sublime is often associated with a set of characteristics—an emphasis on the powerful forces of nature, strong compositions that convey great size and scale, dramatic lighting to heighten the intensity of the scene—and these attributes are found in the Hubble images. But the sublime goes beyond a list of characteristics; it must also include the response of the viewer. Both the nineteenth-century landscapes and the Hubble images use these attributes to convey a sense of awe and grandeur, a sense of a vastness that overwhelms humanity. In the eighteenth century, Edmund Burke and Immanuel Kant attempted to explain why such overwhelming experiences caused pleasure. For Kant, the sublime set in motion the senses and reason, challenging the former and elevating the latter. Through their very resemblance to earthly experiences the Hubble images accomplish the same, and it is through a recurring engagement with the senses and with reason that they invite an aesthetic experience of the sublime again and again.

The slipperiness of the comparison to the landscape is the first example of how the Hubble images call upon both the senses and reason. Even as press releases from NASA and STScI and the comments of astronomers underscore the similarity to landscapes, the images themselves resist efforts to fix their identity. The Eagle

Nebula looks like both a landscape *and* a cloud. It oscillates before the viewer's eyes, requiring us to go beyond what our senses and imagination might suggest in an effort to understand the image.

A Brief History of Representing the Cosmos

The philosopher of technology Don Ihde writes that "new instrumentation gives new perceptions," and at the time of the Hubble's launch both the perspective from an orbiting telescope and the format of the images it returned were novel.[2] Because of its location, the telescope delivered more precise data than what was available from ground-based instruments. The Hubble Space Telescope was also among the first astronomical instruments to use digital cameras to collect data over a large field of view. Since the early twentieth century, photographic plates had been the dominant media in astronomy and were replaced by digital detectors only at the century's close.

The Hubble carries three cameras: the Wide Field Camera 3 (WFC3), the Advanced Camera for Surveys (ACS, known as "a-sis"), and the Near-Infrared Camera and Multi-Object Spectrometer (NICMOS, known as "nik-mos"). These instruments collect data in wavelengths from ultraviolet to near-infrared and radio them to the earth for astronomers to analyze and translate into highly resolved views of the universe.[3] Many of the best-known Hubble images came from data collected by WFPC2, a camera since replaced by WFC3. Astronauts installed the second version in 1994 as a means to correct the telescope's optical problems, and it operated dependably for more than fifteen years, contributing greatly to the Hubble's success.

From new technologies and perceptions arise novel ways of representing phenomena. After nearly twenty years of seeing the universe as mediated by the Hubble's images, a period that corresponds to the widespread adoption of digital imaging, the technologies of the telescope have become nearly transparent. They become evident only when they malfunction or when debates arise around their maintenance. Consequently, it is easy to gloss over the differences introduced by the Hubble—to assume that the instrument simply improved vision—but not consider exactly how perceptions and representations have changed as a consequence of these new technologies. It is an understandable assumption, one underlined by science's rhetoric of constant advancement and arguably supported by the highly resolved

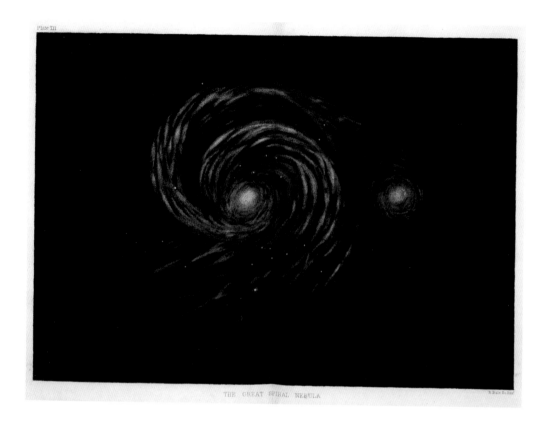

Hubble images. But by briefly looking back at the history of astronomical imaging, we can trace a more exact account of how technology has transformed what we see and represent of the cosmos.

A quest for greater resolution in many ways defines the history of astronomical observing, and the Hubble delivers precisely detailed images. A trio of images of the Whirlpool Galaxy, spanning more than one hundred and fifty years of technological changes, demonstrates how much more astronomers can now observe. The most recent, the Hubble's digital image of the Whirlpool Galaxy (Figure 2), is already familiar to us. The oldest, an engraving based on Lord Rosse's drawings of the Whirlpool, dates from the mid-nineteenth century and was published in J. P. Nichol's popular *Architecture of the Heavens* (Figure 3). The third image, a pho-

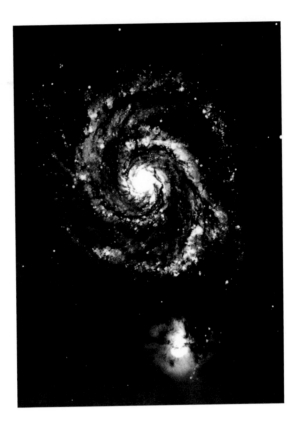

Figure 3. (opposite) The Great Spiral Nebula as observed through Lord Rosse's telescope and published in J. P. Nichol's *The Architecture of the Heavens* (1850). Courtesy of Stanford University Library Special Collections.

Figure 4. Photograph of the Whirlpool Nebula as observed at Palomar Observatory in the 1950s. Courtesy of Caltech.

tograph, was taken in the mid-twentieth century through the two-hundred-inch reflecting telescope at Palomar Observatory (Figure 4).

All three images clearly depict the defining elements of the galaxy: its spiral shape, so clearly visible because of the galaxy's orientation in relation to earth, and its smaller, less distinct companion galaxy.[4] Looking closer reveals the ambiguity that remains in the older images. The lines in the nineteenth-century engraving could correspond to either the dark regions or the bright, and the makeup of the object is unclear. The Palomar photograph gives more definition to the arms, but it is still difficult to determine whether arms and center are masses of stars or some other glowing material. In contrast, the Hubble's Whirlpool exhibits a remarkable degree of detail. Stars dot the arms, and one can trace a ridge of stars along the tops of the

arms into the galaxy's center. Instead of a white, amorphous shape, the galaxy's center reveals subtle patterns that echo those seen throughout the object.

The increased precision derives in part from the locations of the different telescopes. Not only the cloudy nights but the thick layers of atmosphere on clear nights obstructed starlight and prevented it from reaching the Leviathan's mirror. By building telescopes atop mountains, astronomers increased what they could see through their instruments. At an elevation of 5,500 feet above sea level, Palomar Observatory's telescopes take advantage of the thinner atmosphere at higher elevations to ensure improved observation. The Hubble Space Telescope, launched into orbit with the aid of the space shuttle and teams of astronomers, observes the universe free of any obscuring effects of the earth's atmosphere.

The technology used to produce the image also significantly changed how astronomers studied and represented the heavens. To produce the engraving of the Whirlpool, Lord Rosse and his assistants spent several nights peering through the eyepiece of the Leviathan and waiting for the galaxy to come into view. They then quickly sketched it, building up detail with each night of observing.[5] The introduction of photography at the end of the nineteenth century shifted the recording of the view from human hands to a light-sensitive glass plate. The automated process not only ensured a more accurate representation but also extended the limits of human vision by collecting light over time and therefore bringing out previously invisible details. The Hubble's digital cameras, with their greater sensitivity to light, magnify these distinctions even further, resulting in finely rendered views.

Magnification does more than simply bring out incredible detail. Ihde writes that it "is simultaneously accompanied by other changes that reduce other aspects of the object seen. . . . To see the moon through a telescope is to see it close up but also to lose it in its position in the sky."[6] As magnification increases, the context of the object disappears and so too does a visible experience of the whole object. To use an older example: Galileo's telescope magnified the moon, but the small field of view meant that he could only look at small portions of its surface. Representations of observations, Galileo's included, often hide this loss of context. The field of the view of the Hubble's Advanced Camera for Surveys spans only a small section—

about one quarter—of the galaxy. To display and study the Whirlpool in its entirety, astronomers combined several exposures together.

Not all Hubble images are collaged together to ensure an image of the whole; frequently they frame a small portion of a large celestial object. A comparison of a photograph of the Eagle Nebula from the decade immediately before the Hubble's launch and the now familiar view of the region shows a striking difference (Figures 5 and 6). Instead of isolated pillars, the older photograph, which was taken by the accomplished astronomical photographer David Malin, depicts a bright circle in a sea of stars. Upon closer inspection, dark protrusions that vaguely match the columns in the Hubble's images come into view. With magnification, the context and full expanse of the nebula disappears beyond the frame of the image. It is almost a misnomer to refer to the Hubble's familiar spires as the Eagle Nebula, a name that more accurately refers to the entire glowing region seen in the older photograph.

Comparing the Hubble's views of the Whirlpool Galaxy and the Eagle Nebula to older representations also highlights another feature that distinguishes Hubble images: the use of color. Human eyes cannot register different hues in the faint light emitted by galaxies and nebulae but instead see them as dimly white or even pale green. Outfitted with filters that correspond to specific wavelengths of colors, cameras can record on photographic plates or digital detectors the presence of light in a variety of colors. However, each exposure records monochromatically, and color images—whether photographic or digital—require astronomers or image specialists to assign different hues to multiple exposures and combine them together.[7] Doing so in a darkroom required a high degree of expertise, and staff photographers, not astronomers, most frequently developed the few color photographs that circulated. The introduction of digital technology gave every astronomer a set of tools that made it far easier to produce images in an array of colors. It also made it far less expensive to reproduce and circulate images in vivid hues. Scientific journals typically charge authors additional fees to print color images, but they will publish color images electronically without any cost to the researcher.

Again, though, the differences between the two representations of the Eagle Nebula are more dramatic than those between the views of the Whirlpool. The

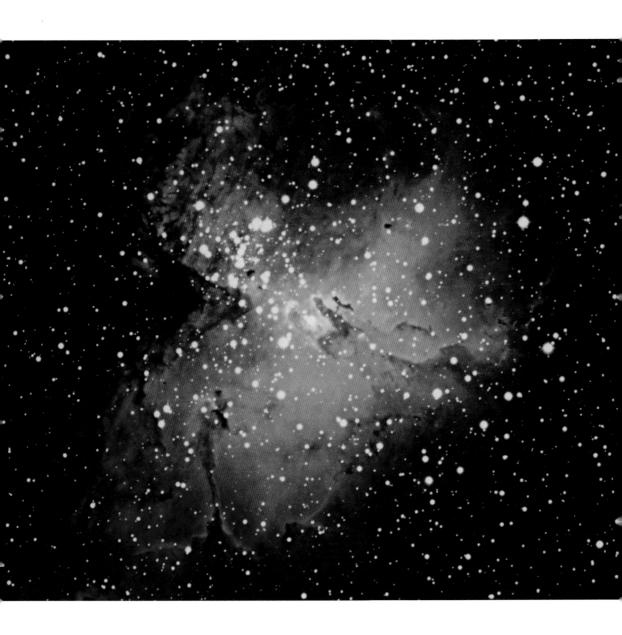

Figure 5. A color photograph of the Eagle Nebula by the astrophotographer David Malin, first published in 1979. Copyright Australian Astronomical Observatory/David Malin Images.

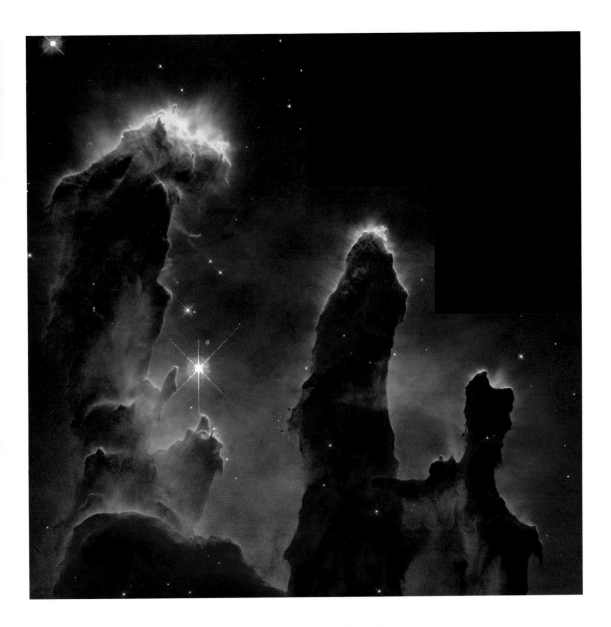

Figure 6. One of the Hubble's most famous images, a view of the Eagle Nebula that is often called the "Pillars of Creation." The unusual stair-step shape of the image is caused by a difference in resolution in one of the four sensors in the Wide Field Planetary Camera 2. November 9, 1995; WFPC2. Courtesy of NASA, J. Hester, and P. Scowen (ASU).

color scheme exhibited by many Hubble images of nebulae distinguishes them from previous ones. The older photograph of the Eagle Nebula shows the object as a pool of pinkish red. It contrasts markedly with the Hubble's representation in which the pillars appear in orange and red against a blue background. The medium, the switch from photographic film to digital data, makes the creation of color composites easier, but it does not explain the shift in representational conventions adopted by astronomers. Only by broadening the discussion of the Hubble images and considering a wider array of visual antecedents does an explanation become clear.

Romantic Spacescapes

Considered independently, the distinctive features of the Hubble images are simple improvements on past representations: more resolution, a tighter focus on areas of interest, and color to clarify differences. Seen as a whole, though, this set of attributes creates a picture, a new view that not only builds on older astronomical traditions but alludes to an artistic one. The resemblance to geological and meteorological formations that I pointed to in the Eagle Nebula images is not unique; rather it is an analogy repeatedly suggested by the color schemes, enhanced details, and compelling compositions of Hubble images. The combination frequently suggests an earthly terrain. Press releases, Web sites, and interviews with astronomers demonstrate that the institutions and individuals who work closely with Hubble images encouraged and appreciated an association between landscapes and spacescapes.

Remarkably, the comparison does not refer to just any landscape or any aesthetic sensibility but rather the Romantic scenes of the American West in places like Yellowstone, the Grand Canyon, and the American Southwest that were popularized by painters and photographers in the last decades of the nineteenth century. American artists such as Thomas Moran and Albert Bierstadt embraced Romanticism historically later than did their European counterparts, but they found in it a visual vocabulary especially well suited to describing and depicting the unfamiliar and awe-inspiring waterfalls, canyons, mountains, and trees of the United States and its territories. Photographers too, notably William Henry Jackson and Timothy O'Sullivan, were influenced by Romanticism.[8] Many of the paintings and photographs were produced as part of the scientific study of the region, a topic I return to in the last

Figure 7. The Trifid Nebula, a star-forming region in the constellation Sagittarius. The stair-step shape is an artifact of the camera, and many Hubble images are cropped to create a rectangular frame. November 9, 1999; WFPC2. Courtesy of NASA and J. Hester (ASU).

chapter, and they gave an eager audience in the East its first glimpse of the striking western scenery. By proposing that the dramatic features and vistas of the unfamiliar landscape were best represented and understood through the aesthetics of the sublime, the images established a visual standard for seeing and representing the American West that endures today.

In keeping with the emphasis on the appearance of the Hubble images, I focus here primarily on the formal and aesthetic attributes of the comparison. Both of the Hubble's views of the Eagle Nebula allude to Romantic landscapes, and examining them as well as the Trifid, Keyhole, and Cone Nebulae alongside nineteenth-century paintings and photographs demonstrates the similarities (Figures 1, 6–9). The analogy first depends on the framing and spatial orientation of the objects.

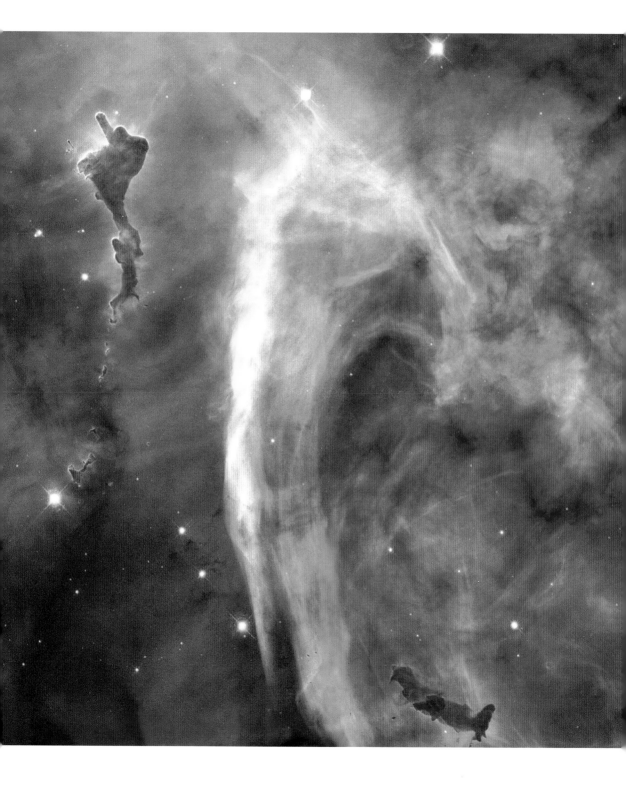

Figure 8. The Hubble Heritage Project's view of the Keyhole Nebula is oriented such that north is to the bottom of the image rather than positioned more conventionally at the top. February 3, 2000; WFPC2. Courtesy of NASA and The Hubble Heritage Team (AURA/STScI).

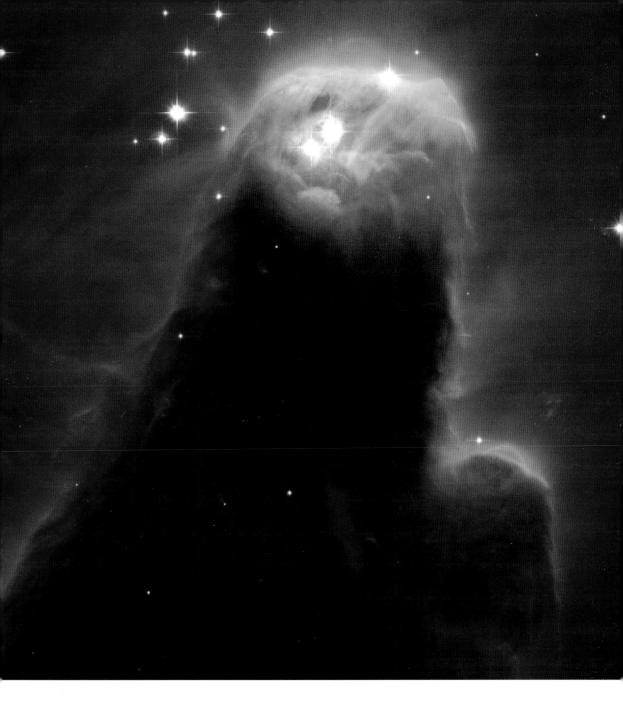

Figure 9. The Cone Nebula was one of four early release observations (EROs) that celebrated the successful installation of the Advanced Camera for Surveys. April 30, 2002; ACS. Courtesy of NASA, H. Ford (JHU), G. Illingworth (UCSC/LO), M. Clampin (STScI), G. Hartig (STScI), and the ACS Science Team.

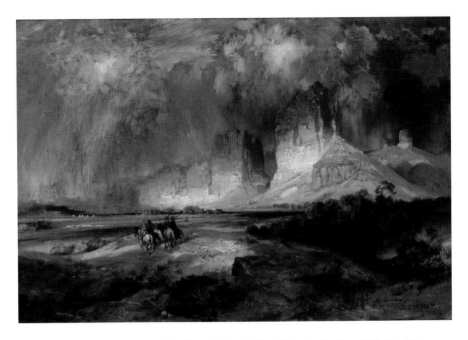

Figure 10. Thomas Moran, *Cliffs of the Upper Colorado River, Wyoming Territory,* 1882. The light, color, and composition of many Hubble images recall scenes of the American West. Smithsonian American Art Museum; Bequest of Henry Ward Ranger through the National Academy of Design.

Instead of self-contained and individual objects such as whirlpools, eagles, crabs, and the like—names given to nebulae based on similarities that arise when viewing the whole object with a less powerful telescope—the pictures focus on small regions within larger objects. Landscapes paintings and photographs never depict an entire mountain range but only a few peaks and valleys. In the five Hubble images, clouds of gas and dust appear as vertical formations reaching upward from a horizon defined by the picture frame, and it is not difficult to imagine them as details from Thomas Moran's *Cliffs of the Upper Colorado River, Wyoming Territory* (1882) (Figure 10). In Moran's painting, fantastic buttes of cream, yellow, and orange rise steeply from the banks of the river, bathed in brilliant sunlight. Moran painted the same cliffs along the Green River several times over the course of his career, and rock pinnacles figure prominently in much of his work.[9] Moran's *The Tower of Tower Falls*

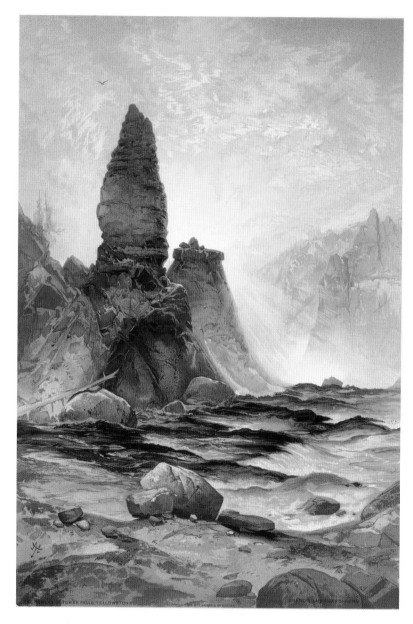

Figure 11. Thomas Moran, *The Tower of Tower Falls,* 1875. Moran created
a collection of prints based on his travels through the Yellowstone region.
Buffalo Bill Historical Center, Cody, Wyoming; Gift of Clara S. Peck, 18.71.9.

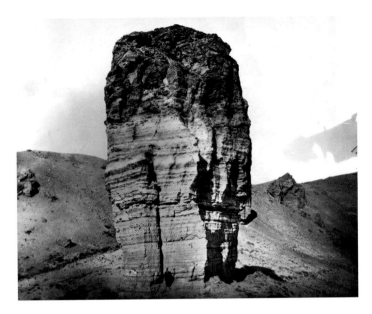

Figure 12. William Henry Jackson, *Giant's Club, Near Green River Station*, 1869.
Fantastic rock formations were common subject matter for painters and
photographers of the American West. Courtesy of the U.S. Geological Survey.

(1875), one of a set of fifteen chromolithographs commissioned and published by
Louis Prang & Co. in a luxurious portfolio of scenes representing the newly formed
Yellowstone National Park, takes a single pillar above a waterfall as its subject (Figure
11).[10] Sunlight shines from behind, giving the tower the same theatrical, even sacred,
halo that surrounds many nebulae in Hubble images.

More than a motif particular to Moran, fantastic towers of rock were icons
of the American West and a common subject in the work of many painters and
photographers.[11] These rocky pillars along with sheer cliffs and yawning canyons all
surrounded by barren and isolated terrain distinguished the American West from
other regions. Europe had mountain ranges that rivaled the Rockies and the Sierras
but it did not have landscapes like these. Not surprisingly, painters and photogra-
phers both documented and celebrated the unique features of western landscapes.
In *Giant's Club, Near Green River Station* (1869) (Figure 12) William Henry Jackson,

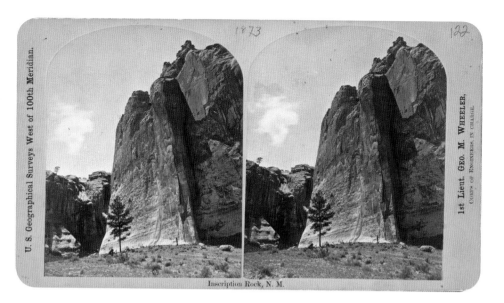

Figure 13. Timothy O'Sullivan, *Inscription Rock, New Mexico*, 1873. O'Sullivan made a stereograph, a common form of visual entertainment in the late nineteenth century, of this rock outcropping.

Figure 14. Timothy O'Sullivan, *South Side of Inscription Rock, New Mexico*, 1873. Views of impressive rock formations are associated with the American West and also evoke ideas of the sublime. Courtesy of the U.S. Geological Survey.

who worked closely with Moran during several journeys through the Western Territories, photographed a weighty monolith not far from the site of Moran's *Cliffs of the Upper Colorado River*.[12] Timothy O'Sullivan shot views of several facets of a rock formation in what is now El Morro National Monument. In *Inscription Rock, New Mexico* (1873) the sheer wall climbs swiftly, looming above the viewer. *South Side of Inscription Rock, New Mexico* (1873) frames a large portion of the rocky protuberance, and it might even be possible to see the 1995 Eagle Nebula as echoing its series of rounded crests (Figures 13 and 14). Both today and in the nineteenth century, such harsh and isolating landscapes punctuated by immense towers and cavernous abysses signify the American West, and they evoke notions of strength, power, masculinity, even hostility.

In the Hubble images the play of light along the nebular surfaces encourages the resemblance to the earth's features of buttes, pillars, and cliffs. The three bright lines toward the bottom of the largest pillar in the 1995 Eagle Nebula suggest ledges cut into a towering formation. The light patterns within the Trifid Nebula outline crags and crevices. The dark spot of the Keyhole promises a cavern, and shadows in the Cone Nebula form a foothill supporting the higher peak. Even without looking for such specific correlates, the texture and detail throughout the formations—the result of careful data modifications that make subtle distinctions visible—give the nebulae a sense of mass, weight, and substantiality that contrasts with the intangibility of a cloud.[13]

Color too supports the analogy to a landscape, and the shift from the red palette of older astronomical photographs to one with a wider array of hues begins to make sense. In the Eagle, Trifid, and Keyhole the shades of orange, red, and yellow in the gaseous pillars resemble colored rocks of the American West, while the blue background evokes an earthly sky. The dramatic backlighting calls to mind the moment when the sun dips and the colors of the landscape are particularly brilliant, the moment many photographers call "the magic hour." To continue such a scenario, the Cone Nebula with its red glow and dark sky seems to capture the last minutes before darkness descends.

Some might protest that such similarities are happenstance, an accidental resemblance that has little significance. However, even a brief introduction to the choices astronomers make during image processing (a subject addressed in greater

detail in chapter 3) quiets such objections. Orientation, perhaps the most critical element for the effectiveness of the comparison, rests in the hands of those who produce and display the images. Traditionally, astronomical images were oriented with north at the top and east at the left, thereby replicating the bodily experience of observing the heavens when one lies on the ground with one's head pointing toward the north. The Cone Nebula follows the astronomical convention of positioning north at the top, but it is the exception. Both views of the Eagle Nebula as well as the Trifid and Keyhole Nebulae deviate from the practice.[14] Although one could argue (as have astronomers who have dropped the convention) that cardinal directions are not relevant for an orbiting telescope, this argument could easily also be used to make a case for maintaining the traditional orientation that astronomers would readily recognize. Instead, astronomers chose compositions that suggest a similarity to earthly terrain. They also adjusted contrast to make evident as much detail as possible, notably more than would be visible to the naked eye or in Hubble images in their raw state, and thereby gave the forms three-dimensionality and solidity. Color too depends on choices made during image processing. The Hubble delivers monochromatic data, and astronomers combined multiple exposures, assigning a different hue to each, to create a color image. Although the results look convincingly like what one sees on earth, the colors of the nebulae do not mirror how one might see them, even with eyes as powerful as the optics of the Hubble Space Telescope. Color schemes reflect conventions more than they do visual experiences.

The press offices of STScI and NASA often made explicit the resemblance of the Hubble images to the western landscape, as when a press release described the Cone Nebula as a "craggy-looking mountaintop of cold gas and dust."[15] In another example, the analogy functions as a means to explain physical processes. Astronomers believe that new stars form within the pillars of the Eagle Nebula. The gas and dust of the nebula surround concentrated pockets of the dense matter that makes up stars. Energy from a large nearby star slowly melts away the gases, and if the sphere of star stuff is large enough then the nebula gives birth to a new star. Scientists call the process photoevaporation, and a press release on the Eagle Nebula in 1995 helpfully explains that it "is analogous to the formation of towering buttes and spires in the desert of the American Southwest."[16] The comparison is intended to make the

star formation process easily understandable. It also encourages the viewer to look at the Eagle Nebula image and see its pillars as buttes, a strong reminder of the visual similarity between the western landscape and the cosmic one.

Another comparison, this one produced by the Hubble Heritage Project, depends on adopting a bird's-eye view. Among the group's earliest images was that of NGC 3132, and as detailed in chapter 3 it was one that forced the group to evaluate its approach to assigning colors (Figure 15). The image depicts a planetary nebula, a category of objects named by William Herschel in the eighteenth century for their spherical appearance, but astronomers now know that they are not planets but the

century artists used human figures to establish scale. A group of Native Americans ride toward the river in the foreground of Moran's *Cliffs of the Upper Colorado River,* and one of Jackson's companions stands at the base of the Giant's Club. The nebulae represented in the Hubble images are too distant for human visitors; nonetheless, the images convey a sense of great size and scale. The huge pillars push toward the edges of the frame, threatening to break through it, much as the geological formations do in Jackson's portrayal of the Giant's Club or O'Sullivan's two photographs of Inscription Rock.

Light also contributes to the sense of great height, and positioning the brightest regions at the top of the image draws the viewer's eye upward. Repeatedly, the Hubble's views of nebulae are oriented with bright glowing regions near to the top of the picture frame, again giving a sense of great height. Albert Bierstadt used light to similar effect in *A Storm in the Rocky Mountains, Mt. Rosalie* (1866) (Figure 16). Although the artist devoted most of the canvas to a verdant valley that teems with

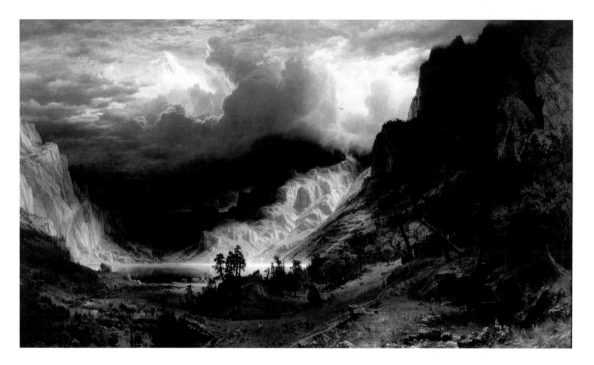

Figure 16. Albert Bierstadt, *A Storm in the Rocky Mountains, Mt. Rosalie,* 1866. Bierstadt used light and color to create an experience of a towering peak rising above a valley of great depth. Copyright Brooklyn Museum; Brooklyn Museum 76.79, Dick S. Ramsay Fund, Healy Purchase Fund B, Frank L. Babbott Fund, A. Augustus Healy Fund, Ella C. Woodward Memorial Fund, Carll H. de Silver Fund, Charles Stewart Smith Memorial Fund, Caroline A. L. Pratt Fund, Frederick Loeser Fund, Augustus Graham School of Design Fund, Museum Collection Fund, Special Subscription, and the John B. Woodward Memorial Fund; purchased with funds given by Daniel M. Kelly and Charles Simon; Bequest of Mrs. William T. Brewster, Gift of Mrs. W. Woodward Phelps in memory of her mother and father, Ella M. and John C. Southwick, Gift of Seymour Barnard, Bequest of Laura L. Barnes, Gift of J. A. H. Bell, and Bequest of Mark Finley, by exchange.

carefully rendered flora and fauna, a gleaming, snowcapped peak, impossibly high and distant, rises above the valley below.

Bierstadt also used changes in contrast to convey depth by alternating bands of dark and light as the valley recedes into the distance. The Heritage Project's NGC 602, a view of a cluster of young stars in the Small Magellanic Cloud, employs distinctions in tone to pull the viewer's eye into the deep abyss (Figure 17). A dark

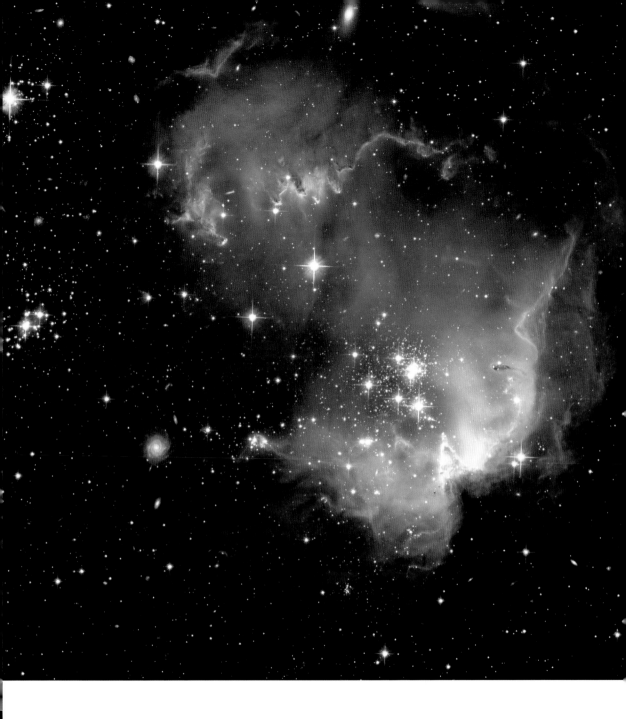

Figure 17. The Hubble Heritage Project's depiction of NGC 602 in the Small Magellanic
Cloud uses light and color to convey a sense of depth. January 8, 2007; ACS.
Courtesy of NASA, ESA, and The Hubble Heritage Team (STScI/AURA)–ESA/Hubble Collaboration.

ring opens to a brighter region, and each strata of the cloud varies in light intensity. The result is a visual experience of great depth. Released in 2007, NGC 602 benefits from the fame of the Hubble's earlier nebulae images. It is easy to find small pillars within the image, and for those familiar with the Eagle, Trifid, or Keyhole Nebulae such features are a means to estimate size and scale, much the same as tiny figures in the landscape.

Although the Orion Nebula does not resemble features of the landscape so directly, it interweaves visual allusions to Romantic scenes with a sense of expansive space (Figure 18). When observed in 1994–95, a panoramic view of the Orion Nebula required more than forty-five separate images. This entailed an extremely large amount of observing time for a single object, especially at such an early point in the telescope's history when many eager astronomers waited for their chance to observe with it.[18] The Hubble Web site's press release justified the lengthy and numerous observations by likening the Orion Nebula to a landscape: "Many of the nebula's details can't be captured in a single picture—any more than one snapshot of the Grand Canyon yields clues to its formation and history." The vast size and scale of Orion dwarfs the Grand Canyon, but the experience of photographing the great chasm, the way it extends beyond the frame of any camera's viewfinder, makes it akin to Orion. The comparison does not end with scale, however, and the next sentence once again extends the comparison to appearance: "Like the Grand Canyon, the Orion nebula has a dramatic surface topography—of glowing gases instead of rock—with peaks, valleys and walls."[19]

As in other Hubble images, contrast creates an experience of moving into deep space. Veils of darker clouds are layered on brighter ones until they open to reveal another realm. Although the point of view differs, the colors along with the detail and texture within the clouds make the comparison to the Grand Canyon an apt one. Moran's *Chasm of the Colorado* (1873–74) depicts the subtle shifts of hue and tone in the rocks of the Grand Canyon (Figure 19). The size and scale of the landscape challenged the artist's ability to contain it within the space of a single canvas. Moran implied its vast expanse by painting a network of chasms that repeat variations on the same form until they fade into the horizon, much as do the formations within the Orion Nebula.

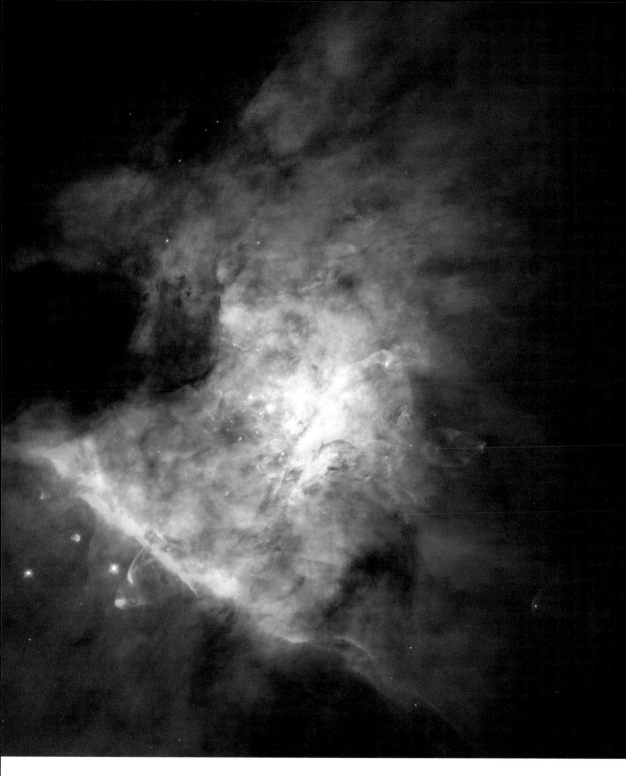

Figure 18. The image of the Orion Nebula required astronomers to stitch together a large number of observations to capture even a small section of the object. November 20, 1995; WFPC2. Courtesy of NASA, C. R. O'Dell, and S. K. Wong (Rice University).

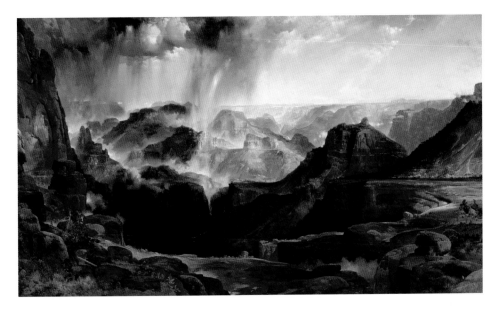

Figure 19. Thomas Moran, *The Chasm of the Colorado*, 1873–74. The vast scale of the Grand Canyon was difficult to represent in a painting, just as it is challenging to frame an immense nebula within a digital image. Smithsonian American Art Museum, Lent by the Department of the Interior Museum.

Scholars of American art have frequently connected the sublime with the ideology of Manifest Destiny, using terms such as the panoptic sublime or the magisterial gaze to qualify the aesthetic experience.[20] Such accounts focus on the point of view offered in many of the nineteenth-century landscape paintings, and they argue that the viewer typically looks down on a landscape from a position of power or control. In this context, the sublime becomes not an experience of being overwhelmed by the vast size and scale of nature but rather one of dominating it. Bierstadt's *A Storm in the Rocky Mountains, Mount Rosalie* and Moran's *Chasm of the Colorado* adopt the raised perspective and might be interpreted as examples of this sense of the sublime. The question then becomes whether the Hubble images also participate in the rhetoric of Manifest Destiny and present the universe as under our power.

I will return to these themes in the last chapter when I take up the symbolic value of the landscape, and especially the connection between space exploration and

the frontier. For now, though, I want to hesitate before labeling either the nineteenth-century landscapes or the Hubble images as taking up the panoptic sublime or the magisterial gaze. Unlike the paintings used to demonstrate the pervasiveness of the ideology, many of which were executed by Thomas Cole several years earlier, neither Bierstadt's nor Moran's paintings include signs of settlement. Although painted at a time when surveyors mapped the mountains and canyons, charting such landscapes is not the same as conquering them, and the peaks of the Rockies and the depths of the Grand Canyon remain areas that resist human control. In the case of the Hubble images astronomers also gain knowledge about the objects that populate the cosmos, but the images do not propose the possibility of controlling NGC 602 or the Orion Nebula. Even the critical formal element—the elevated point of view—is ambiguous. My descriptions of both NGC 602 and the Orion Nebula focus on the promise of great depth, but it is unclear whether we look up or down at the space that opens before us. Furthermore, and perhaps most importantly, these accounts of the sublime rely heavily on the formal elements of the paintings to make their connection to ideology. While I began with a similar attention to appearance, I want to take up the philosophical understanding of the sublime as well.

Craggy mountains, sheer cliffs, and other features that characterize the American West had not always been considered aesthetically appealing, and before the eighteenth century European landscapes of similar size and scale were associated instead with grave danger and the fallen state of the earth.[21] As appreciation for European examples of such phenomena grew, philosophers attempted to explain why the extreme emotions caused by spectacular, awe-inspiring, and even threatening experiences gave rise to pleasure. Two influential documents, Edmund Burke's *Philosophical Enquiry into the Origin of our Ideas of the Sublime and Beautiful* (1757) and Immanuel Kant's *Critique of Judgment* (1790), were critical in defining the sublime and have remained touchstones for more recent commentary on the aesthetic concepts that informed Romanticism. Burke's treatise marks the solidification of the aesthetic rather than rhetorical understanding of sublimity, while Kant's work, as Samuel Monk notes, "is the great document that coordinates and synthesizes the aesthetic concepts which had been current through the eighteenth century."[22] Both philosophers contrast the beautiful and the sublime, and both are interested in ex-

plaining experiences of pleasure and displeasure (or pain). Burke ultimately offers physiological explanations for our aesthetic responses to sublimity or beauty. Kant, on the other hand, does not attribute such experiences to the phenomenal world and argues against situating it either in the physicality of the body or in the objects themselves. Instead, he asserts that the sublime exists entirely in the mind as a response of reason and the imagination, which he associates with the senses.

Despite this distinction, both treatises list violent thunderstorms, erupting volcanoes, lofty mountains, and roiling oceans among the experiences that can evoke the sublime. Burke's and Kant's accounts of the initial reaction to such phenomena are also quite similar, and both wrote of the temporary suspension of the power of reason. Burke identifies astonishment with the sublime and describes it as "that state of the soul, in which all its motions are suspended, with some degree of horror. In this case the mind is so entirely filled with its object, that it cannot entertain any other, nor by consequence reason on that object which employs it."[23] According to Burke, the mind most readily experiences a momentary loss of reason when confronted by terror. Pleasure arises not immediately but in terror's aftermath, in the delight experienced when the threat is relieved or recognized as only illusory. For Kant too fear precedes pleasure, and he writes that the sublime is "a pleasure that arises only indirectly: it is produced by the feeling of a momentary inhibition of the vital forces followed immediately by an outpouring of them that is all the stronger."[24] The second rush is not one of relief but rather a discovery within "ourselves [of] an ability to resist [that] which is of a quite different kind, and which gives us the courage [to believe] that we could be a match for nature's seeming omnipotence."[25] This recognition of a power to resist follows the initial gasp of awe, wonder, or fear. Therefore, Kant's dynamic sublime, as he labels it, possesses an affirming quality that tempers the terror so central to Burke's definition.

The night sky featured in the efforts of both authors to characterize the sublime. Burke considered the act of contemplating the stars to be a certain experience of the sublime, writing that "the starry heaven, though it occurs very frequently in our view, never fails to excite an idea of grandeur."[26] Together the vast number of stars and their "apparent confusion" gave rise to reflections on the infinite. Burke believed them so numerous and disordered as to make it impossible for us to become

familiar enough to disrupt their sublimity. His account sounds like that of a hopeless Romantic, one who lets imagination reign and who, by always seeing the world anew, fails to recognize the cyclical patterns that order the heavens.

Kant, however, built his aesthetic reflections on his scientific interests, and it is his attention to both the senses and reason that makes his insights especially valuable for interpreting the Hubble images. Years before he developed his aesthetic philosophy, he had theorized that some stars may in fact be something much larger: namely, island universes akin to our Milky Way with each possessing its own planets. In his essay on the heavens, the younger Kant reflects almost breathlessly on the implications of such a system:

> If the grandeur of a planetary world in which the earth, as a grain of sand, is scarcely perceived, fills the understanding with wonder; with what astonishment are we transported when we behold the infinite multitude of world and systems which fill the extension of the Milky Way! But how is this astonishment increased, when we become aware of the fact that all these immense orders of star-worlds again form but one of a number whose termination we do not know, and which perhaps, like the former, is a system inconceivably vast—and yet again but one member in a new combination of numbers. We see the first members of a progressive relationship of worlds and systems; and the first part of this infinite progression enables us already to recognize what must be conjectured of the whole. There is here no end but an abyss of a real immensity, in presence of which all the capability of human conception sinks exhausted, although it is supported by the aid of the science of number.[27]

Confronted with a limitless universe, Kant describes it as an experience that baffled the senses. Here, reason—presented as the "science of number"—barely prevents the complete capitulation that marked Burke's notion of the sublime. But Kant's acknowledgment of its role means that terror does not triumph.

For Kant, size distinguishes the sublime from the beautiful, and he underlines the ways it pushes up against the limits of our rational faculties. As he states in *The Critique of Judgment,* "We regard the beautiful as the exhibition of an indeterminate

concept of the understanding, and the sublime as the exhibition of an indeterminate concept of reason. Hence in the case of the beautiful our liking is connected with the presentation of *quality,* but in the case of the sublime with the presentation of *quantity.* "[28] Kant divides the sublime into two categories: the dynamic sublime (discussed earlier) and the mathematical sublime. When he returns to a description of the universe, he adopts a more measured tone than in his youthful account. Nonetheless, the vastness of the universe, especially in relation to the scale of humans, exemplified for him the mathematical sublime:

> Nature offers examples of the mathematically sublime, in mere intuition, whenever our imagination is given, not so much a larger numerical concept, as a large unity for measure (to shorten the numerical series). A tree that we estimate by a man's height will do as standard for [estimating the height of] a mountain. If the mountain were to be about a mile high, it can serve as the unity for the number that expresses the earth's diameter, and so make that diameter intuitable. The earth's diameter can serve similarly for estimating the planetary system familiar to us, and that [in turn] for estimating the Milky Way system. And the immense multitude of such Milky Way systems, called nebulous stars, which presumably form another such system among themselves, do not lead us to expect any boundaries here. Now when we judge such an immense whole aesthetically, the sublime lies not so much in the magnitude of the number as in the fact that, the farther we progress, the larger are the unities we reach.[29]

Kant's description, a prequel perhaps to Charles and Ray Eames's *Powers of Ten,* zooms the reader out beyond the Milky Way. For Kant, there is no reason to believe that this would be the end of the journey, the absolute limit. Rather than the edge of the universe it is the edge of human imagination. Reason, though, can take us still further as it conceives of the infinite.

Kant argues that the experience of absolute greatness, the infinite, leads to a conflict between the imagination, which depends on the sensory experience, and reason. And it is in this struggle between the two that Kant locates the great power

of the sublime. The tension between the two faculties sets the mind in motion, a movement that "may be compared with a vibration, i.e. with a rapid alteration of repulsion from and attraction to, one and the same object."[30] Imagination attempts to comprehend the infinite but cannot. Reason, however, does not depend on the senses and can conceive of absolute greatness, thereby transcending the limits of the imagination and demonstrating the stunning power of the human mind. In sum, as Kant writes, "sublime is what even to be able to think proves that the mind has a power surpassing any standard of sense."[31]

To interpret Kant strictly, sublimity does not rest in an object or an image but rather in the mind, in the mental motion induced by a conflict between imagination and reason, between fear and the rational response of strength. Initially, the sublimity of Hubble images depends on the sensory response of the viewer. Through their resemblance to American landscapes and their use of sublime tropes, the Hubble images employ the iconography most associated with such a response. They suggest that one ought to see the cosmos as sublime by reminding the viewer of earthly examples of such a response. Perhaps even more significantly, and as the chapters that follow demonstrate, Hubble images repeatedly introduce a conflict between the senses and reason, and thereby encourage an experience of the sublime that goes beyond their glossy surface.

Aesthetic Intentions

The purpose for crafting Hubble images (and the nineteenth-century landscapes for that matter) goes far beyond eliciting an aesthetic response. However, the Hubble Heritage Project took the regular production of images as their primary goal and the members of the group were deeply concerned with the responses the images evoked in a range of viewers. Their reflections demonstrate a sustained engagement with the sublime.

Several of those who worked closely with Hubble data recognized the relationship to Romantic aesthetics, and they commented on the similarity in appearance and the common interest in conveying a sense of great space and scale. In the Heritage Project's Dumbbell Nebula, for instance, subtly colored clouds fill the frame (Figure 20). The densest streaks of yellow, orange, and purple divide the image along the diagonal as they separate the darker upper region from the brighter lower portion. The contrasting light as well as the complementary hues of oranges and

yellows against blue and purple give the scene vibrancy and dynamism. The image has a painterly quality, and one that Keith Noll, one of the founding members of the Hubble Heritage Project, acknowledged as follows: "In some ways, this reminds me, especially the way the light works in this one, of some of the landscape paintings of Bierstadt and some of the other painters of the American West."[32] His choice of artists is particularly apt; Bierstadt closely observed the cloudy skies and painted careful studies of their varying forms, and in his large paintings, as the art historian Barbara Novak described, he "repeatedly piled extraordinary varieties of cumulus one on the other, to create a theater of rhetoric beaming down tangible doses of sublimity."[33]

Noll did not connect the subject matter of the two images, the earthly and celestial clouds, but rather pointed to a shared quality of light: "I think it's just the character of the light here, the way that this is illuminated. He [Bierstadt] tended to have these western landscapes, and they were always sort of illuminated with this kind of hazy golden glow." The similarity goes beyond one of appearance, and Noll suggested that Hubble images and Bierstadt's paintings evoke a comparable response in viewers:

> And in some ways, I think that his work is fairly analogous to what we're doing. . . . He was painting landscapes, real landscapes, but it was more than just a literal, photographic kind of reproduction. He added on these sort of layers of light and depth that gave them a very evocative feel, a sense of grandeur, a sense of awe, a sense of mystery—a lot of the same things that I think we're going after with these images.[34]

Noll identified in Bierstadt's work and the Hubble's Dumbbell Nebula a shared power to do more than simply document the physical attributes of the cosmos. While Noll did not use the word sublime to describe Hubble images, the combination of words he chose—awe, grandeur, and mystery—equals the sublime.

Howard Bond, another of the founding members of the Hubble Heritage Project, pointed to a connection to European examples of the sublime, in particular the work of the German painter Caspar David Friedrich. When describing the relationship of such images, Bond stated that

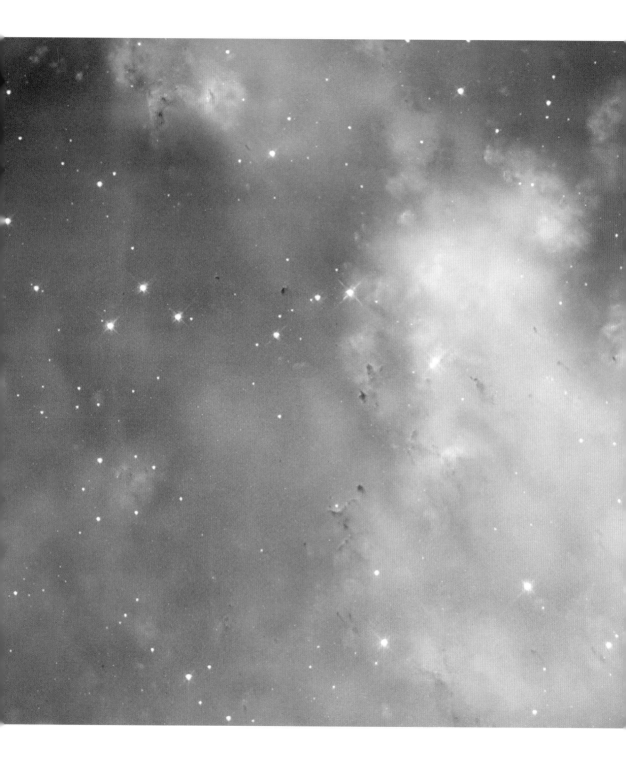

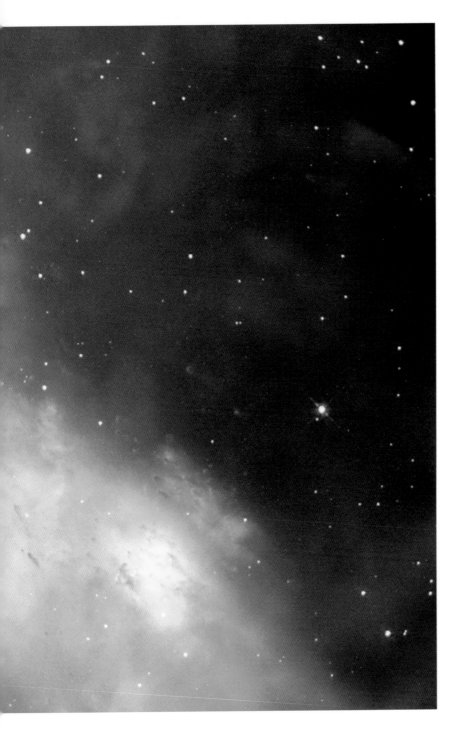

Figure 20. The Hubble
Heritage Project's view of
a portion of the Dumbbell
Nebula, a planetary nebula,
has a painterly quality.
February 10, 2003; WFPC2.
Courtesy of NASA and
The Hubble Heritage
Team (STScI/AURA).

[Friedrich] portrays nature as this gigantic, almost indifferent force. There are humans in the paintings, but sometimes, not always, and they're kind of incidental. There's that famous painting, *Das Eismeer* [The Iceberg], where Nature is actually grinding the works of man to smithereens . . . There's a parallel to what you see in astronomy, these vast things going on in the Universe which apparently have no regard to or [are] indifferent to us puny humans.[35]

His comparison takes up a central theme of the sublime: a sense of humanity's insignificance when faced with the powerful forces of nature. A visit to Bond's Web site reveals his enthusiasm for the artist.[36] The background of the page is a version of *The Iceberg*, on which the astronomer has posted two photographs of himself. In the first he stands next to the Heritage Project's image of the Ring Nebula, and in the second he poses next to Friedrich's *Monk by the Sea* at the Nationalgalerie, Berlin. Although the two examples bear little visual resemblance, they arouse similar experiences in the viewer.

Despite these references to the Romantic tradition, it would be wrong to claim that astronomers are careful students of aesthetics or nineteenth-century landscapes. After all, more than a century separates the Hubble images from the Romantic views of Moran, Bierstadt, Jackson, and O'Sullivan. In that time, many in the art world largely turned away from landscapes that combine careful study of the physical world with an evocation of the sublime. Instead, the exploration of the sublime continued in abstract expressionism, earth art, and other more conceptual twentieth-century art movements.[37]

Representations of awe-inspiring scenery did not, however, disappear. In fact, they multiplied as transportation improved and cameras became standard equipment for tourists who were guided to vista points that encouraged them to photograph those sites considered most sublime.[38] Popular culture also adopted Romanticism, a shift that was already evident in the nineteenth century as demonstrated by the variety of ways in which views of the American West circulated. Illustrated magazines, railway brochures, and scientific reports helped to disseminate the Romantic image of the landscape. Through equally varied forms the Romantic aesthetic endured throughout the twentieth century and ensured a continued interest in representing features of the landscapes that dwarfed humanity with their size, scale, and power.

Although works such as Ansel Adams's photographs, Hollywood westerns, Chesley Bonestell's space art, and science fiction films are not the only examples of Romanticism's afterlife, they helped to guarantee a cultural familiarity with Romantic tropes. For the Hubble images, they also made the aesthetics of the sublime directly relevant to representations of the cosmos.

In conversations and interviews, astronomers and officials from NASA and STScI often spoke of reading science fiction and seeing films in the genre. Some knew the work of Bonestell and recalled pouring over his illustrations as children. Only the photographs of Ansel Adams were mentioned with the same frequency. While they did not explicitly connect science fiction and these later photographs with the nineteenth-century Romantic tradition, the lineage is undeniable.

When asked about photographers he admired, the Heritage Project member Zoltan Levay replied that "certainly the big one is Ansel Adams. I mean, everybody prizes Ansel Adams."[39] Levay's comments were typical, and the members of the Heritage Project planned and eventually created a set of black-and-white Hubble images they privately dubbed the "Ansel Adams Gallery." And for many an amateur photographer, as is Levay himself, Adams looms large as both an aesthetic model and a technical guru. Books, calendars, posters, and stamps—a set of venues shared by the Hubble images—have made his black-and-white landscape photographs nearly omnipresent even more than a quarter century after his death, while his work remains a favorite subject of museum exhibitions.

Adams helped to establish an interest and appreciation for nineteenth-century photographers of the American West by bringing their images out of government archives and into the canon of art history. His own photographs display the influence of the earlier landscapes, and Adams frequently took up similar subjects and presented them in dramatic fashion. *Monolith, the Face of Half-Dome, Yosemite National Park* (1927) tightly focuses on a geological formation, emphasizing its sheer vertical drop by cutting off the picture before the rock face meets the valley below. Clouds fill the valley in *Clearing Winter Storm, Yosemite National Park, California* (1937), and the photograph recalls Bierstadt's painting of a mountain valley during a different season (Figure 21). Although Adams photographed popular tourist destinations, he framed the scene to eliminate any sign of human habitation and abandoned the convention

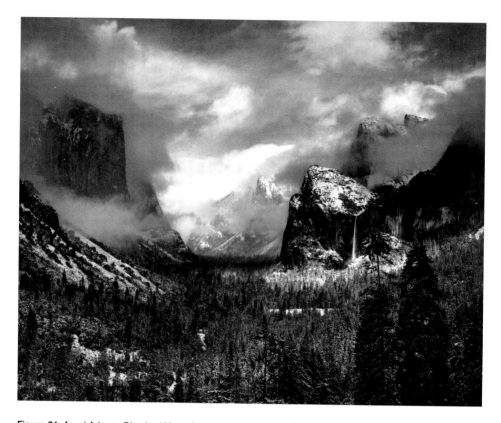

Figure 21. Ansel Adams, *Clearing Winter Storm, Yosemite National Park, California,* c. 1937.
Photographs by Adams continue the interest in the dramatic landscape of the American West.
Copyright 2011 The Ansel Adams Publishing Rights Trust.

of including figures as a means to measure scale. By inviting an appreciation of a landscape empty of humans, Adams's photographs helped to prepare the viewer for the empty worlds depicted in Hubble images.

With the popularity of Hollywood westerns, the Romantic vision moved from still photography into motion pictures. Mountains provided the setting for many films, including Anthony Mann's *Bend of the River* (1952) and *The Far Country* (1954) with their dramatic views of craggy peaks. However, deserts and canyons became even stronger symbols of the American West, solidifying an association that began

with the nineteenth-century paintings and photographs.[40] Monument Valley with its soaring buttes and mesas, the very forms later emulated in the Hubble's views of nebulae, became a favorite setting for director John Ford. Films like *Stagecoach* (1939) and *The Searchers* (1956) presented panoramic vistas that diminished the size and strength of even the mighty U.S. Cavalry.

Artists and filmmakers turned to the same Romantic model as the interest in space travel grew in the mid-twentieth century. The space artist and author Ron Miller goes so far as to suggest that "space art as we know it today could not have existed before the Romantic nineteenth century and its revolutionary discovery of the visionary landscape."[41] Whether the images promoted serious scientific exploration or established a setting for science fiction stories, the iconography of the sublime again became a means to convey vast size and scale as well as evoke an imagined vision of the unknown.

Chesley Bonestell's convincing depictions of planets, rockets, and space stations are the best known examples of space art from the years immediately before the advent of space travel. When Bonestell was imagining the surfaces of planets and their moons, places that not even unmanned spacecraft had surveyed or visited, he combined an awareness of current scientific theories with an appreciation of the sublime. Bonestell illustrated several articles that discussed the feasibility of space travel, and he was the artist for Willy Ley's influential book *The Conquest of Space* that argued in support of manned space exploration. While Ley's text explained how space travel could come about, Bonestell's images "stimulated the interest of a generation of Americans and *showed* how space travel would be accomplished."[42] In *Saturn as Seen from Titan* (1944), a painting first published in *Life* magazine and later as an illustration in *The Conquest of Space*, craggy and barren rocks rise up from the moon's surface as a waxing Saturn glows in the blue night sky (Figure 22). Omit the ring around the planet and add a few cumulus clouds and the image would be a good knock-off of a Romantic painting. The impact of Bonestell's work was aided by its wide distribution. Not only did he publish in magazines and books, he also designed sets in the same style for several science fiction films, including *Destination Moon* (1950), *When Worlds Collide* (1951), and *War of the Worlds* (1953).

The Romantic allusions in science fiction are hardly surprising because, as the

Figure 22. Chesley Bonestell, *Saturn as Seen from Titan,* 1944. The imagined view from a moon of Saturn was published first in *Life* magazine and then as part of Willy Ley's *The Conquest of Space.* Reproduced courtesy of Bonestell LLC.

film scholar Scott Bukatman argues, sublimity is fundamental to the genre: "The precise function of science fiction, in many ways, is to create the boundless and infinite stuff of sublime experience and thus to produce a sense of transcendence beyond human finitudes."[43] Bonestell's film sets did this through artist's renderings of imagined planetary landscapes, but some filmmakers turned to the very scenery that had so effectively evoked the sublime in nineteenth-century landscape paintings and photographs. As such, the rocks, pinnacles, and canyons that symbolized America in Hollywood westerns took on a new role.[44] Directors of low-budget science fiction films in the 1960s reframed the western landscape by presenting it as the surface of

Mars, the moon, and other extraterrestrial worlds. In the Stargate sequence of *2001,* Stanley Kubrick intercut novel visual effects with scenes from Monument Valley shown in psychedelic colors. In this use of a familiar landscape, the film scholar Vivian Sobchack identifies a tension between the unknown and the recognizable: "The visual surface of all SF film presents us with a confrontation between and mixture of those images to which we respond as 'alien' and those we know to be familiar."[45] Sobchack's formulation recalls Kant's suggestion that the sublime involves a conflict between the imagination and reason, between what the senses cannot grasp and what reason can understand.

But of course, not every astronomical phenomenon resembles a tower, canyon, or mountain. Galaxies, in particular, stand out as denizens of the heavens and not the earth. But even when the visual analogy falters, the effort to convey great size and scale sustains the link to Romanticism and the sublime. Astronomers often point to the image of the Tadpole Galaxy, which was released to celebrate the successful installation of ACS in 2003, as a favorite because it so effectively communicates the vastness of the cosmos (Figure 23).[46] The galaxy and its long tail reach from the upper-left to the lower-right corner of the frame. Levay, who worked extensively on crafting this image and many others, offered a detailed description: "It's such a strange, strange looking galaxy. It's got this long tail that's streaming off. . . . You see the background. That's the other thing, that you see all of these background galaxies in addition to this spectacular foreground object. So you get this amazing sense of depth."[47] As with the representations of the western landscape where rocks and trees are the familiar forms in the foreground that provide a measure of scale, the oval-shaped galaxy in the Hubble image becomes a means to judge depth and distance. The repetition of shape in increasingly smaller sizes suggests the vastness of the landscape and the immensity of the universe.

Although the image communicates a physical characteristic, a measureable distance for astronomers who can interpret the data, Levay asserted that it goes beyond just conveying depth:

> It requires some understanding of what you're looking at, but once you get
> that understanding, it sort of feeds on itself emotionally, but you get this

Figure 23. Tadpole Galaxy was one of a set of four images that celebrated the successful installation of the Advanced Camera for Surveys. April 30, 2002; ACS. Courtesy of NASA, H. Ford (JHU), G. Illingworth (UCSC/LO), M. Clampin (STScI), G. Hartig (STScI), and the ACS Science Team.

by astronomers goes beyond the scope of this book. However, an archive established by the STScI press office gives some clues as to how fans and followers of the telescope view both the instrument and its images. As part of the Hubble's twentieth-anniversary celebration, the press office invited the public to "share the way the Hubble touched your life or tell us what the telescope means to you" by posting online, e-mailing, or using other forms of digital media (Facebook, Twitter, text messaging). The press office also promised that the messages would be stored with the scientific data.[52] Since its launch, the collection has grown to over sixty thousand entries and increased at a rate of more than a thousand messages per month long after the anniversary celebration ended.

Many of the messages closely mirror the fundamental attributes of the sublime. The invitation to contribute a comment did not mention the images, but the majority of the submissions did. The images were described as amazing, awe inspiring, stunning, beautiful, and sometimes even sublime, and the contributors often remarked that they elicited a sense of wonder and mystery by portraying the vastness of the cosmos. Several felt overwhelmed when viewing the images, and even recounted, as in this example, a physical response:

> These pictures are more than just beautiful colors. They are more than just a sightseeing trip through the universe. These pictures shake the very foundation of everything I have ever believed in, and leave me reeling, breathless, and stunned at what wonders exist beyond the scope of our imagination. I can only respond with mouth agape, and tears in my eyes as I try to console myself, knowing the closest I will ever get to these wonders is through my computer screen.

Many also commented that the sense of immensity conveyed by the images made clear the relative insignificance of human concerns. One message suggested that "the images from the Hubble telescope spark my imagination and creativity. The Universe is a large place and I am but a speck in comparison. The images give me perspective and my daily problems are small in comparison." Others expressed gratitude to NASA and to the Hubble Space Telescope (frequently addressing the instrument as a person), as well as to the astronomers, astronauts, and engineers who

sustained the mission. And a few also attributed a decision to pursue a career in science or engineering to their response to the Hubble images.

All of these messages are consistent with the intentions of those responsible for producing the Hubble images, supported by the press releases and interviews with astronomers. But another recurring theme emerges, one that is not part of the official rhetoric that circulates around the Hubble images, namely, a religious interpretation. Although less common than general expressions of amazement or awe, many contributors read religious meaning in the Hubble images. Several cited Psalm 19; and one message reads: "As the Bible says, 'The Heavens reveal the Glory of the Lord.'. . . . The beauty and wonder revealed in the pictures that the Hubble transmits is truly awesome! Science is the study of God. Glory to God in the Highest!" In other messages, the Hubble images were credited with having a profound impact on individual religious beliefs. As one person wrote: "The Hubble Deep Field photo is responsible for solidifying my belief in God the Almighty. For only God can explain such wonder. How could so much Heaven come from nothing without a Great Creator?"[53]

Although not explicitly encouraged by the astronomers and image specialists who craft the Hubble images, it is not surprising that many connected their sublime appearance with the divine. In both the artistic and philosophical explorations of the sublime, an experience of nature sparked the aesthetic response. Historically, nature has often been equated with God, and in early nineteenth-century America, as Barbara Novak writes, "the sublime had been largely transformed from an esthetic to a Christianized mark of the Deity resident in nature."[54]

Novak's argument moves from an analysis of the shifting meanings of the sublime to a discussion of the challenges faced by artists who took up the landscape as their subject matter:

> Revelation and creation, the sublime as a religious idea, science as a mode of knowledge to be urgently enlisted on God's side—with these the artist, approaching a nature in which his society had located powerful vested interests, was already in a difficult position. In painting landscape, the artist was tampering with some of his society's most touchy ideas, ideas involved in many of its pursuits.[55]

Although the Hubble images come out of a very different historical moment, one that is arguably more oriented toward secular interpretations and less than convinced that science aids the divine, contemporary astronomy takes up the scientific study of the heavens, and as such it could hardly avoid similar entanglements with religious ideas. Hubble images and the astronomers who worked with them address the very creation of the universe and explore mysterious celestial phenomena. Even as the press releases maintained a distance from religious interpretations, allowing only an occasional echo as when referring to the Eagle Nebula as the Pillars of Creation, the images have a life of their own, and it was as they circulated more widely that specifically religious interpretations became attached to them.

Despite the tendency of the sublime to slip toward the divine, Kant's understanding of it, while potentially allowing for such an interpretation, resists the equation between transcendence and religious feeling. To reiterate a point made earlier, Kant locates the aesthetic experience in the mind, writing that "the sublime must not be sought in things of nature, but must be sought solely in our ideas."[56]

A Cloudy View

The religious response of many viewers might also be attributed to an undeniable sense of the ephemeral that haunts the Hubble images. Despite the allusion to buttes of slowly eroding rock, the Eagle Nebula offers no such solidity. To visually experience nebulae as akin to western landscapes requires a profound transformation, a shift from intangible and elusive clouds of gas and dust into solid mass and a place that one might visit. But the transformation is never complete. Even in those nebulae images that most closely resemble the landscape, their curving shapes and the filaments that float delicately away along their edges indicate their true nature. Such subtle reminders hardly trip up a viewer. The mutability of clouds has long invited fantastic projections, from the simple to the elaborate. Naming the nebulae, whether recognizing in them a whirlpool, a tadpole, or a mountain range, extends the practice to cosmic clouds.

Considered through the lens of history, the clouds also evoke nineteenth-century Romanticism, a period during which, as the art historian Hubert Damisch explains, "the modern spectator was invited to take pleasure in obscurity, the ephemeral, change, and to derive the greatest satisfaction and instruction from that which was

the hardest to fix and understand: wind, light, cloud shadows, and so on."[57] Artistic interest in the clouds followed from scientific attention to them, and in the first decade of the nineteenth century an English chemist, Luke Howard, developed a classification and naming system for clouds. Key figures in the German and English Romantic movement—Goethe, Shelley, Constable, and Ruskin—embraced the Latin terms and careful descriptions of the clouds, honoring Howard and his observations with poems, paintings, and other tributes.[58]

American artists paid careful attention to the clouds as well, and scientific advances in geology and meteorology fascinated them.[59] The Hubble images encourage viewers to see cosmic clouds as landscapes, and the work of Romantic artists hinted at just this possibility. In Moran's *Cliffs of the Upper Colorado River,* billowing clouds fill the sky and reach down toward the rocky forms, and the two seem almost to merge into one. As the eye follows the tops of buttes into the distance, any separation between earth and sky disappears in atmospheric blur. Bierstadt similarly obscured the distinction between clouds and mountains in *A Storm in the Rocky Mountains.* Again, the profile and shape of both phenomena echo each other, suggesting an underlying relationship between the two natural forms.

Whereas the white, puffy forms in the earth's atmosphere move and change continuously, constantly creating new shapes and patterns, the shapes of the nebulae—the patterns in the cosmic clouds—can endure for centuries and millennia. Humans can barely imagine such a timescale, and the only earthly approximation comes through the study of geology. Even still it is a distant approximation. The eons spent forming the Grand Canyon, the Rockies, and the Sierras are only a small portion of a galaxy's lifetime. Inadequate as it may be, the comparison to the landscape attempts to convey a sense of the great span of cosmic time, a Romantic experience of humanity's insignificance in the face of all that outlasts us, and it is a notion that the transience of atmospheric clouds could not communicate.

Despite this inability to express the temporal scale of the universe, the cloudiness of the nebulae, their very uncertainty, underscores their relationship to Romanticism. Symbolically, clouds, as Damisch demonstrates, have multiple functions within a painting, but most often they signify a border or a limit. In Renaissance paintings of religious visions, artists often portrayed a divine apparition seated or

standing on a cloud, which marked the line between two different realms, celestial and terrestrial; between two different modes of vision, the inspired and the mundane; and between two modes of representation, one governed by geometry and one by color and light.[60] Within a biblical context, clouds had a hierophantic function. God appeared as a pillar of cloud and led the Jews through the desert during the exodus from Egypt.[61] Damisch argues, however, that the cloud functions not only to make the divine known, but also to obscure and hide its manifestation.

This duality speaks to larger questions about the nature of representation. As Damisch writes: "*Cloud* reveals only as it conceals: in every respect, it appears to be one of the most favored signs of representation, and manifests both the limits and the infinite regress upon which representation is founded."[62] Clouds then become a sign of that which cannot be represented, that which exceeds the capabilities of ordinary human experience, whether it be the divine, the inspired, or the invisible. In Kant's system, this is the moment when reason takes over. In their very cloudiness the Hubble's nebulae images remind us that while they extend human vision into another realm, the limits of vision are real. The landscape reference lulls the viewer into believing human senses can experience the cosmos. The cloudiness reminds the viewer that such phenomena remain beyond humanity's visual reach, and even the spectacular Hubble images cannot fully capture the cosmos. Instead, we must rely on other means of comprehension.

It is through the ambiguity of the reference that the true sublimity may lie of the Hubble images, although it is a sublime with an added twist. It begins with a sense of certainty. The Hubble images look familiar enough that one can, at least at first, imagine seeing such a place, but the moments in which the comparison falters make them alien and unclear, perhaps even tinged with some fear of the unknown. They oscillate between the familiar and the alien, between what we can see and what we cannot. We are simultaneously drawn into the images and unable to make sense of them. And in their strangeness, in our inability to truly fix them in place, they surpass the limits of our imagination. Our eyes cannot see the Eagle Nebula like this, cannot see the Whirlpool Galaxy like this. The transcendent power of human reason, the faculty that undergirds our trust in science, promises that we might well come to understand such alien spacescapes.

AMBIVALENT ASTRONOMERS AND THE EMBRACE OF HUBBLE IMAGES

Astronomical Seeing

Based on the large number of Hubble images and their widespread circulation, it is easy to assume that their production was the telescope's primary purpose. The elements fundamental to astronomical observing since the late nineteenth century—light, telescopes, and cameras—support such a conclusion. Each seems grounded in an experience of vision. Light enables seeing, whether reflected off of objects or emitted by them. Telescopes extend that vision by allowing humans to see images of distant objects and scenes. Lenses, whether part of the optical system of an eye or of a telescope, project images. Photographic cameras record pictures. Since the invention of the camera it has been understood as a surrogate for the human eye. As William Henry Fox Talbot writes, "[The Camera] may be said to make a picture of whatever *it sees.* The object glass is the *eye* of the instrument—the sensitive paper may be compared to the *retina.*"[1] At its most basic, astronomical observation—a word that itself connotes sight—depends on vision as well as on the devices that enhance and imitate it.

However, if the same elements of astronomical observation are understood in terms of the physical processes at work, a different notion emerges, one that places greater emphasis on abstract data and underplays the senses. Scientists separate light from vision when they define it as measurable energy; instead, it becomes a series of numeric values that corresponds to wavelength or intensity, attributes that the naked eye may or may not discern and never with the precision of an instrument.

Reducing light to its measurable properties and subtracting out the sensory elements subtly changes how one understands the instruments used for recording the cosmos. The telescope becomes a device not for seeing but for magnifying measurable quantities of light. A camera is a technology not for taking pictures but for recording how many photons a distant object emits. With the use of digital cameras that record becomes a numeric value. Reframed in these terms, the Hubble Space Telescope turns into an instrument for collecting data about the amount and type of energy in different regions of the cosmos, data that can be analyzed through reason.

Arguably, both ways of understanding the Hubble Space Telescope are correct. It is simultaneously an instrument of vision that returns pictures and a device that collects numeric data. As such it embodies what the historian of science Peter Galison identifies as a common tension within science, that between images and data.[2] As one might expect, each mode of representation has a different function within science. While images show the specificity and complexity of the world in a manner that engages human intuition, data invite logical analysis and abstraction. Considered in these terms, a possible connection between the telescope and Kant's sublime lies within the very makeup of its observations. Their dual nature, the fact that they are simultaneously understood as appealing to the senses and to reason, has the potential to bring together the two faculties that the philosopher saw as fundamental to the sublime.

Rather than take up the aesthetic experience, Galison focuses on the separate uses of these different modes of representation as well as the translation from one to the other. Through examples from several different areas of science he demonstrates that both have a place within the pursuit of scientific knowledge, and he carefully states that he intends "neither to bury the scientific image nor to sanctify it."[3] Scientists, however, have often adopted a far less diplomatic stance. Galison's aphoristic summary of the attitudes of scientists—"We must have images; we cannot have images"—speaks to the ambivalence of their attitudes toward visual representations.[4] The rap on images is familiar; the senses are easily tricked and deceived, whereas the analysis of numeric data calls on the certainty of reason. While images may have their place, numbers and logic come out ahead. No scientist would replace the terms in Galison's phrase and suggest a ban on data.

Despite the preference for quantitative methods, the practices of astronomers push against this. Even as some demean images, others find them scientifically and aesthetically valuable; sometimes the same person holds both views. Considering science in a wider context and as a human endeavor makes evident the variety of anxieties and concerns that orbit around images. The history of the Hubble Space Telescope, perhaps more markedly than any other scientific project, illustrates that science is a very human endeavor. It is subject to shifts in plans, mistakes, and equally remarkable moments of success. The place of images through this history—from the ambivalence that dogs them to the embrace embodied by programs like the Hubble Heritage Project—underscores the critical place of the senses in astronomy. As discipline, it never fully abandons images and therefore it is possible to experience the sublime because the imagination, a critical element of the aesthetic experience and one that Kant associated with the senses, is not left behind.

While ambivalence toward images characterizes all branches of science, astronomy's relationship to seeing and picturing is an especially vexed one. Unlike other scientists such as biologists or chemists who can probe and manipulate the materials and phenomena they study, astronomers can only look. The notions of light, telescopes, and cameras discussed above already establish the centrality of vision, and the history of astronomy's engagement with these elements only further solidify the connection. Astronomy's history intertwines with that of optics, and astronomers such as Kepler and Newton contributed to scientific understandings of vision and light. Galileo's telescope stands out as the first instrument to radically amplify our sensory experience. Astronomers also assisted with the development of devices for making images. John Herschel corresponded frequently with Talbot about chemical methods for fixing light, and he gave the name "photography" to the process developed by Talbot.[5] In more recent years, astronomers have helped to enhance the performance and adaptability of digital detectors, a now omnipresent imaging technology.

The practice within astronomy of producing one pictorial representation for scientific analysis and another version for public display both confirms and complicates attitudes toward images.[6] The sociologist of science Michael Lynch and the art historian Samuel Edgerton document this approach in an ethnographic study

focused on image processing that they conducted in the late 1980s. When the researchers asked about aesthetics, the astronomers repeatedly discussed the pictures they made for public presentations, magazines, and journal articles. While many took great pride in these photos, the astronomers considered images made for display as separate from their research agendas as well as less important. The language they used revealed their underlying ambivalence toward visual representations, and they often referred to the polished color images as "pretty pictures."[7]

As an aesthetic category, a peculiar ambiguity distinguishes prettiness from other sensory experiences.[8] To judge something as pretty both acknowledges the sensual pleasures it provides and points to its inadequacies, a lesser position underlined when the word is modified as "more than pretty" or "merely pretty." A woman who is called pretty may feel genuinely complimented but also wonder why she does not measure up to the standard of beauty. Although a notch above the ordinary, prettiness is common and conventional enough to approach the banal. I might notice a pretty scene in passing, but it does not absorb my interest. It is something that catches my attention briefly and then disappears, remembered, if at all, as only a vaguely pleasurable experience. Even when pretty shifts from adjective to adverb, it tempers the word it accompanies. A pretty good day could always be better. The possibility of a higher aesthetic level that has not been reached, one that would elicit a response of much greater depth and value, stands behind every use. Prettiness makes no claim of distinctiveness, but apologizes for what is missing.

In its focus on shallow pleasurable sensations, prettiness shares some attributes with Kant's notion of the agreeable. In *The Critique of Judgment* he defines the agreeable as "what the senses like in sensation." The sublime brings into relationship the sensible and the supersensible, the imagination and reason. In contrast, the agreeable is based entirely on sensations and elicits only an increasing appetite for such sensations. In the end, the agreeable does not "contribute to culture, but it belongs to mere enjoyment."[9] Kant's most colorful and amusing characterization comes when he describes it as "all those charms that can gratify a party at table such as telling stories entertainingly, animating the group to open and lively conversation, or using jest and laughter to induce a certain cheerful tone among them . . . the whole point is the entertainment of the moment, not any material for future meditation

or quotation."[10] The agreeable and the pretty share an emphasis on fleeting sensual enjoyment that does not linger or resonate.

The lesser position of astronomical images made for display derives most immediately from their pictorial nature. The phrase "pretty pictures" implies a comparison to representations in another mode, namely, numbers and mathematics. Pictures cannot match the precision and elegance of equations or calculations. Also, their specificity closes off the possibility of making abstract and general statements about the nature of the cosmos, statements that are possible through statistical analysis. The highest aesthetic regard then belongs to a different system of representation, and pretty pictures falter before scientists even evaluate their sensual qualities. By their very definition as pictures, they cannot attain the beauty of mathematics.

Nonetheless, not all astronomical images are tagged as pretty. Many examples of great interest to scientists are blurry, black and white, and difficult to decipher. They show astronomers details that lay at the edge of the telescope's resolution, where noise and signal are difficult to distinguish. As Lynch and Edgerton argue, these pictures have aesthetic aims too, in particular a desire to make clear what is obscure. But astronomers do not make claims about their attractiveness or expect them to evoke emotion, at least not in the usual sense. Instead, they position these images as akin to numeric data, requiring reason and logical thought for their analysis. In some regards, the production of highly polished, colorful images compensates for astronomers' reliance on vision and visual representations. Creating two categories of images—one explicitly judged as less valued but aesthetically compelling—opens up the possibility for images that might avoid the pitfalls that accompany visual representations.

Some scholars, most notably the art historian James Elkins, have responded to the divide between images for display and those for scientific analysis by calling for more attention to less self-consciously aesthetic astronomical images. Elkins writes in *Six Stories from the End of Representation* that "outside the poison well of sentiment and sensationalism there is a truly lovely desert of astronomical images that do not try to be pretty."[11] While such images raise another set of questions about aesthetics, some of which Lynch and Edgerton answer, and while they contribute to the advancement of science in a different way from those made for public display, Elkins's harsh dismissal of the colorful views of the cosmos fails to acknowledge their

larger cultural significance. It also accepts with little question the aesthetic judgments of the scientists, whose relationship with images is far from simple.

As demonstrated in the last chapter, the Hubble images evoke the sublime, not mere prettiness, and engage both the senses and reason. Unlike many NASA missions, which last for a few weeks or even years, the Hubble Space Telescope has returned images for more than two decades, including world-famous icons like the view of the Eagle Nebula. Other large observatories have longer histories, but they do not have the marketing juggernaut of NASA behind them. The Hubble Heritage Project, a group dedicated to the regular release of visually compelling images, also makes the telescope unique. While press or public relations offices for other observatories regularly release images, no other astronomical research center boasts a group that functions as a hybrid of science, art, and public relations. Furthermore, the Hubble's years in orbit also largely coincide with the rise of the Internet as a widely available communication medium, and the telescope's images circulate online more widely than perhaps any other set of scientific representations.

This apparent embrace of images emerged against a backdrop of ambivalent attitudes about images. As such the history of the Hubble Space Telescope, an instrument associated both with the promise of extended vision and marked by the difficulties of achieving it, offers an opportunity to consider how this ambivalence plays out and how astronomers attempted to resolve this tension in the case of the Hubble images. We can trace several aspects of this uncertainty through the history of the Hubble Space Telescope images from the early planning stages of the instrument through the formation of the Hubble Heritage Project in 1997. Four sets of images function as benchmarks in this history: representations of the telescope that predate its launch, photographs used to promote the Hubble's primary camera, the Hubble's view of the Eagle Nebula, and the images produced by the Hubble Heritage Project. These different moments illustrate the variety of anxieties that accompany images and image making, from uncertainty about extending vision through technological means to the fear that the senses will overtake reason. In the end, several astronomers and the institutions that support them recognized the value of seeing the Hubble's return as simultaneously engaging both imagination and reason, thereby deepening the relationship of these images to notions of the sublime.

Picturing a Telescope, Presenting the Cosmos

Pictures of the Hubble Space Telescope, quite logically, predate those taken through it, and they tell the history of the project before the telescope's launch. The images spotlight the technology by documenting its appearance in a manner that recalls earlier science fiction visions of rockets and observatories in space and asserting the sublimity of the powerful machine.[12] Less deliberately, the representations also made proposals about the appearance of the images that would come from an orbiting telescope. The images often combine a representation of the telescope with telescopic views of the cosmos. In doing so, they acknowledge the complex desires that accompany the use of technological means to extend the senses. By predicting how the Hubble would see the cosmos, they also shaped expectations for its visual return, promising that the telescope would deliver dramatic, vividly colored images.

The first widely circulated pictures of what was then called the Large Space Telescope appeared in the December 1972 issue of *Sky and Telescope*. They illustrated an article by the astronomer C. R. O'Dell, who had recently been selected to lead the development of the telescope. In addition to an artist's rendering of the telescope in orbit and a cutaway diagram of the instrument's internal design, the magazine published a photograph of Marshall Flight Center in Huntsville, Alabama, and a pair of photographs that suggested what the view through the telescope might look like.[13] A few months earlier, NASA had signaled its support for the project by designating Marshall Flight Center as the field center for the telescope.[14] In the context of the article, the photograph of three multistory buildings at Marshall lent the project authority. Readers of *Sky and Telescope* would have known that scientists in Huntsville had designed and built the rockets for the Apollo missions. It was probably also no coincidence that the article appeared in the same month that Apollo 17, the final manned mission to the moon, made its lunar landing. NASA was actively seeking ways to engage the public in new missions and projects.

By 1972 plans to observe the cosmos from outside the earth's obscuring atmosphere were already several decades in the making and familiar to scientists.[15] In 1946 Lyman Spitzer, a young astronomer from Yale University, had outlined the benefits of an observatory in space as part of a classified RAND Corporation document.[16] At the time, the technological challenges of launching an orbiting telescope, as well as

the necessary financial resources, lay beyond the reach of astronomy's typical sources of support: private patrons and universities. With the creation of NASA in 1958, funding for space science swelled, and with it came an increased attention to the possibility of orbiting astronomical observatories. A year after the agency's founding, NASA began planning a program to support such telescopes. During the 1960s, enthusiasm grew both within NASA and the larger astronomical community as studies, committees, and meetings considered the research programs that a large space telescope would make possible. The conversation culminated in 1969 with the publication of "Scientific Uses of the Large Space Telescope," a report from a National Academy of Sciences committee that detailed the important scientific questions that the telescope might address.[17] The authors intended these early publications for an audience of specialists and not the general public; they contained no pictures of the telescope or simulations of its observations.

O'Dell's *Sky and Telescope* article announced the space telescope to a wider audience, albeit one both friendly to the project and with at least some expertise in telescopes, and he described the advantages such an orbiting telescope would offer. Not surprisingly, at this early stage in the project's history the two illustrations of the telescope in *Sky and Telescope* presented largely schematic and preliminary views of the instrument. In the artist's rendering, a large half-page spread that opened the article, a giant tube with two square panels at one end orbits above the earth (Figure 24). Without a cutout of the telescope's exterior, which allows the viewer to see the optical system inside, it would be difficult to discern the precise function of the object. In the background of the image, and shown much smaller in size, the space shuttle hovers with its bay doors open. The scene recalled a *Collier's* magazine illustration by Chesley Bonestell from twenty years earlier showing a view of a huge circular space station (a model for the space station in Stanley Kubrick's *2001*), a space ferry, and a space telescope. However, the scale and focus shifted in the 1972 illustration. While Bonestell's orbiting telescope was small, just a fragile skeleton of struts, the space telescope looms large and its solid exterior promises strength. The telescope would not rely on a space station but only a diminutive shuttle.

A second sketch in the article in *Sky and Telescope* diagramed the optical system and showed an astronaut at work in the "instrument room." The worker

Figure 24. An early representation of the Hubble Space Telescope shows the instrument orbiting above the earth with the space shuttle in the distance. Courtesy of *Sky and Telescope* magazine.

floats free of a spacesuit because initial plans called for a pressurized area to make it easier for astronauts to adjust and repair the telescope. Together, the space shuttle in the first image and the astronaut in the second hinted at the telescope's relationship to other NASA projects. Congress approved funding for the space shuttle program in 1972 as well, and the fates of both projects were closely linked throughout their histories. The historian Robert Smith neatly summarizes the place of the telescope within the institution as well as its relationship to other projects as follows:

> The telescope had become solidly embedded in the aims of both the Office of Space Science in NASA Headquarters and the Marshall Space Flight Center, and by packaging the telescope together with the Space Shuttle, the telescope program was gaining wider interest in the space agency.

NASA as an organization now had a firm commitment to at least study the telescope in some detail, and the coalition advocating the telescope's construction was growing in strength.[18]

During the early years of its development, NASA optimistically predicted that the space shuttle would make space travel commonplace. As a result, launching and maintaining an orbiting telescope would be a relatively easy and inexpensive task. The astronaut working on the telescope without an encumbering spacesuit illustrated this expectation.

While the artist's conception imagined a new technology, a pair of photographs of the Andromeda Galaxy (M31) attempted to convey the improved astronomical seeing that an orbiting telescope would afford. As the closest neighbor of the Milky Way and one that had a similar spiral structure, Andromeda was an interesting choice. Because a view from outside the Milky Way lies beyond humanity's vision, textbooks often present Andromeda as a surrogate for our galaxy. Its image thus functions as a mirror, proposing that observing the distant reaches of the cosmos would lead to a better understanding of our immediate environment. The choice of objects also alludes to Edwin Hubble's discovery in the 1920s of a Cepheid variable star in the Andromeda Galaxy. In the first decade of the twentieth century, astronomers had identified a direct relationship between the period of pulsation and luminosity in these pulsating stars; Cepheids with longer cycles of brightening and dimming were more luminous. By comparing absolute brightness, which is determined through plotting light fluctuations, and apparent brightness, which is based on photometric observations, astronomers could calculate the distance to a Cepheid. Although Galison does not use this example, it illustrates the cooperative relationship between images and data. Hubble began by visually observing and photographing Andromeda. He then translated his visual experience into numeric form to find both absolute and apparent brightness, deriving numeric values from images and then using them to determine the distance to the galaxy. He determined that Andromeda lay far outside the Milky Way. In doing so, he solved a long-debated question about the location of the spiral nebulae in relationship to the Milky Way and quantitatively demonstrated that the universe was comprised of numerous independent star systems. With this allusion

to Hubble's work, O'Dell indicated the high aspirations astronomers and NASA had for the telescope. They expected its observations to lead to conclusions as profound as Hubble's rethinking of the universe. The decision to name the instrument in his honor many years later further underscored a long-held expectation.

As resonant as the Andromeda photographs were, their explicit purpose was equally remarkable. The pair of photos tried to simulate an experience of better vision by contrasting a sharp photograph taken from a ground-based telescope with a second version that had, according to the caption, been artificially degraded such that the sharp version was five times better. Because neither photo could depict what the telescope would see, the reader was expected to imagine it. Using the comparison of the blurry photo to a sharp one, he or she was encouraged to conjure a third photo improved to a similar degree. O'Dell appropriately cautioned that "we can only speculate about what will be seen when LST [Large Space Telescope] is trained on presently known objects," and the exercise proposed by the pair of images tested the abilities even of the most discerning viewer.[19] More than adequately predicting what the telescope would see, the images proved the necessity of such an instrument.

Over the next five years, NASA continued to study the feasibility of a large space telescope as well as move forward with a basic design. In 1977, Congress allocated the needed funding and the space telescope officially entered into the development stage.[20] Following this NASA called for proposals from potential contractors, and the resulting engineering reports, technical studies, and promotional materials introduced images that brought together the orbiting observatory and predictions of its performance (Figures 25 and 26).[21] Lockheed Missiles and Space Company and Martin Marietta Corporation competed to build the Support System Module, the section of the telescope that would provide power, radio communication, pointing mechanisms, and other basic functions.[22] Both companies repeatedly adopted the trope of showing the orbiting observatory in the midst of its work. Some elements of the instrument remained consistent with the 1972 illustration, namely the basic shape and the solar panels, but the later pictures also reflected some of the design changes that occurred in the intervening years. A hatch opened to allow light from the distant universe into the instrument, and radio antennae communicated data back to earth. Astronauts are nowhere to be found; the telescope would work without someone at the controls.

Figure 25. A promotional image from Lockheed Missiles and Space Company combines a view of the telescope with a view through it. Smithsonian Institution Archives.

Figure 26. This same image appeared on the cover of the engineering report submitted by Martin Marietta when the company was competing to build the support system for the Hubble Space Telescope. Smithsonian Institution Archives.

The setting for the telescope differed in a more striking manner, one that linked the instrument and its observations. Instead of depicting the telescope just above the earth, the engineering reports and promotional materials placed it in the heavens and portrayed it against a backdrop of stars, galaxies, and nebulae. But if a viewer could see the telescope in its orbit, the view would be markedly different. The nebulae, one on the right side of Lockheed's image and one in the upper-left corner

of Martin Marietta's image, would be too faint to observe with the naked human eye. Also, the bright stars would lose their diffraction spikes because the brilliant rays of light that appear to radiate from them are artifacts of the instruments used for observing. In sum, rather than simply a picture of the telescope in orbit, the images combine a view of the telescope with a view through it.

This practice of collaging together a view of the telescope with a view through it was repeated throughout the history of representing the Hubble. During this period even NASA's logo for the project was a stylized version of the composition. It is a strangely confusing convention, one that expresses what the philosopher of technology Don Ihde describes as a fundamental ambivalence that accompanies technologies that enhance the senses:

> Instrumentation in the knowledge activities, notably science, is the gradual extension of perception into new realms. The desire is to see, but seeing is seeing through instrumentation. Negatively, the desire for pure transparency is the wish to escape the limitations of the material technology. It is a platonism returned in a new form, the desire to escape the newly extended body of technological engagement. In the wish there remains the contradiction: the user both wants and does not want the technology. The user wants what the technology gives but does not want its limits, the transformations that a technologically extended body implies. There is a fundamental ambivalence toward the very human creation of our own earthly tools.[23]

At one level, the Lockheed and Martin Marietta images visually celebrate the technology that the companies could build. The composite images also propose an experience of seeing the cosmos in which the enabling technology had disappeared. To present an orbiting telescope against a backdrop of nebulae and galaxies expresses a profound desire to see it in just this way. Yet it is an impossible view, one that is dependent on other hidden technologies.

When Lockheed won the contract it celebrated with a full-page advertisement in the *Washington Post* that similarly presented the instrument against a photograph

from a ground-based observatory. In large typeface the ad proclaimed: "In 1983, man may see to the edge of the universe with this NASA/Lockheed Space Telescope."[24] Unfortunately, the schedule trumpeted by the ad would prove overly ambitious; NASA and its contractors completed the development and construction of the telescope three years later than the ad predicted and significantly over budget. During this period, the project changed and evolved to accommodate shrinking budgets, shifting political agendas, and daunting engineering challenges. Several diverse entities had a stake in the project: government agencies, contractors from private industry, and astronomers who worked in research centers and universities. The difficulty of coordinating their differing interests and ideas sometimes slowed and impeded the telescope's progress.

During these years of development and construction, a number of images of the telescope circulated. As projected launch dates approached, magazines often ran special issues focused on the telescope. In the mid-1980s a painting by the space artists Rick Sternbach and Don Dixon became a favorite of publications like *Science Digest, Astronomy,* and *Sky and Telescope* (Figure 27).[25] Both artists' careers bridge science and science fiction, and the view of the Hubble could easily have been on the cover of *Analog* or any other popular science fiction magazine of the same period.[26] The telescope and space shuttle are again partnered in orbit above the earth, and an intensely red nebula glows in the background. The moon in the distance further complicates the confusion between which aspects of the scene are visible to the human eye and which aspects require technological mediation.

The painting also exhibits an emotionalism that, if even present in the other representations, is understated at best. The surface of the earth erupts with snow-covered mountain peaks that bleed into an equally jagged layer of clouds. The red nebula, far more vivid than the pinkish-red photographs of the period, curves upward, almost like flames that burn a hole in the heavens. The artists took up O'Dell's challenge to envision a better view as they imagined and then depicted the columns and pillars of the nebula with a hyperrealism that no photograph could match at the time. Here the tropes of the sublime make an appearance as the artists predicted what the Hubble would see. Not only would it improve vision, it would reveal a brilliantly colored (although with a more limited palette than Hubble images would eventually exhibit) and dynamic cosmos.

Figure 27. Rick Sternbach and Don Dixon, *The Hubble Space Telescope*, 1983.
The artists' rendering of the telescope at work was featured on several magazine covers
in anticipation of the instrument's launch. Copyright 1983–2011, PerkinElmer, Inc.

Oddly, the telescope does not point toward the spectacular phenomena the artists carefully painted but rather directly upward. The compositional choice underlined once again the ambivalence about using technology to gain such a view by making simultaneously visible the telescope and a view through it. The painting invites us to appreciate telescope and cosmos as separate examples of the sublime. With its gleaming silver surface, cylindrical shape, radio antennae, and open hatch it is a machine not in a garden, to borrow Leo Marx's phrase, but in the firmament, a late twentieth-century manifestation of the technological sublime. But the painting also presents the Hubble as a bridge between earth and cosmos, a conduit between two realms, and a means to understand them both.

Cameras and Pretty Pictures

While the public face of the Hubble Space Telescope suggested an enthusiasm for pictorial representations, the attitudes of astronomers responsible for designing and building its instruments tell another story. The history of what would come to be known as the Wide Field Planetary Camera (WFPC), the camera that scientists expected to use for a large number of observations, testifies to a different kind of ambivalence than seen in the earlier representations of the telescope. Rather than expressing a desire to experience an unmediated and extended vision, it raises questions about the validity of the senses and vision as means of gaining knowledge. The camera adopted for the Hubble relied on a new type of digital detector, and the comments of those involved in the WFPC's development hinted that this new technology made the pictorial representation of the cosmos even less important than in the past, maybe even expendable.

During the planning stages of the Hubble Space Telescope, the Science Working Group—a powerful advisory committee of thirty-eight astronomers, most from outside NASA's ranks—asserted that a data-gathering camera was essential to the mission's success.[27] With the WFPC, astronomers would collect exact measurements of light intensity from ultraviolet through near-infrared wavelengths and could examine objects too faint to observe from earth. Not surprisingly, the relative inaccessibility of an orbiting telescope required astronomers and engineers to develop new devices for recording light from the heavens. Since the late nineteenth century, astronomers had relied on photographic plates for most of their observations.[28]

Although NASA expected the space shuttle to visit the telescope regularly, astronauts obviously wouldn't be there to change plates on a nightly basis. Other unmanned missions had faced the same problem, and astronomers and engineers had designed cameras with electronic detectors.

When planning the WFPC, NASA and the Science Working Group first considered an electronic detector outfitted with a modified television tube, a technology commonly used for remote sensing during the 1960s and 1970s. The introduction of charge-coupled devices (CCDs) and the enthusiasm that quickly rose around them changed their decision.[29] Invented at Bell Labs in 1970, CCDs offered several technical and pragmatic advantages over photographic film and television tube detectors, all of which help to position the camera more firmly in the category of data-collecting device.[30] Variations in light intensity are registered by CCDs on a solid-state electronic array of cells, which ultimately corresponds to the grid of pixels displayed on a computer screen as an image. Relative to other detectors CCDs cover a wider dynamic range—the ratio of maximum to minimum light intensities. Because they are geometrically stable, astronomers could precisely and accurately determine the location of a light source. (While photographic plates also had this capability, television tube detectors returned less reliable data in this regard.) The value of each pixel is in direct proportion to the amount of light detected, and therefore CCDs are also photometrically accurate. Astronomers could use that value to precisely calculate the distance, size, and other attributes of the stars, galaxies, and nebulae they observed. Already in the early 1970s, CCDs had attracted the interest and investment of both commercial and military organizations, and therefore they were nearly guaranteed to receive ongoing support and development. But in their earliest manifestations, CCDs had some significant limitations. They covered a small field of view with the first versions measuring only a few hundred pixels on each side. Also, they were not sensitive to ultraviolet light. Equally important, as a new and only minimally tested imaging technology they introduced significant uncertainty into an expensive and high-profile project.

The Science Working Group concluded that the advantages outweighed the risks. In 1976, NASA awarded the contract for a CCD camera to a group at the California Institute of Technology (Caltech) and the Jet Propulsion Laboratory (JPL).[31] During the decades that followed, CCDs became the standard detector in

astronomical cameras as well as a nearly ubiquitous technology in digital imaging devices for consumers. It was, then, a fortunate choice, and one that ensured that Hubble data were consistent with other astronomical datasets.

The use of electronic technologies also fundamentally shifted how astronomers experience and work with their observations. Electronic detectors deliver numeric data; computers must then translate that data into a pictorial representation. With older observing technology such as photographic plates, the translation process worked in the reverse direction. Astronomers or computers (first humans and later machines) derived numeric data from an analog image, making estimates by eye or with the use of a micrometer that measured light intensity. The introduction of CCDs made the data even better than what was available photographically, pushing observations far beyond what could even be represented or detected by the human eye. At one level, then, images might seem unnecessary. If the data are already in hand and they exceed humanity's visual capacities, why return to a pictorial representation? Although not explicitly asked, conversations that arose around the WFPC suggest that this question was percolating just below the surface.

The Caltech/JPL group was led by James Westphal, a much-admired instrument engineer. By 1976, NASA had already selected another group at JPL to build a CCD camera for the Jupiter Orbiter, a mission eventually known as Galileo.[32] Teams at JPL had also contributed instruments to the Mariner, Viking, and Voyager planetary missions. Although this experience with planetary cameras made JPL an ideal place for developing the Hubble's camera, Westphal noted that it also led to some confusion:

> One of our problems with the Wide Field Camera at JPL is that the Image Processing Lab at JPL, which has done this magnificent job of picture processing from all the Mariners, Viking and Voyager, and so forth, is just not geared to the idea that we are not taking pictures. We're doing two-dimensional photometry. . . . It's a totally different enterprise, and it's very hard to convince people. . . . There is apparently something subtle about it that doesn't seem subtle to us. It does so, unfortunately, to people that haven't been associated with it. So forever that kind of discussion is going on. It goes on a lot.[33]

Westphal made these comments in 1982, which was after NASA had widely circulated brilliant false-color images of Jupiter and Saturn but well before the launch of the Hubble. The confusion he found mysterious seems hardly so. The very method by which the cameras recorded light was undergoing a fundamental change, a shift from the analog to the digital. That change had implications not only for how astronomers understood images but how they used them when studying different types of celestial objects. The underlying ambivalence about the place of images within science only further complicated matters.

Westphal emphasized how astronomers would employ the WFPC's data as evidence when he spoke of two-dimensional photometry. He expected them to analyze the precisely measured distinctions in light intensity, distinctions that were too subtle for the human eye to see but that could be represented numerically. He might well have thought that an image of such subvisible variations in light was an inaccurate representation. Through image processing, astronomers could (and would) make visible such differences, but at least in the pictorial representation they would lose the precise measurement of light intensity.[34]

That is not to say that Westphal necessarily thought the images from the planetary missions were not scientifically valid or valuable sources of evidence. Astronomers who study the stars, galaxies, and nebulae rely on measurements of light to answer some of the most basic questions: How far away is it? How large is it? How luminous is it? Photometric measurements hold less value for planetary scientists, who often have as much in common with geographers, geologists, and meteorologists as they do with those studying the stars. They need to see the features of the planet's surface, the details of its cloud cover, the makeup of its moon or rings. Therefore, the pictures of Mars, Jupiter, and Saturn contributed greatly to humanity's knowledge of the planets.

But Westphal was also far from consistent in his discussion of images or in his use of them. Before NASA awarded the contract to Caltech/JPL, each contender for the contract submitted a proposal. Several years later, Westphal recalled the work that went into it: "We took special pictures on the 200-inch [telescope at Palomar Observatory] for this proposal to demonstrate the device. We did a lot of photometry and a bunch of other stuff." Westphal used the word "pictures" to refer to the

test observations with CCDs, thereby contradicting the very distinction that he was at pains to make when discussing the images from planetary missions. He went on to clarify the reasons why his team felt such observations were necessary:

> Our intent was to sell the device, to sell the CCD, to sell the Wide Field Camera. We did that on purpose, recognizing that if we were to compete with whoever else might be out there competing for the Wide Field Camera . . . that we had to have a really overwhelmingly believable case. That was our perception of the selection environment.[35]

By providing evidence of the effectiveness of the CCDs and their value for scientific analysis, Westphal's group positioned their proposal as a viable alternative to the older, more established technology.

In selling the proposal, images took an even more prominent place. In addition to the images made with CCDs, Westphal and his team incorporated color photographs taken through the 200-inch telescope at Palomar Observatory. The photos of well-known astronomical objects—the Lagoon Nebula, the Eagle Nebula, the Orion Nebula, Saturn, the Andromeda Galaxy, and the Crab Nebula—did not prove the viability of CCDs, demonstrate the improved vision of the instrument, or function as a backdrop against which to display the telescope.[36] Instead, they indicated what the camera might observe in a manner that relied on understanding cameras as taking pictures not strictly measuring light. Those who reviewed the proposal could enjoy them aesthetically, and one would assume that they expected the Hubble with its cutting-edge camera to return even more impressive images.

Although Westphal initially resisted adding images, JPL staff members with expertise in proposal writing convinced him of the value of the images:

> Nancy [Evans] did two things that were crucial to the matter. . . . One was, she convinced us that we should put in sections dividers as pretty pictures. First, they had to be color pictures; and secondly, every separate section in the technical proposal would start out with a picture appropriate to that section. . . . Now when she proposed that to me, I said "That is hokey. I'm

Space Telescope enjoyed a series of articles and editorials that praised the project as an achievement for science and predicted nothing but future success. The metaphors employed in the headlines, including "Harvesting the Universe" for an editorial in the *New York Times* and "Hunting the 'Blueprint of Eternity'" for a front-page feature in the *Washington Post,* promised an unveiling of physical—and even metaphysical— secrets of the cosmos.[44] With this same article, the *Washington Post* published a full-color illustration of the Hubble Space Telescope on the front page. The NASA Art Program commissioned the painting, and the space artist Paul Hudson's depiction recalled earlier artists' renderings (Figure 28). Again the Hubble floats above the earth's atmosphere, dwarfing the space shuttle. But instead of placing it against a background of celestial wonders, Hudson silhouetted the telescope in front of the glowing sun. The halo that surrounds the instrument underlines the spiritual associations that accompanied the promise of new insights into the workings of the universe. One of the astrophysicists long associated with the project, John Bahcall, went so far as to propose that the universe may not live up to the instrument humans had built for observing it: "If we are disappointed, it's not the telescope's fault. . . . It will be because of a lack of imagination on the part of God."[45] Such claims left little room for failure.

The contradictory use of images continued as the launch neared. Although NASA nixed plans to produce colorful and attractive images, it decided to release some of those used to test the telescope. Only two days after the front-page story accompanied by Hudson's illustration, the *Washington Post* reported that NASA planned to "release raw 'engineering' images from the pioneering Hubble Space Telescope a few days after it is launched rather than keeping with the original plan of waiting two weeks or more for electronically processed 'pretties.'"[46] The substitution of engineering images and the accelerated schedule was a compromise to please all parties. The press and public would see early results and the astronomers would not find their scientific work threatened by the potential misuse of the images or by the lesser status of images in general. Although delayed for several weeks by a series of mechanical problems—everything from an antenna tangled in a power line to shaking solar panels—the plan to present engineering tests in place of processed images was, at least initially, successful. Journalists were invited by NASA to Goddard Space Flight Center where scientists downloaded data and displayed the observations with

only minimal image processing, in effect, directly from the telescope. The grainy black-and-white images of a few bright stars had little aesthetic appeal and almost no resemblance to the views predicted before the launch or those now associated with the Hubble. Nonetheless, both journalists and scientists praised them highly at their initial release. The Hubble Space Telescope seemed poised to fulfill all the promises that it had carried into orbit.

Almost immediately, though, astronomers and NASA administrators realized that the images appeared peculiar.[47] Instead of delivering the precise views they had expected, the telescope returned blurry pictures. Eventually astronomers and engineers determined that the primary mirror had been ground incorrectly by only a fraction of a micron, thereby causing a spherical aberration that distorted the images. Astronomers relied heavily on visual evidence to diagnose the problem. They compared the actual images with simulated views and also developed computer simulations of spherical aberration. Despite the importance of numeric data in science, the ability to recognize anomalies visually and match the Hubble's images with simulated views was critical. The knowledge gained about the problem's source helped astronomers to develop computer programs to correct the images, programmatically eliminating some of the noise caused by spherical aberration. Although deeply disappointed, devastated even, astronomers recognized that the flawed images and data offered insights unavailable through ground-based observations. Furthermore, the telescope could return undistorted ultraviolet light and spectrographic observations without difficulty, meaning that a large percentage of the proposed research was still possible. Nonetheless, in the months immediately after this discovery the public perceived the telescope as severely damaged and thus an example of excessive government expenditure with no return. Congressional hearings and intense scrutiny of NASA's project management followed, as well as debates regarding whether resources should be dedicated to its repair.[48]

The Hubble's problems with blurred vision brought to the forefront the absence of visually impressive images and their importance in communicating the Hubble's mission to a larger audience. Participants in the congressional hearings frequently noted NASA's failure to provide the expected views of the cosmos. Senator Jake Garn (R-Utah), who had flown as the first civilian on the space shuttle in

1985 and who strongly supported the space program, spoke of the role of images in gaining financial support for the space exploration: "I just cannot tell you from a public perception standpoint to have beautiful pictures coming back from Hubble, how that would have helped the chair and me in getting an adequate budget rather than having these kinds of hearings. So I am disappointed. So is everybody at NASA."[49] Garn's colleague in the House of Representatives, Jack Buechner (R-Missouri) echoed the sentiment in response to the emphasis by NASA officials on the value of ultraviolet and spectrographic observations:

> You pointed out that we're getting some great ultraviolet tests. . . . We like to have something to look at. But I guess in that vein, that's what we as representatives of the American taxpayers are faced with [as] the most dramatic problem, and that is I have yet to have one of my constituents say, "God, there are some great ultraviolet tests being taken out there." You can't show them on television. People can't see the bang for their buck.[50]

From the perspective of scientists focused on the numeric data, such calls for images might have seemed beside the point. The WFPC could be defined not as picture-making apparatus but as a device for gathering numeric data. However, the body of images that predated the Hubble's launch repeatedly promised spectacular cosmic vistas. The two different understandings of the purpose of the telescope came into direct conflict when the Hubble failed to deliver stunning images.

Although the congressmen spoke of a desire to show images to the American people, Congress itself was an equally important audience, perhaps an even more important one. Ray Villard, then an STScI public affairs staff member and later STScI news chief, reiterated this point when he speculated that even a few images might have lessened congressional ire:

> What I felt bad about was that [Edward J.] Weiler [NASA Chief Scientist for the Hubble Space Telescope] had to testify before Congress in early July of 1990 and he had no pictures to show because that [EROs] program had been scuttled. . . . We started getting some nice pictures late in July and it

was clear that the telescope was, if not perfect, . . . still better than [pictures taken] from the ground. . . . If Weiler could have held this up in front of Congress and said, "Well you know, this isn't as good as we wanted, but it's not bad," that would have made a world of difference.[51]

Although Villard lamented the elimination of the EROs program because NASA officials could not show visual evidence of Hubble's even hobbled abilities, the situation may have worked in favor of the telescope's long-term health. The absence of attractive pictures damaged NASA's reputation, but if the images had been just good enough then Congress may not have approved a repair mission. Without the pictures, repair seemed the only means for salvaging the expensive telescope.

Because the memory of the Hubble's early problems lingers, it is easy to assume that the telescope languished for years in orbit with little return. In retrospect, NASA and STScI quickly responded and released images that would appeal to the public. By August 1990, only two months after announcing that the instrument was flawed and with several scientists and NASA administrators spending the time in congressional hearings, NASA distributed new, more aesthetically developed images. The first batch included a previously unresolved star cluster, a view of Saturn that showed clearly a break in its rings, and a third image that astronomers suggested might be evidence of a black hole. Others followed in quick succession, and the choice of objects demonstrated that NASA and STScI intended to rehabilitate the telescope's reputation with images. A picture of an unusual storm on Saturn generated excitement. The sharpest view of Pluto to date allowed astronomers to clearly see its largest moon, Charon, and it delivered on the promise that the Hubble would extend human vision.[52] However, astronomers repeatedly cautioned that these images relied on extensive computer processing, and as the WFPC team member William Baum stated, "It can only be done effectively for bright objects. Therefore it is urgent that we fix the telescope so that faint distant objects in the universe can be explored in the same exquisite detail."[53]

After identifying the problem with the mirror, astronomers determined that they could correct the optics by adding another set of mirrors to focus the aberrant light rays. It was an elegant solution, one that required the replacement of a single existing instrument instead of forcing astronauts to make delicate repairs on several

instruments. Because of the critical role of the WFPC and the necessity of a success-ful repair, NASA also decided to replace the camera with a new one. A modified ver-sion, originally intended as a backup, was nearly complete, and astronomers made adaptations to its design to account for the spherical aberration. During the repair mission in December 1993, astronauts then installed two new instruments: WFPC2 and a new instrument with the unwieldy name Corrective Optics Space Telescope Axial Replacement (and yet the catchy acronym COSTAR).[54]

Dramatic pictures of astronauts at work on the telescope brought renewed attention to the instrument, but interest shifted to its improved vision less than a month later when NASA and STScI exhibited a series of EROs at the annual meeting of the American Astronomical Society in January 1994. Several sets of images emphasized the repaired Hubble's ability to deliver highly resolved views of the universe. Black-and-white views of a small region of the sky as observed by WFPC2 were displayed alongside views of the same area through the origi-nal WFPC and ground-based telescopes. In the images from the newly repaired camera, a single star shines brightly from the center of the frame. Four diffraction spikes—artifacts of the optical system, but expected ones—are arrayed around it at right angles, and a scattering of other stars gleam clearly in the background. The contrast with the other two images, a heavily pixilated view from an unspecified ground-based telescope and the spirographic patterns produced by the Hubble's flawed mirror, was undeniable.

Perhaps even more tellingly, the agencies released a collection of ten color images of nebulae, galaxies, supernovae, and globular clusters. Several of them—the Orion Nebula, M100, and Eta Carinae—were familiar objects that astronomers had observed for centuries and, even more importantly, admired for their appearance. Although not as polished as the later examples of Hubble images, they predicted the future production of more images intended for visual enjoyment.[55] They also resembled the imagined views that predated the telescope's launch. As in the fre-quently reproduced painting by Sternbach and Dixon, reds and blues highlighted the details of the nebulae 30 Doradus and Orion. The perfect spiral of M100 recalled the spiral galaxies pictured in O'Dell's *Sky and Telescope* article and the aerospace contractors' composite scenes (Figure 29). Although the images appeared long after

Figure 29. An image of the center of spiral galaxy M100 was released to demonstrate the improved vision of the Hubble after the critical first repair mission. January 13, 1994; WFPC2. Courtesy of NASA and STScI.

anyone would have liked, the Hubble finally hinted that it might live up to expectations. The images, however, did not go beyond proving that the Hubble's camera could take attractive pictures. They did not address the ambivalence associated with images, but rather repeated the established practice of producing a set of views for public display.

The Eagle Lands

Later in 1994 the collision of Comet Shoemaker-Levy 9 with Jupiter helped to illustrate the usefulness of the Hubble Space Telescope for science by allowing astronomers to observe an unusual event in great detail. NASA and STScI took advantage of the enthusiasm surrounding the collision and heightened it by releasing a new image each day via the Internet as the comet approached the planet.[56] But although the images showed impressive and scientifically interesting details, they did not rival the vibrancy of the pictures returned a decade earlier when Voyager 1 flew by Jupiter.[57] Nor did they portray the distant reaches of the universe in vivid detail as images before the Hubble's launch had predicted. To fully rehabilitate the telescope's reputation, NASA and STScI needed visual representations that were aesthetically powerful and scientifically interesting, both unfamiliar and consistent with expectations. The 1995 observations of the Eagle Nebula met these criteria (Figure 6).

When NASA unveiled the Eagle Nebula at a televised news conference in November 1995 the image received immediate praise. The *New York Times,* the *Washington Post, USA Today,* and other major newspapers printed articles featuring the image, and *Newsweek, U.S. News and World Report,* and *Time* all ran stories in the following weeks.[58] The articles explained that the image showed photoevaporation—a process by which light heats dense gases and causes ionization—and that this aided in the formation of new stars, but the reports also focused on the appearance of the image. Journalists described the scene as dramatic, eerie, monstrous, stunning, and breathtakingly beautiful, and they compared the formations to stalagmites and thunderclouds. NASA dubbed the image "The Pillars of Creation," a highly evocative name that invited religious interpretation. Although inspired by the image's appearance and the suggestion that new stars developed within the clouds of gas, the title resonated across religion and popular science, recalling everything from biblical

accounts of God appearing as a pillar of clouds to Carl Sagan's declaration that "we are made of star stuff."

The 1995 view of Eagle Nebula combined aesthetics and science more effectively and dramatically than any previous Hubble image. By showcasing the visual potential of Hubble data, it illustrated the telescope's capacity to deliver images even more spectacular than those predicted before its launch. However, this was not an image made solely for promotional purposes or aesthetic display. It also exhibited valuable information that scientists could use as a means to better understand the cosmos. Because it combined scientific content and visual appeal, the Eagle Nebula had great value as a pedagogical and promotional tool, and it remains one of NASA's most reproduced and admired images. More significantly, it blurred the lines between pretty pictures and data, and thereby opened up the possibility that astronomical images might elicit a more complex aesthetic response.

In the wake of its fame, the image of the Eagle Nebula has also been taken up by scholars in a variety of different disciplines as well as by practitioners of scientific imaging.[59] It has inspired religious visions, works of literature, even new self-help methods.[60] The ability to give rise to such a diverse array of progeny depends on the image's delicate balancing of science and aesthetics. To recognize the scientific content, though, requires looking at the Eagle Nebula deliberately rather than simply allowing it to play on the senses. When an image circulates widely, as this one has, it loses the context necessary to understand it in a scientific manner and accrues new meanings that threaten to overrun the original intentions. Arguably, this is a danger that accompanies all images. The art historian James Elkins, while bemoaning the paucity of information that accompanies many scientific images made for display, calls for "an inch-by-inch analysis . . . to bring out the individual artistic decisions and their histories, together with—matched line by line with—an inch-by-inch account of the scientific meaning of each form."[61] In the same spirit, a biography of the image with close attention to its production and reception as both a scientific image and an aesthetic one demonstrates the interpretative strategies employed by different audiences. The flexibility of this image of the Eagle Nebula, its openness to multiple readings, made it more than a pretty picture or a dry scientific image, and it ultimately encouraged the production of more Hubble images.

Although the response to the image of the Eagle Nebula was remarkable, its production was in many respects quite ordinary. The observation began, as most others did, as a means to forward a research program. Jeff Hester, a young astronomer and assistant professor at Arizona State University who proposed the observation, was interested in the fine structure in nebulae—structures that could be observed in regions undergoing photoevaporation. Because he had spent time working with the WFPC and WFPC2 team as a postdoctoral fellow, Hester had access to the Hubble Space Telescope; guaranteed observing time on the world's newest and most powerful telescope was one of the significant perks of the position. By examining images from previous research, he realized that the geometry and position of the Eagle Nebula made it an ideal location for observing photoevaporation. The tops of the three elephant trunks—the whimsical name astronomers then used for the columns that are the focus of the image—curve away, affording a clear view in profile, and the region behind them is largely empty of any objects that could confuse an interpretation. Hester rejected other sites, such as the Orion Nebula, because he feared that observing elephant trunks within a concave shape would obscure details, and he suspected that looking at the edge of such a region would prove challengingly complex.[62] Furthermore, Hester realized that three large elephant trunks in the Eagle would fit tightly within the strangely shaped field of view of WFPC2, which is caused by the lower resolution of one of the four CCDs in the camera.[63] He selected a set of filters that would detect the presence of certain glowing gases in the region, and the Hubble Space Telescope collected the data according to his specifications on April 1, 1995.

Hester hoped the data would provide insight into a physical process, and he did not plan the observation with the explicit intention of creating a visually impressive picture. But, after his colleague at ASU, Paul Scowen, downloaded the data from STScI, both realized that the image offered more than scientific insights. Excited by what they saw, the pair spent the afternoon showing their colleagues a rough version of the Eagle Nebula image. "It really started to become apparent," recounted Hester, "that not only is the science impressive, but this is just a really spectacular image. . . . You could show it to people who were scientists, and people who would normally say, 'Nah, images are just images. A pretty picture,' were [saying] 'Wow! That's neat.'"[64] Hester's anecdote underscores the visual appeal of the Eagle Nebula,

but it also raises the question of what made it more than a pretty picture; that is, one able to appeal not only to the senses but also to reason.

The paper on the Eagle Nebula published by Hester, Scowen, and their colleagues in the *Astronomical Journal* made evident the amount of information visible in Hubble images if one looked at them with the eyes of a scientist. The authors depended heavily on morphological analysis, the close study of the visual representation of the nebula.[65] Their approach, which involved few complex equations or difficult mathematical calculations, was somewhat unusual in late twentieth-century astronomy. In addition to studying the color image, the authors examined views through separate filters and enlargements of some regions. Regardless of which representation they used, the appearance of the nebula helped them to gain insights into the physical structure and processes at work within it. The authors pointed to the way the columns were illuminated, explaining that it was caused by ionizing stars. They used the differences between the appearances of the three columns to draw conclusions about their positions relative to nearby stars. Because the large column on the left glowed along the side facing the camera, they suggested that it was behind the stars, while the other two columns, with their darkened faces and glowing backs, must be in front of them. They described the pattern in the glowing haloes around the elephant trunks as striations, citing them as evidence that the radiation from the stars was ionizing and evaporating material. By comparing the difference between the sizes of the halos when observing with different filters, they developed a model for the flow of the materials. The authors also identified in the gaseous columns smaller structures, little trunks that protruded from the larger ones. These structures they called evaporating gaseous globules (EGGs), and they argued that the EGGs were the birthplaces of new stars. (Despite the obvious invitation, the acronym did not give rise to headlines about an eagle laying eggs.) The authors posited that the EGGs were composed of denser material that evaporated more slowly and revealed an internal structure within the elephant trunks. The EGGs contained stellar material accreted from the surrounding molecular cloud, and, over time, radiation from a nearby massive star would evaporate the enveloping gases, eventually separating the stellar object from the larger column and forming a new star.

To both identify and communicate the physical processes at work within the Eagle Nebula, Hester and his coauthors carefully translated Hubble data into a vivid image. They combined thirty-two different exposures, taken with four different filters and four separate CCD arrays. While remaining true to the scientific content, Hester had to make clear the important elements in the images by appropriately positioning the object in the frame, using contrast to bring out important details, and assigning meaningful colors to the monochromatic Hubble images. For the last on this list, the assignment of color, Hester broke with convention. Instead of the reddish hues familiar from photographs of the region or from artists' renderings, he made a composite image that exhibited the full spectrum of colors. He combined three separate images taken through three different filters and assigned red to one exposure, blue to a second, and green to a third. His choice of color assignments was not arbitrary, as in many false-color astronomical images, nor did he limit himself to the visual capacity of the human eye. Instead, he mapped the colors according to the relative wavelengths of the glowing gases. Red was associated with the longest wavelength, blue with the shortest, and green with the one in the middle.

Although the colors are meaningful for those who have the key, they are not naturalistic. No human eye could ever see the Eagle Nebula in the palette that Hester chose. Nevertheless, he argued that he used color to suggest, enhance, and interpret, in his words, "what's there in nature." Rather than fundamentally changing the image, the choice of colors augmented the three-dimensionality of the forms, which helped to illuminate the photoevaporative process evident in the data. Hester identified color as the most significant and influential attribute of his rendition of the Eagle Nebula, saying, "I wish I could've copyrighted the palette, the use of color, the way that I put that image together, because that's kind of become the standard." Although his claim of invention seems exaggerated—other astronomers had experimented with a similar approach to color for other celestial objects—his decision was a critical one. Astronomers were actively searching for a scientifically meaningful way to assign color, and the incredible response to the Eagle Nebula led to a consensus around relative wavelengths. Thus Hester could claim "that's what people do with images now, and the reason that's what people do with images now is because that's what I did with the Eagle Nebula image."[66]

Hester's primary goal was not an artistic picture, but he readily acknowledged similarities in the methods used by scientists and artists:

> When you're dealing with images like this, you're really in the same business, because the same use of color and contrast and composition and texture . . . that an artist uses to communicate what they're trying to communicate in what they see, you use when you put these pictures together.[67]

All visual representations, regardless of their purpose, rely on a common set of qualities to make a picture. Hester found the techniques employed by artists fascinating, and he spent museum visits studying the brushstrokes of paintings and artists' uses of color. Yet, he did not consider himself an expert in art or art history. His experiences, instead, reflected astronomy's engagement with pictures and picture making. His interest in astronomy began in his youth, and he built telescopes and experimented extensively with astronomical photography. While in graduate school, he learned to extract information from digital data through image processing techniques. Because of this knowledge Westphal and the WFPC team offered Hester a postdoctoral position to assist with the final stages of the development of the Hubble's primary camera, and he later joined the team that developed the WFPC2 camera. Hester's involvement with the instrument team provided him with detailed knowledge of its capabilities as well as access to the telescope.[68] While his biography evinces a long-standing interest in astronomical imaging, Hester's experiences were not unique. Many astronomers had an early interest in observing and imaging, and by the 1990s others had begun experimenting with digital image processing methods. Nonetheless, by the time Hester proposed observing programs for the Hubble and worked with the data it returned, he could rely on years of experience developing instruments for capturing images, processing images, and presenting them to an audience.

Unlike some astronomers, though, who might have dismissed the color image of the Eagle Nebula as just a pretty picture, Hester acknowledged and even encouraged viewers—both scientists and nonscientists—to appreciate its aesthetic appeal. He and his coauthors published the full-color image of the Eagle Nebula in the *Astronomical Journal* at a time when publishers charged authors additional

fees for color images. Other astronomical observations typically appeared in one version in the journal article and another version for press releases, but the same representation of the Eagle appeared in all venues.[69] Hester and his coauthors also explicitly stated their appreciation for the aesthetics of the image. After focusing on the scientific content of the image for several pages, they ended the paper on a different note by writing that "the WFPC2 images of M16 are visually striking, and noteworthy from that perspective alone. They also provide a fascinating and enlightening glimpse of the physical processes at work in the interplay of massive stars and their surroundings."[70] The comments recalled Hester's initial experiences of sharing the Eagle Nebula with his colleagues and their recognition that this was more than a pretty picture. But the final words of the paper went further and proposed that the aesthetics of the image, its visual impact alone, made it worthy of attention. Rather than considering its appeal to the senses as less important than its scientific content, aesthetics and science were granted equal validity and value.

The response of the audience beyond the scientific community demonstrated the alliance of aesthetics and science. The physical features that Hester and his coauthors found of greatest interest were discernible without magnifying the image; from even a basic description one could locate the smaller structures within which the infant stars nest. Although the source of the radiation, the massive star, lay beyond the frame of the image, the glowing tops of the pillars implied intense activity and interaction. The image conveyed enough information that those with little knowledge of astronomy could gain insight into the physical processes at work in the Eagle Nebula. Its pedagogical value was not limited to the precise focus of Hester's research agenda, however, and he described a range of possible "science stories" that one could tell with the picture. The individual pillars might illustrate the scale of light-years; the column on the left side measured three light-years from top to bottom. On a more cosmic scale, the conditions in the Eagle Nebula were akin to those that gave rise to the sun and its planets. In other words, the Eagle Nebula was like a baby picture of the solar system, a snapshot of it more than four and a half billion years before the earth formed. "That's a science story that you can communicate to Aunt Martha if you need to," boasted Hester. "It's a science story that you can express to people."[71]

Arguably, all of these science stories might have been told with a black-and-

white image that astronomers had not carefully composed. But the vibrant colors, monumental forms, and dramatic lighting in Hester's rendition of the Eagle Nebula sparked new interest both in such stories and in the object itself. Catalogued by Charles Messier in the eighteenth century, stargazers—amateurs and professionals alike—had long turned their telescopes to the Eagle Nebula. Images of it had existed for centuries, from drawings by William and John Herschel to photographs from Mount Wilson and Palomar Observatories, including one used by Westphal in the WFPC proposal. Because of this long history of observation and representation, the enthusiastic response to the Eagle Nebula was initially surprising. The memories of Ray Villard, head of the STScI's press office, underline the unexpected appeal of the subject matter. He described receiving a telephone call from the NASA administrator Edward Weiler, who announced plans for a press conference focused on Hester's image of elephant trunks:

> I said, "Oh, come on. You are really getting desperate." . . . I was thinking scientifically for a news story. What am I going to write about? These stalk-like structures are all over the place. . . . And he said, "You've got to see the picture." . . . I was really cocky. I said "I can imagine what an elephant trunk looks like." . . . And then he [Weiler] came up to the Institute [with the picture]. . . . My jaw dropped and I must have looked at it for five minutes. . . . The picture has a hypnotic effect.[72]

Villard's skepticism speaks to his belief that a press release should offer more than a pretty picture. Ideally, it should announce a new scientific discovery or insight, something that would lend itself to a news story and demonstrate the important scientific contributions made by the telescope. However, seeing the Eagle Nebula made him want to revisit familiar stories because it presented the phenomenon in a startlingly new fashion. Hester himself remembered with pleasure the audible gasp the picture elicited when he showed it during lectures at planetariums. The version of the nebula from Hubble data created by Hester changed the place of the Eagle Nebula by giving it new status in our imagining of the cosmos.

 Why this image and this depiction of the Eagle Nebula? "What made it what

it became," Hester modestly proposed, "was that kind of chance confluence of events at the right time, at the right place, with the right image and the right message to go along with it."[73] The image was released at the moment in Hubble's history that the telescope's success was becoming known. The depiction of the Eagle Nebula was visually impressive, and the scientific story was accessible and also compelling. While the coincidence of these events, aided by the choice to release with a televised press conference, contributed to the Eagle Nebula's distinctiveness, it does not explain the visual appeal. As detailed in chapter 1, the Eagle Nebula as crafted by Hester and his colleagues also suggested a resemblance to Romantic landscape paintings and photographs and evoked the aesthetic tradition of the sublime. The composition and color encouraged such a reading, distinguishing it from earlier astronomical images. The image's success, and ultimately that of the Hubble Space Telescope, depended on seeing the universe as simultaneously alien and familiar, as both beyond our imagination and firmly within our grasp. Through the viewer's recognition of the resemblance to a familiar visual tradition, the Eagle Nebula does more than appeal to the senses. More than a pretty picture, the image creates a tension between the senses and reason as it proposes that the Hubble delivers a sublime view of the cosmos.

Soon after the Eagle's release, callers to a CNN television program claimed they could literally see the face of Jesus within the extraterrestrial clouds, a resemblance highly dependent on Western portraits—and far more difficult to discern than any of the features described by the scientists.[74] Those who claimed to see this vision ignored certain historical facts, namely that the light recorded in the image predated the historic birth of Jesus.[75] Such assertions might easily be dismissed as an example of pareidolia, or of finding a pattern where one does not exist. Or it might be claimed that NASA courted religious interpretations by bestowing the title "Pillars of Creation" on the image.

However, such unscientific responses support the notion that the Eagle Nebula is more than pretty. To be aesthetically appealing, the image has to allow for such misinterpretations. Although not unmoored from the phenomena it represents, the way the image portrays the clouds of gas and dust invites other possible interpretations and the identification of patterns beyond the strictly scientific ones. Because it resembles a particularly American landscape, the scene encourages a certain

nationalistic response. It is an interpretation that is reinforced by its name, the Eagle Nebula, which might bring to mind the official symbol of the United States (even though the moniker derives from the appearance of the object and long predates any American observations of it). The image also conveys a sense of the vast size and scale of the cosmos. With this comes a recognition of the insignificance of humans and of their potential to transcend the mundane, but it does not dictate the means to achieve such transcendence. It is easy to dismiss the vision of Jesus within the nebula as unsophisticated religious fervor; however, seeing a portrait of the divine made human is an indication of the image's sublimity. Faced with something that exceeds the power of the imagination, the mind turns to other explanations in its quest for truth. For the devout, a deity provides an explanation for that which baffles. For the scientifically minded (and for Kant in his account of the sublime), reason fulfills this need. Ultimately, whether approaching the image scientifically or religiously, the viewer is after truth, but it has a different face—quite literally in this case—for each.

When Hester addressed aesthetics and the appeal of scientific images like the Eagle Nebula, he did not refer to visual tradition or history.[76] Instead, he turned to biology and evolution by suggesting that "part of who we are as humans is that we enjoy finding order in the midst of complexity." According to Hester, this basic human attribute underlies a range of human endeavors as well as the pleasure that arises from them:

> It's when you have this blending of order and complexity that the human mind gets engaged. That's what gives rise to art. That's what gives rise to music. That's what gives rise, I think, to literature, frankly. That's also science. And so all of these different things—art, literature, music, science—are coming from exactly the same part of what makes us human. They're all expressions of the same thing and the way that we relate to the world. My job as a scientist is to look to the world, to find patterns that I think are important patterns, and then to find a way to communicate those patterns, to present them in a way that other people can see not just my data, but can see what it is that I'm trying to show them is significant about these data, which is precisely the same thing that an artist does.[77]

Hester's statement recalls Gestalt psychology as well as the efforts by the artist Gyorgy Kepes and his colleagues at MIT in the mid-twentieth century to similarly locate a connection between art and science in structure.[78] One might also consider the capacity to recognize pattern and find order to be an aspect of reason. Hester argued further that the Eagle Nebula and other Hubble images are "aesthetically appealing because they're scientifically interesting. They are scientifically interesting because they are aesthetically appealing. The overlap between those two expressions of that part of us is manifest in these images."[79] Hester's comments are free of the ambivalence that marked many astronomers' view of images. Instead, he embraced the possibility, seeing it as inevitable even, that images are simultaneously artistic and scientific. They engage the human mind at multiple levels. To go a step further, Hester's words offer another example of the tension between reason and the senses that Kant deemed to be essential to the sublime.

Ensuring a Legacy

The problems that arose immediately after the Hubble's launch ensured that STScI and NASA regularly provided polished images. But it was the later favorable response to the Eagle Nebula that quickly affected the appearance of the Hubble images released to the public. Until 1995, STScI press releases often featured a black-and-white image. When color was used, the images usually relied on different shades of a single hue rather than a full-color array. But by 1997, a color version accompanied all but one of the black-and-white images included in STScI press releases. While color was only one aspect of an image's appearance, it signaled the greater attention paid to creating visually appealing images. The exception in 1997 was an early release observation, a view of the Butterfly Nebula that marked the success of the second servicing mission, and the absence of color may have reflected the nature of the mission. Astronauts installed two instruments, the Space Telescope Imaging Spectrograph (STIS) and the Near-Infrared Camera and Multi-Object Spectrometer (NICMOS) that did not deliver pictorial data. For subsequent servicing missions NASA and STScI took a different approach. The third mission in 1999 was followed by the release of color views of the Eskimo Nebula and Galaxy Cluster Abell 2218. By the fourth servicing mission in 2002 and the installation of the Advanced Camera for Surveys (ACS), NASA and STScI eagerly

Figure 30. After the final repair mission, NASA and STScI released several images to announce its success, including (clockwise from upper left) views of the Butterfly Nebula, Stephen's Quartet, Jet in Carina, and Omega Centauri. September 9, 2009; WFC3. Courtesy of NASA, ESA, and the Hubble SM4 ERO Team.

Figure 31. The Hubble Heritage Project crafted a set of four images for its initial release, including a view of Saturn. October 21, 1998; WFPC2. Courtesy of NASA and The Hubble Heritage Team (STScI/AURA).

image. In the image of a Seyfert galaxy, the brilliant white and yellow core appears surrounded by halos of bluish stars. By including a range of objects—a planet, a star field, a nebula, and a galaxy—the set summarized Hubble's observations of the universe. The choice of objects acknowledged the scientific purpose of the telescope, while the choices made in image processing, a topic that will be discussed in the next chapter, determined the color, contrast, and composition. The results invited an aesthetic appreciation of the images. The telescope has disappeared from view, and the images offered the possibility that humans possessed the visual acuity to see the cosmos as never before.

Over more than ten years of operation with a schedule of releasing one image per month, the Heritage Project has assembled an impressive gallery of pictures. Although most of the images gain an audience through press releases orchestrated by

Figure 32. The colorful Sagittarius Star Cloud was part of the Hubble
Heritage Project's first collection. October 21, 1998; WFPC2.
Courtesy of NASA and The Hubble Heritage Team (STScI/AURA).

Figure 33. By including an array of different objects in its first release, the Bubble Nebula (NGC 7635) among them, the Hubble Heritage Project demonstrated the range of observations made by the telescope. October 21, 1998; WFPC2. Courtesy of NASA and The Hubble Heritage Team (STScI/AURA).

Figure 34. The yellow core of Seyfert galaxy NGC 7742 contrasts with its bluish arms in this early image from the Hubble Heritage Project. October 21, 1998; WFPC2. Courtesy of NASA and The Hubble Heritage Team (STScI/AURA).

STScI, others appear more quietly on the project's Web site. The collection encompasses an incredible range of astronomical objects, many of which astronomers had observed as part of their research programs. The Heritage team searched the archived data and developed images that made them visible to a larger audience and in a form that layered aesthetics onto science. The Keyhole Nebula, NGC 602, and the Dumbbell Nebula, all examples discussed in the last chapter, were produced in this manner (Figures 8, 17, and 20). The Heritage team made numerous views of galaxies newly available: a closeup of the Whirlpool Galaxy induced a sense of vertigo (Figure 39); a set of interacting galaxies, NGC 2207 and IC 2163, danced in lockstep, and a light jet-streamed from the center of M87 (Figure 35). Other images displayed the Hubble's ability to detect very faint light. In a supernova remnant from within the Large Magellanic Cloud, the filigrees of glowing gases intertwined in a delicate knot of color offset by a flat black background (Figure 36). The group also followed through on their proposal by requesting and dedicating time to new observations of famous objects such as the Ring Nebula, the Horsehead Nebula, and the Sombrero Galaxy. Instead of eventual and sometimes unplanned translations of scientific data, pretty pictures became the reason for data collection; scientific results are the secondary return.

In some respects, the Hubble Heritage Project extends existing methods for reaching a larger audience and encouraging the continued support for the telescope, whether in the form of the public's goodwill or funding from Congress. Frattare's and Levay's association with the public outreach office, as well as the involvement of Christian and Kinney, ensure that the Heritage Project's work is coordinated with public relations efforts at the institute and ultimately at NASA. In 1997, the press office distributed a list of criteria to help astronomers determine whether their research might be considered newsworthy. Novelty and exceptionality dominated the list: new discoveries, unexpected events, and superlative cases.[91] If an image does not meet any of these standards but is visually appealing, the Heritage Project offers another outlet. Unlike other press releases, these images need not focus solely on the science. In some cases, the members create another version of an image with greater attention to aesthetics, and when this happens the Heritage team coordinates with both the astronomers who proposed the observation and the press office. If a more scientifically oriented release is planned, it takes precedence. Yet the Heritage Project

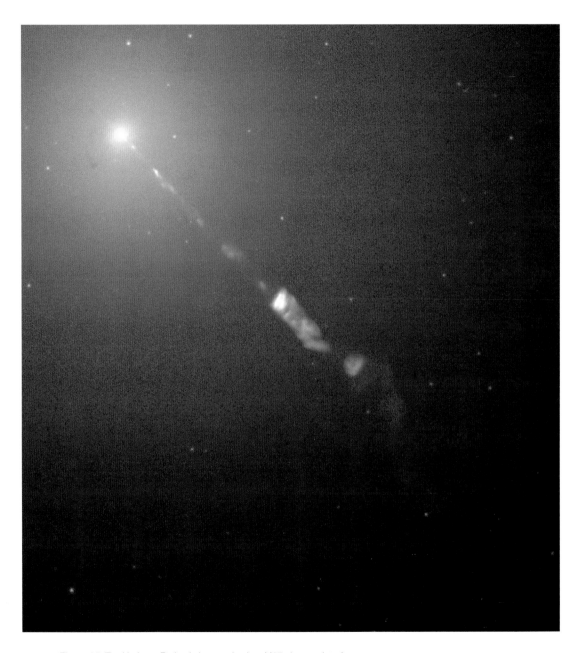

Figure 35. The Heritage Project's image of galaxy M87 shows a jet of light streaming from a black hole at its center. July 6, 2000; WFPC2. Courtesy of NASA and The Hubble Heritage Team (STScI/AURA).

Figure 36. The press release that accompanied the Heritage Project's view of a supernova remnant in the Large Magellanic Cloud, designated N49, compared the colorful filaments to fireworks. July 3, 2003; WFPC2. Courtesy of NASA and The Hubble Heritage Team (STScI/AURA).

is not simply a branch of the press office but instead retains its independence. Final approval for an image rests with the team members, and the press office can choose not to issue a press release. The Heritage Project also asserts its connection to the scientific community. With Noll acting as the principal investigator and funding coming through NASA grants, its structure and support mirrors those of a scientific investigation. The result is a hybrid that combines aspects of a scientific project, public relations, and artistic exploration.

The group's status as a scientific project is confirmed by its access to observing time on the telescope. As requested in the original proposal, the project receives a small allocation from the director's discretionary time with about half the images coming from the archive and half from new observations. According to Noll, the group used an average of twenty-five orbits each year, which accounted for less than 1 percent of the telescope's total available observing time. Demand for the telescope far exceeds the available observing time, and compelling scientific proposals are delayed or rejected simply because the instrument is oversubscribed. Nonetheless, time is dedicated to creating images that focused less on science and more on aesthetics. Some scientists object to this use of the telescope, feeling it should be solely dedicated to the pursuit of pure science. Whether deemed a large or small amount of time, the choice indicates the importance that the institute and NASA place on creating visually appealing images. The Heritage Project's archive further demonstrates a commitment to a particular way of depicting and presenting the cosmos.

As the Heritage Project matured, the group developed and codified methods for processing images. Although the Eagle Nebula was one model, the regular production of images forced the members to think more deeply about how to translate data into images. Their work might easily suggest an unabashed embrace of visual representation. However, anxieties about the place of images in astronomy did not disappear. Differences between the initial proposal and one written for the project's fifth year make evident the complicated place of images within astronomy. The group requested similar resources and funds—observing time and a budget for personnel and incidental expenses—but frugality had a justification lacking in the earlier proposal: "An important part of our vision is to accomplish our goals with the minimum necessary resources. We believe this is critical if we are to retain the

support of the general astronomical community."[92] Throughout the proposal, the relationship with astronomers received more attention. The involvement of scientists in new observations was always expected, but the later proposal more explicitly acknowledged those whose archival data became the basis for Heritage images. Although astronomers might dismiss images as having less value than numeric data, they still wanted credit regardless of how their observations were displayed.

The proposal also cited the photographs taken by William Miller at Mount Wilson and Palomar Observatories in the late 1950s as a model for the Heritage Project. As a staff photographer, Miller took advantage of windows of free time to make photographs. By grounding their use of the telescope in the past example, the members of the Heritage Project claimed that their use of the Hubble for image making had historical precedence. They also aligned their images with Miller's color photographs and the methods used in their production. Unlike in the first proposal, the group made a greater effort to explain their approach to translating digital data. The standards for the images repeated the text from the earlier proposal, but instead of ending with the removal of artifacts the proposal dedicated several sentences to the group's practices regarding color. The section concluded with a general governing principle for their approach to image processing, stating that "the primary goal is to maximize the aesthetic appeal and showcase the astrophysical phenomena of the final image without introducing unnecessary manipulation of the data."[93] These additions reflect many of the questions and issues addressed by the Hubble Heritage Project in its first years of operation.

In the history of Hubble images, the Heritage Project is a culmination of several decades of uncertainty about images. The anxieties around image making in astronomy began with ambivalence around the extension of vision and a desire for unaided sight. They wove through debates about what the telescope should produce: numeric data, scientific images, pretty pictures, or some hybrid of all of these. In end, NASA, STScI, and the astronomical community sided with images that suggest the possibility of reconciling, in uneasy tension, the senses and reason. It is this choice that makes it possible to align the Hubble images with the sublime. To transcend the ordinary and mundane we cannot eliminate the visual. An affirmation of humanity's greatest potential—the sublime—ends with reason, but it begins with the senses.

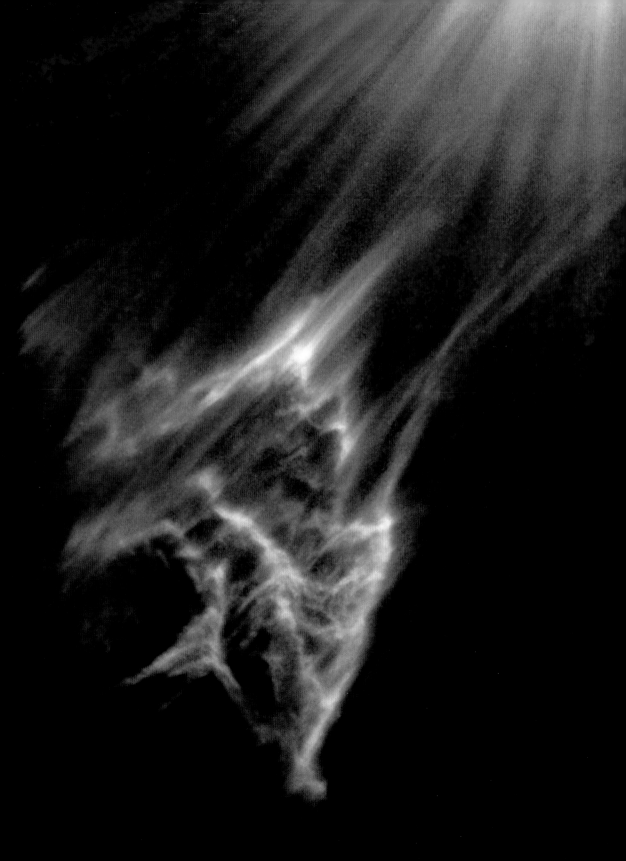

TRANSLATING DATA
INTO PRETTY PICTURES

Hybrid Images

How do Hubble images represent the cosmos? In chapter 2, I argued that they are more than pretty pictures, and in fact have scientific and aesthetic value. I have referred several times to their status as digital images, and I explained very briefly how that can affect their appearance. However, more attention and more sophisticated analysis is necessary to properly address the topic. The medium of the Hubble images coupled with their relationship to science makes them into complex hybrids. Their digital makeup brings together two modes of representation, number and image. Working in concert, the telescope and cameras extend perception by magnifying and recording light; they enable observations with incredible precision and across a range of wavelengths. The resulting data are indexical records of physical properties that exceed the limits of vision and of representation. The astronomers must use image processing software to make that expanded range of data legible to the human eye. Because digital data are numeric, astronomers can intervene by modifying a single value, or pixel, or an entire data set. But they must also determine, given the impossibility of a perfect translation, the elusiveness of a perfect reflection of numeric data as visual representation, when to maintain indexical aspects and when to convey attributes symbolically.

Analog images, of course, also allow for specific and general alterations to their appearance. Digital images are distinct because of the ease of making such changes and the possibility of doing so in a manner that leaves no trace. Every astronomer

has the tools—a computer and image processing software—to make such changes, whereas changes to a photograph required a darkroom and the expertise to use it. (That is not to say that manipulating digital data does not require expertise, but the opportunity to do so is far more available.) Also, digital image processing can offer a far greater degree of control. To make certain types of modifications, astronomers apply algorithms based on mathematical functions, a process that can be exactly repeated or reversed. Software can automate mathematical transformations that astronomers might perform with a set of equations, as well as allow for pictorial expression of the modified data.

As scientific images, which should accurately refer to the phenomena they represent, such changes might seem unnecessary for the Hubble images. Isn't the best image, the truest one, the version that most directly transforms the phenomena of the world into a representation? Such a notion rests on the objectivity of the instruments, or what the historians of science Lorraine Daston and Peter Galison call mechanical objectivity. However, as they argue, twentieth and twenty-first century scientists have increasingly supplemented mechanical objectivity with trained judgment, thus producing an image reliant on the ability of its maker "to synthesize, highlight, and grasp relationships in ways that were not reducible to mechanical procedure."[1] For the Hubble Space Telescope, the larger cultural turn toward trained judgment has another rationale: the extension of perception exceeds the capacity of representation. Hubble images cannot imitate the appearance of celestial objects because some of their features are invisible to our eyes. They also cannot exactly imitate the data; the precise distinctions within the data also are beyond what our eyes can see. Therefore, astronomers have had to find a way to display the data that makes it possible to experience the cosmos with the senses without compromising the validity of the representation.

Perception and representation, number and image, index and symbol—the hybridity of the Hubble images raises a question that haunts all scientific images: What is their relationship to the phenomena they purport to represent? When observing with the Hubble Space Telescope, astronomers are forced to consider what constitutes a legitimate image. What modifications to contrast, color, and composition are acceptable and which ones are not? Because the new medium of digital imaging upended estab-

lished conventions, astronomers who worked with Hubble data early in its history (for whom the Hubble Heritage Project often acted as spokesperson) found themselves groping toward a new set of guidelines for representing and displaying astronomical phenomena. In many cases astronomers sought direct correlations, a key that could be followed in multiple situations, but the complexity of the data, the diverse audiences for the images, and deeply engrained ideas about the visual culture of science made such an approach inadequate. Furthermore, it limited what an image might achieve or what it might represent. In the end, the experiences of astronomers with the images exceed their ability to account fully for how they produced them. A deeper analysis of the process of translation is therefore called for, and the critical theorist Walter Benjamin's approach to literary translation, with its promise of finding truth in the movement between different modes of expression, offers a means to understand the conversion from data to image. It also reiterates another important aspect of the sublime, the possibility of transcending the limits of the senses.

The Hubble's views of the cosmos are doubly mediated, translated first from celestial objects into data and then translated a second time into images. The multiple levels of translation are not unique to digital technology—astronomical photographs undergo a similar set of mediations—but there are significant differences. With photographs, images are the first translation from physical object to representation, and the data are derived from the image. To move from one mode to the next in this order, from image to data, is consistent with the larger ideals of science. The analysis becomes increasingly more exact, more numeric, more precise. The move to digital images seems to move from the exact to the messy, from the objective to the subjective, from the indexical to the symbolic. The process can seem contrary to a strict definition of how science attempts to understand the world.

In addressing the relationship between data and image, Zolt Levay, who had a hand in producing most of the Heritage Project images as well as many others issued by STScI's press office, explained that the appearance depended first on the data. "The reason the pictures are spectacular is not from what we do to them," suggested Levay, "but from the fact the data is better than any other astronomical data that has ever been produced."[2] At the same time, he acknowledged that the Hubble images are translations of that data, and he used an analogy to photography and,

appropriately enough, to the process employed by Ansel Adams. When making a print, Adams did not simply reproduce the negative. In fact, while his negatives resembled his prints, the differences between them were often dramatic. Using a variety of techniques in the darkroom, dodging and burning, for example, Adams translated the negative into a print that matched how he visualized the scene.[3] As he wrote in *The Negative,* the second volume in a series of instructional manuals on photography, producing a negative that matched his visualization could "be compared to the writing of a musical score. . . . We know that musicianship is not merely rendering the notes accurately, but performing them with the appropriate sensitivity and imaginative communication. The performance of a piece of music, like the printing of a negative, may be of great variety and yet retain the essential concepts."[4]

In response to Adams's approach, Levay asked: "What is the reality? Is the reality the original scene? Is the reality the negative? Or is the reality the final print?"[5] Arguably, neither negative nor print could be an absolute correlate to reality. The negative represented the landscape in one way and the print in another. Both were black and white. While Adams pushed the negative to match how he perceived the original scene, the photograph cannot exactly correspond to his visual experience. Even the scene itself was mediated by his sensory apparatus. Instead, just as Adams did, those who make Hubble images strive for a translation that best represents reality, or at least what we know of it. As Levay continued:

> I'm not saying that I'm Ansel Adams by any stretch of the imagination. But what we hope to do is to render in these images what is inherent in the data. The manipulation that we do, and we manipulate the data—certainly you have to, to produce any image—but the manipulation we do is to render features that are inherent in the data that you would otherwise not be able to see.[6]

Unlike a landscape photograph, we cannot compare a view of a nebula or galaxy to a visual experience. To connect Levay's two comments: the Hubble Space Telescope records more information about the universe than any telescope before it, yet there are many possible ways to pictorially represent those data.

When astronomers and members of the Heritage Project translate data into visual form, they make choices about contrast, color, and composition. They rely on their expertise to interpret the data in a manner that they believe best expresses the information. While the translation process is hardly unique to the Hubble images, the relative novelty of digital imaging within astronomy and the culture as a whole makes them a case study in how institutions and individuals respond to the introduction of a new medium. In addition to developing and codifying new approaches to light, color, and composition, those working with Hubble data also needed to explain their choices to other astronomers and to those outside the scientific community. The Hubble Heritage Project, with its pledge to release an attractive Hubble image each month, was instrumental to both efforts. The careful accounts by astronomers of how to make a Hubble image tend to focus on details such as the basics of how to assign color to a black-and-white image and what it might mean. In this chapter I cover these fine points of crafting an image, which are fundamental to understanding how the Hubble images represent the cosmos. But I also address the larger significance of color, contrast, and other pictorial elements, along with the assumptions implied in how astronomers document and describe their choices. The final results both refer to nineteenth-century Romantic landscapes and codify physical properties that go beyond the visible realm, making the Kantian sublime again a relevant tool for understanding our response to them.

Going Digital

The Hubble Space Telescope's launch and its early years of operation coincided with a period of transition within the history of astronomical imaging. Astronomers have long relied on visual representations, first those drawn as an observer peered through an eyepiece in the blackest hours of the night, and later those recorded on photographic plates. However, the shift from film photography to digital detectors at the end of the twentieth century forced them to reconsider established pictorial practices and conventions, thereby opening up new possibilities for representing the universe. At the same time, the culture at large was coming to terms with the implications of going digital. As a result, those who produced the Hubble images, and especially the Heritage Project, took up the task of educating the public on image processing.

The Hubble Space Telescope was among the first projects to adopt a charge-coupled device (CCD) camera. The orbiting telescope quickly became the poster child for the detector, and it was repeatedly cited in articles that described its many potential uses.[7] However, nearly fifteen years would pass between the decision to build a CCD camera and the orbiting telescope's first use of the technology. During that time astronomers embraced CCDs, describing them as "within a small factor of being perfect detectors" because of their wide dynamic range, geometric stability, and photometric accuracy.[8] Ground-based observatories soon began designing and using digital detectors. Photographic plates remained the dominant recording medium into the 1990s, but by 1980 more than twenty research groups representing major observatories from around the world were experimenting with CCD imaging systems.[9] By 1987, every major telescope in the world had a CCD camera as part of its observing equipment, and the detectors were also planned for probes to Halley's comet and the Chandra X-ray Observatory.[10]

Despite the enthusiasm for CCDs, their adoption didn't come without questions. Many expressed concerns that the large size of the files would overwhelm available computer power. The success of CCDs was in large part enabled by a coincident increase in computer storage capabilities. The small size of the detectors also raised questions about their limits, and even the early proponents predicted, as noted by Jerome Kristian and Morley Blouke, that "it is doubtful that anything will soon replace photographic plates, with their unique combination of simplicity, low cost and ease of handling, storage and reproduction."[11] But by the end of the twentieth century, all observatories and even most amateur astronomers had gone digital.

Even before the adoption of CCDs and the regular delivery of digital data, astronomers began experimenting with computer image processing. As James Westphal mentioned in comments quoted in chapter 2, the Jet Propulsion Laboratory developed sophisticated techniques to enhance and display the data returned from planetary missions. By the mid-1970s, astronomers interested in observing more distant celestial objects from ground-based observatories started to experiment with image processing. In at least one instance, astronomers at Palomar Observatory and JPL worked together to scan photographic plates and then used image processing techniques to reduce noise, enhance contrast, and add color. In addition to testing

the efficacy of such methods for astronomical images, the pair also argued that the improved images led to "important scientific results" and enabled them to identify previously unobserved faint features in outer regions of galaxies.[12] Their comments once again underscore the value of images for astronomy.

By the mid-1980s, digital image processing of astronomical images was common enough that it inspired the ethnographic study completed by the sociologist of science Michael Lynch and the art historian Samuel Edgerton. Through interviews with two groups of astronomers the authors documented some of the steps taken when astronomers made images for public display and for scientific analysis. While their work offers a valuable account of early digital image processing and one that suggests that certain standard practices were emerging, the astronomers were not fully aware of them. For example, the astronomers did not identify a convention for color, one of the aspects of the Hubble images that have received the most attention. The article documents a moment of transition, a moment before conventions had solidified. The high profile of the Hubble images forced astronomers to think more carefully about their choices as well as how they presented them to a wide audience.

While astronomers described CCDs as near-perfect detectors, the commercial and cultural adoption of digital imaging happened more gradually and was accompanied by more ambivalence. During the 1980s and 1990s, more and more newspapers and magazines began using digital imaging. With the growing popularity of the medium, many raised questions about the malleability of digital images, seeing the new format as threatening the assumed validity and trustworthiness of all photographic representations. The possibility that photographs couldn't be relied on to show truth was described as cause for fear and anxiety, even as it was acknowledged that photographs had never been as trustworthy as their apparent verisimilitude might suggest.[13] The controversy often centered around photojournalism and questions of when, where, and what degree of intervention were permissible. A cover of a 1982 issue of *National Geographic* became the most infamous example. To make a horizontally composed photo fit the vertically oriented magazine, the editors moved the pyramids, "the very image of immutability," as the photographer Martha Rosler notes.[14] The introduction of consumer products expanded the opportunities for such manipulations. In 1990 Kodak introduced PhotoCD, a product that

encouraged photographers to digitize and electronically store their photos. And in that same year Adobe launched Photoshop, software for image processing.

In *The Reconfigured Eye: Visual Truth in the Post-Photographic Era* (1992) William Mitchell summarizes the state of affairs by proposing in the very title of his book that digital technology requires a rethinking of the relationship between the object and its representation.[15] In recounting the rise and spread of digital cameras, expanded storage capacity, and other advances that helped to make digital imaging technology widely available in the late 1980s and early 1990s, Mitchell writes:

> The result was that the means to capture, process, display, and print photograph-like digital images—which had hitherto been available in only a few, specialized scientific laboratories and print shops—now fell within reach of a wide community of artists, photographers, and designers. Concern about the potential social, economic, and cultural effects of the technology reached a crescendo.[16]

While he carefully discusses examples of image manipulation from throughout the history of photography, demonstrating that absolute faith in the photograph is a misplaced belief, his words undercut any sense of certainty that this history had prepared viewers for the new world of the digital. He closes the book by saying that

> an interlude of false innocence has passed. Today, as we enter the post-photographic era, we must face once again the ineradicable fragility of our ontological distinctions between the imaginary and the real, and the tragic elusiveness of the Cartesian dream. We have indeed learned to fix shadows, but not to secure their meanings or to stabilize their truth values; they still flicker on the walls of Plato's cave.[17]

Mitchell mourns the closing of the photographic era, which he sees as a brief, albeit illusory, reprieve from the uncertainty that accompanies visual representation.

The critique of digital image processing never turned directly to astronomical images, but NASA was often mentioned as a pioneer in the field of digital image

processing.[18] The concluding image in a special issue of *Time* magazine published on October 25, 1989, and entitled "150 Years of Photojournalism" had particular relevance for space exploration. Carrying the caption "A picture of something that never took place," the digitally modified version of the famous shot of Buzz Aldrin walking on the moon shows not just a single astronaut but seven of them. The editors used the image to demonstrate the possibility of digital manipulation. It is an obvious fake; each astronaut has an identical reflection in his visor, only one set of footprints disturbs the dusty surface, and the figures in the distance are much sharper than the ground on which they stand. It seems likely that anyone flipping through the magazine would notice these incongruities. However, the editors' choice to modify a NASA photograph was suggestive. Perhaps playing off rumors that the moon landing was an elaborate hoax, it called into question the validity of the images collected for purposes of science, images of distant places that could only be directly experienced by a select few or only seen through a prosthetic of vision, like the Hubble Space Telescope.

It was into this environment of uncertainty and ambivalence that the Hubble Space Telescope and its digital camera finally launched in 1990. Despite the public debates about digital imaging, the validity of Hubble images was not directly questioned at that time. It may be that the immediate problems with focusing the telescope diverted attention from such concerns. However, the issue of how to negotiate public suspicion of digital imaging remained. With the rise of the technology and the accompanying anxiety, newspapers and magazines developed ethical standards for photojournalism that significantly restricted the ways in which they manipulated images. Scientific journals also began scrutinizing images more closely and instituting stricter guidelines.[19] Astronomers, however, could not eliminate image processing. Without it, many of the elements in the data would remain invisible or illegible.

The situation was further complicated by the relative novelty of digital image processing within astronomy at the time of the Hubble's launch. Although astronomers had been manipulating images digitally for twenty years, a consensus had not been reached around such issues as color or composition. As discussed in the first chapter, color photographs had been difficult to produce, requiring a high degree of expertise in the darkroom. Digital files made it simple to assign colors and transform

a black-and-white image. Composition had largely been determined by convention and followed the experience of looking up at the night sky with one's head pointed toward the north. In an echo of this, astronomical photographs were typically displayed with north at the top and east to the left. Cardinal directions have no relevancy for an orbiting telescope, and therefore astronomers began allowing aesthetic judgments to guide how they oriented an image. While they were not alone in this effort, the Hubble Heritage Project team had a central role in establishing (and testing) conventions as well as educating their peers and the public about the place of digital imaging in astronomy.

The members of the Heritage Project did not explicitly set out to explain image processing techniques. Their primary goal was the creation of images for an audience beyond the scientific community. They expected the images to expand the public's understanding and interest in astronomy, but they did not, at least not at first, expect to educate the public or their fellow scientists about how the images were produced. The original proposal for the Heritage Project paid minimal attention to the image processing methods they would employ, stating simply that the group planned to "produce the highest possible quality, 3-color images in a standard square or rectangular format with minimal cosmetic defects from seams, saturated columns, and other common WFPC2 artifacts."[20] It did not explain how they might assign color, how they would address contrast, and what limits they might place on their use of the powerful tools made available through image processing software.

Within only a few months, though, the group recognized the need to educate their audience. When they released their first image in October 1998 they also described how the images were made, if only in very basic terms. In the case of the Bubble Nebula, the supporting text briefly, and somewhat vaguely, explained why colors in a Hubble image may not match those perceived by the human eye. The Heritage Project's portrait of the Bubble Nebula was then compared with two other versions, including one taken on a photographic plate. The description also linked to another page, entitled "How Heritage Images Are Made from HST Data." Here, the process of assigning color was spelled out in more detail and supplemented by a hand-drawn diagram of different approaches. Such early attempts to document

the methods used to craft the Hubble images make clear that the group quickly recognized the need for such explanations. With subsequent releases, they continued to clarify how they translated Hubble data into images and why they made certain choices regarding color, contrast, and composition.

The effort to educate soon expanded beyond those who visited the Heritage Project's Web site. Within a few years, the participants in the Heritage Project began presenting papers and publishing articles that detailed their approach to image processing. Zolt Levay and Ray Villard, the STScI news director, wrote an article for *Sky and Telescope* that detailed how the STScI press office and the Hubble Heritage Project crafted images from data.[21] A story on *60 Minutes* featured Levay at the computer choosing colors for an image. In addition to educating the public, the Heritage Project also shared their methods with the scientific community. Soon after its inception, the group began exhibiting and discussing their images at the American Astronomical Society's annual meeting. Starting in 2001, Levay and Lisa Frattare, one of the Heritage Project members who worked closely with the images, also began delivering presentations on how they made the images.[22] In collaboration with several astronomers and photographers from other major observatories, they also published an article on their approach in the *Astronomical Journal,* which is perhaps the most detailed explanation of the approach used by many astronomers.[23]

How to Make a Hubble Image

The accounts of how astronomers process Hubble data are, in effect, training manuals for how to read the images as well as how to make them. The astronomers, especially those involved with the Heritage Project, took great care in explaining what they do and why. Despite the claims of skeptics, they had little to gain from falsely presenting the data. It would not further their scientific research, and it could gravely damage the reputations of the Hubble, NASA, and science more generally. (Astronomers often take quite seriously the responsibility of presenting science in the best possible fashion, seeing themselves as high-profile representatives of the discipline.) At a basic level, the translation from data to image corresponds to what Bruno Latour calls a "reversible chain of transformations," a series of radical ref-

ormations that link the messy phenomena of the world to a representation.[24] It is through this series of transformations that scientists gain insight and knowledge as well as share it with others. But, as Latour acknowledges, each move along the chain is accompanied by its own messiness, its own set of choices. Daston and Galison propose that trained judgment aids scientists in these choices; that is, expertise enables them to distinguish between data and noise, between a modification that brings out attributes of the data and one that obscures them.

Despite astronomers' attempts to be thorough, the articles, especially those intended for an audience outside the scientific community, never tell the whole story. Frankly, it would be impossible to account for all the variations and complexities in a set of Hubble data. Just as the objects they record are unique, so too are the data. The astronomers offer a set of principles to follow, a set of guidelines, rather than strict rules that govern all translations from data to image. The difficulty of fully documenting the approach to image processing makes it necessary to attend not only to what astronomers say but also to what remains unsaid or incompletely explained. Because the Hubble Heritage Project aspires to create images that appeal to the senses as well as reason, the members of the group introduced even more complex image processing. One could say that they relied not only on their expertise in astronomy but also their knowledge of how to balance the scientific content with a desire to present the cosmos in a vivid, dynamic, and engaging manner. They also attempted to anticipate questions that might be raised about the images, both by other astronomers and by the larger public.

The details of how to make Hubble images are interesting in and of themselves because they shed light on how to interpret the images. The assumptions behind astronomers' choices and the appearance of the images can also shape a reading of the images. And one finds that together these various aspects of image processing—the documentation, the decisions, and the results—rehearse a tension between reason and the senses that is found not only in the contrast between numbers and images but also in Kant's description of the sublime. To understand the images fully requires that the viewer read them through two different lenses, letting them oscillate between a resemblance to the Romantic landscape and a record of the physical attributes of the celestial objects.

The Tools

Before delving into image processing methods, a brief summary of how astronomers obtain data from the telescope is useful. The Heritage Project depends heavily on the Hubble's archive of previous observations as a data source, and it also receives an allotment from the director's discretionary time. Other astronomers can also freely search the database of observations, and as it has grown the archive has become an increasingly more valuable resource.[25] However, in most cases astronomers must proceed through a longer process in order to observe an object in a new way or for the first time.

After identifying a research project astronomers submit a proposal to STScI, which then undergoes peer review. If the Telescope Allocation Committee, a group of astronomers assembled by STScI, approves the proposal—a decision that takes into account not only the scientific value of an individual proposal but also its relationship to others in that observing cycle and the need to use the Hubble Space Telescope for a range of different types of research—the observation is incorporated into the telescope's schedule. After the Hubble Space Telescope completes the observation, the data are radioed to earth. The astronomers are then notified by STScI that the requested data are available, and they can download the data set to their computers and begin analyzing it. Those who request an observation have proprietary rights to the data for one year, after which they become part of the Hubble's archive and are available to anyone.[26]

Once collected, the data set moves through a series of software programs—undergoing a set of translations—even as it remains a digital file. Each shift to a new format makes it possible for astronomers to interact with it in a slightly different way. They receive the data as Flexible Image Transport System (FITS) files, a standard format for astronomical data.[27] The name indicates the program's most important feature, flexibility, and it can accommodate data from optical and radio telescopes as well as spectrographs; this allows astronomers to interchange and compare different sources. Although FITS files are the most immediate form available from the telescope, they are not raw and untranslated data. Instead, STScI developed a suite of software programs to calibrate the data: automatically adjusting for known artifacts of the instrument (such as bad pixels), variations in the performance across

the CCD, and the impact of the shutter speed on exposure.[28] The translation process begins even before astronomers receive the data, thereby reflecting the automated potential of digital media.[29]

In scientific papers using Hubble data astronomers document the calibration process, often stating that the data have traveled through what was known as the "standard pipeline." Calibration is standard practice; nevertheless, astronomers feel compelled to acknowledge it, and the reasons for its application are worth noting. Adjusting the data aligns them more closely with an ideal observation of an object, one that would not reflect the inevitable flaws of detector or instrument. The calibration process improves the raw data, attempting to return them to a state closer to the phenomenon itself. The choice is related to objectivity and the different historical notions of it that Daston and Galison describe. But it is neither an example of mechanical objectivity or trained judgment. Instead, it sits in between, using a machine—computer software—to make a trained judgment.

Anyone with an Internet connection can preview the rough images generated from the calibrated data. Instead of sharp, vividly colored scenes, the images are dark, devoid of any color, and streaked with distracting white lines called cosmic rays (Figure 37). They also often show only portions of the object that is depicted in the familiar images. To create an image with clearer structure and less noise as well as to begin interpreting data, astronomers move the FITS files into another program designed for the purpose. Many rely on Image Reduction and Analysis Facility (IRAF), typically supplemented by software written especially for Hubble data.[30] Within IRAF, astronomers and imaging specialists assemble the disparate data collected from different detectors within the camera into legible pictures. Almost all Hubble images are composites of several exposures, and astronomers use IRAF to programmatically mosaic separate images together. To create images of the Eagle and Trifid Nebulae, for example, Jeff Hester fused images from the four CCDs within WFPC2 into seamless pictures (Figures 6 and 7). Only the strange shape of the field of view reveals that they are collages. Astronomers also combine numerous "dithered" observations. Dithering refers to the practice of pointing the telescope at the same target for multiple exposures, but changing the position of the object in the field of view. The difference may be as small as a few pixels and intended to

one of the images released with the installation of ACS in 2002 (Figure 38). The array of six images displays three with a broad data range along the top and three with a dramatically reduced range of data along the bottom. The example at the top left, the one closest to the raw data, appears dark and nearly devoid of detail; one can only make out the galaxy's bright core and a faint hint of its arms. With a reduced data range more of the galaxy's shape comes into view, but the brightest regions are extremely oversaturated. The nonlinear functions—square root and log—result in images with many shades of gray, thus revealing not only the galaxy's form but subtle variations in brightness throughout its extent.

Interestingly, Levay and Frattare do not state a preference for any of the Tadpole Galaxy images, but they recommend striving for "a 'broad tonal range' with detail apparent at all brightness values."[36] In a paper for the *Astronomical Journal* they (and their coauthors) similarly propose that "a scale function needs to be chosen that will optimize the contrast and detail throughout the image." They also specify when certain modifications might be most useful. "In general, a linear scale function works well when most of the structure of interest in a data set has a modest dynamic range and structural detail is very subtle," they write. "A logarithmic scale often works well when there is a large dynamic range in the structure of interest but most of the structure is faint."[37] In other words, and logically enough, the less one might see in an uncompressed version of the data, the more sophisticated the adjustments must be.

When enhancing contrast, the points of intervention can quickly multiply. To reiterate: most Hubble images are composites of several exposures and usually combine exposures taken with different filters. Because the dynamic range will vary for each exposure, astronomers may independently scale each one or apply a separate function to make more structure visible. In a scientific context this may happen less often, but the Heritage Project members frequently do this. In the *Astronomical Journal* they explain that "it is important that a separate scaling system be determined for each data set, because the goal is to maximize the intensity contrast in each data set, and the value ranges for each data set are different."[38] By compressing the data, or reducing the range, for each exposure in a manner that brings out detail, a composite of several can have detail throughout the image, not just in one

wavelength. Different mathematical functions might also be applied to separate data sets, although this is rarely done because it can introduce unwanted artifacts.

When developing images for scientific analysis, astronomers will often stop after enhancing the contrast. Making visible the morphology of a nebula or galaxy is sufficient for their purposes. Because the Heritage Project has additional goals, namely, producing an aesthetically satisfying image and sharing it with a large audience, its members continue to enhance the appearance. They usually scale the data within IRAF, or more recently with the FITS Liberator, but then employ additional techniques after they have moved the image to Photoshop. Often they scale the same exposure more than once to bring out details that fall on opposite ends of the light intensity range and then recombine them.[39] In such instances, the extension of vision depends on the flexibility of digital image processing software, which makes it possible to see different parts of an object as if with separate sets of eyes.

A Heritage Project image of the center of the Whirlpool Galaxy, released in 2001, illustrates the potential to combine images and affect the contrast and display of structure (Figure 39). The astronomers who commissioned the observations had made an image from the data, which was published in the *Astronomical Journal*.[40] Levay described their version as follows:

> They were studying spiral structure . . . and they produced a version that reduced the dynamic range. In other words, it darkened the nucleus and brightened the spiral arms so the image was flatter overall. So you could see detail through the spiral arms and all of the way into the nucleus, and that's very nice because you can see all of that detail through it.[41]

From the tip of the galaxy's arms to its center, there is no dramatic variation in brightness (Figure 40). All regions of the galaxy exhibit a similar degree of structure, even the core where the brightness of the concentrated stars usually obscures the morphology. It would seem that the astronomers' version fulfills the goals of scaling by optimizing the detail throughout the image.

As a Heritage image, however, Levay "felt that it was too flat." To address this, he combined their version with one that his team had done,

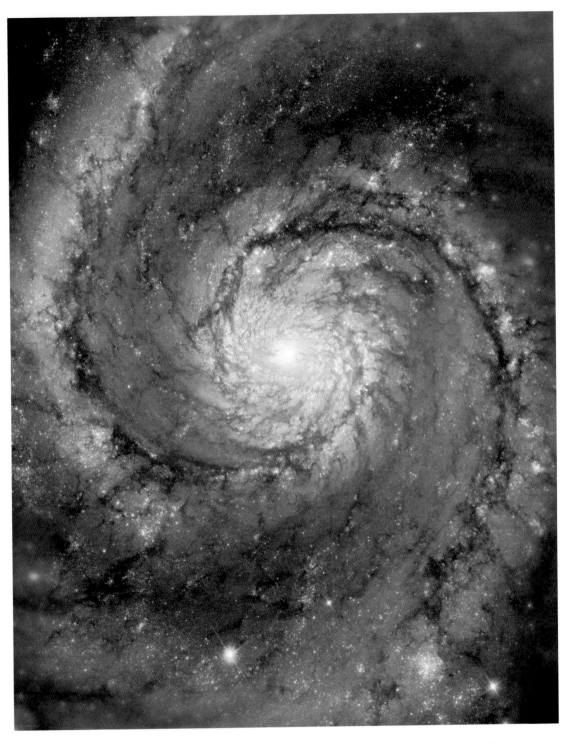

Figure 39. As crafted by the Heritage Project, the center of the Whirlpool Galaxy is shown much brighter than the spiral arms. April 5, 2001; WFPC2. Courtesy of NASA and The Hubble Heritage Team (STScI/AURA).

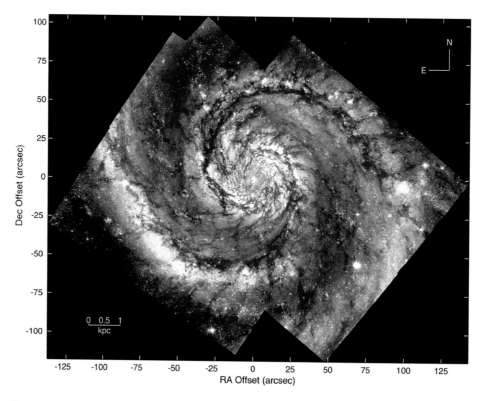

Figure 40. In the version published by astronomers in the *Astronomical Journal*, the center and arms of the Whirlpool Galaxy have a consistent degree of brightness and detail throughout. December 2001; WFPC2. Courtesy of Nicholas Z. Scoville.

which wasn't flattened in that way and so had a much, much brighter nucleus than spiral arms. By combining the two, I thought that we were able to show it more realistically in that the nucleus really is much brighter than the arms. In fact, even this [the Heritage] version is unrealistic in the sense that the nucleus is *really* a lot brighter than the spiral arms.[42]

The combining of images goes further. As the jagged edges of the astronomers' version reveal, the Hubble Space Telescope observed only the center of the Whirlpool Galaxy. To ensure a rectangular frame, Levay also incorporated an image from a ground-based telescope into the Heritage Project's view of the Whirlpool Galaxy. Although subtle, it is possible to see a loss of resolution at the corners of the image.

The decision to create such a composite, one that combines different visualizations of the same data as well as images from other observatories, demonstrates the variety of concerns that go into crafting a Heritage image. Rather than simply scaling data in order to see the structure, members of the Heritage Project wanted to create both a visually appealing image and one that would convey basic information about the phenomena that fill the universe. Levay spoke of aesthetic reasons and a desire to mirror the visual experience of observing the galaxy. He noted how the different approaches to light intensity impacted the sense of space. In contrast to the flatness of the first version, the Heritage image suggests a movement into depth. The bright core functions almost as a vanishing point that pulls the eye of the viewer into the infinite distance. However, aesthetics may not have been sufficient reason to introduce such complex adjustments to the contrast. By combining multiple scalings, Levay produced an image that acknowledged the resolution of the Hubble's data but still resembled the Whirlpool Galaxy of older representations, both drawings and photographs, in which the relative brightness of the galaxy's core and arms are very distinct (Figures 3 and 4). In doing so, the Heritage Project could also educate the public about the characteristics of spiral galaxies; the core glows with the concentrated energy of many stars, and the stars are more dispersed along the arms.

While the Whirlpool Galaxy is a particularly complex example, changing the contrast has a profound effect on how we see the cosmos. Instead of faint traces of glowing energy, the Hubble images present dazzling pyrotechnics. Yet the light perfectly matches the perceptual abilities of our eyes; it does not overwhelm our vision with its brilliance but reveals complex patterns that portray the cosmos in constant motion: spiraling, streaming, bending, and flowing. The subtle range of tones encourages our eyes to see the nebulae and galaxies as three-dimensional forms. The gradations of light read as differences in depth.[43] And the broad tonal range endorsed by the Heritage Project also has an emotional impact, thus creating a heightened sense of drama.

Modifying contrast subtly shifts and changes the appearance of an object at multiple points and in ways that can seem dauntingly complex to the less mathematically minded. Interestingly, the compression of data receives only limited attention in all the information about how to produce Hubble images. While changes to contrast

are well documented in journal articles and presentations for professional conferences, they are not described on the Heritage Project's Web site or on STScI's HubbleSite, a resource for those outside the astronomical community. The lack of attention to contrast changes is perhaps most striking when one looks at what the Heritage Project labels as "original images" and makes available on their Web site. The images, one for each exposure that is part of the final composite, lack color (Figure 41–43). They present the camera's full field of view rather than a carefully composed frame. However, although less polished than the final version they are *not* unmodified images; many have already undergone changes to the contrast. For example, in the preview image of NGC 602 found in the Hubble's archive, saturated light obscures the pillars of the nebula (Figure 44). The Heritage Project's original images display them with a sharpness and clarity that could only result from compressing the data.

The members of the Heritage Project are neither hiding the changes to contrast nor falsifying the images by making such changes. Descriptions of the methods for modifying contrast are available in some sources, and every astronomer who looks at the images would immediately recognize that such detail is unlikely to be seen without compressing the data. However, the presentation of the enhanced images as "original" suggests that the members of the Heritage Project feel little anxiety about using image processing to make the structure of the phenomena visible. The lack of discussion about contrast changes markedly differs from the efforts made by the Heritage Project to educate other scientists and the public on their approach to color.

Figure 41. In addition to the final color composite, the Heritage Project posted black-and-white images of NGC 602 on its Web site. Each was taken through a different filter, this one for visible light. Courtesy of NASA, ESA, and The Hubble Heritage Team (STScI/AURA)–ESA/Hubble Collaboration.

Figure 42. NGC 602 as observed through a filter for infrared light. Courtesy of NASA, ESA, and The Hubble Heritage Team (STScI/AURA)–ESA/Hubble Collaboration.

Figure 43. NGC 602 as observed through a filter for hydrogen and nitrogen emissions. Courtesy of NASA, ESA, and The Hubble Heritage Team (STScI/AURA)–ESA/Hubble Collaboration.

Figure 44. The preview image for NGC 602 available through the Hubble's data archive demonstrates the careful adjustments to contrast necessary to bring out detail in the image. ACS/WFC. Courtesy of Multimission Archive at the Space Telescope Science Institute (MAST).

41

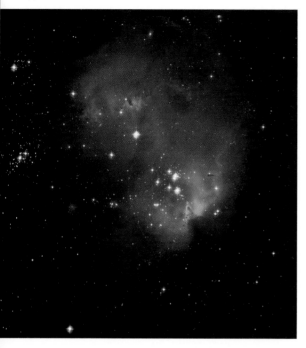

42

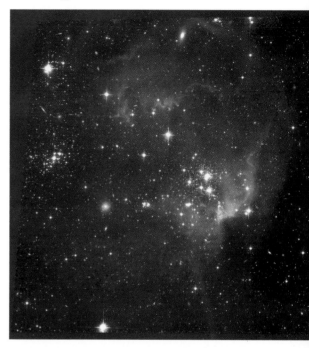

43

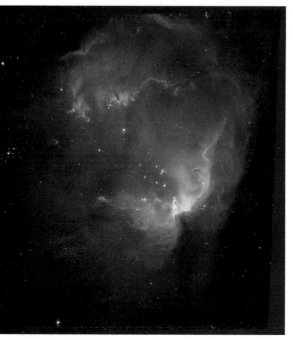

44

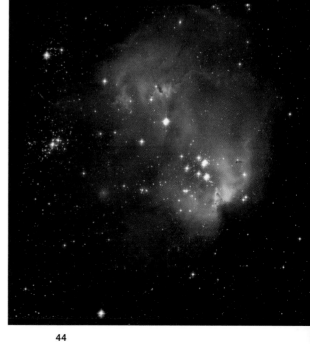

Arguably, the methods used to reveal the structure of celestial objects might be considered as analogous to efforts in artistic contexts to delineate form or design. If so, the lack of attention to how it is done rehearses a long-standing set of associations between structure and reason. By making visible the morphology of the galaxy or nebula, an astronomer enables us to glimpse the design of the universe. In discussions of art, design was often associated with drawing, and as the art historian Jacqueline Lichtenstein emphasizes in her account of the debates about the place of color in painting, "drawing is always defined as an abstract representation, a form of a spiritual nature, whose origin resides solely in thought."[44] Not surprisingly, given Kant's interest in the interplay between reason and the senses, he argues for a similar hierarchy, elevating form over color: "In all the visual arts, including architecture and horticulture insofar as they are fine arts, *design* is what is essential; in design the basis for any involvement of taste is not what gratifies us in sensation, but merely what we like because of its form." He continues by noting that

> the colors that illuminate the outline belong to charm. Though they can indeed make the object itself vivid to sense, they cannot make it beautiful and worthy of being beheld. Rather, usually the requirement of beautiful form severely restricts [what] colors [may be used], and even where the charm [of colors] is admitted it is still only the form that refines the colors.[45]

In sum, form and design engage the mind, appealing to reason and higher orders of thinking, whereas color fascinates the senses. That is not to say that form does not elicit an aesthetic response, but it is one understood as engaging rational thought. Astronomers' efforts to reveal the form and structure of the universe are wrapped in their confidence in reason. Images that incorporate modifications to contrast in order to better display form or design can seem to require less explanation than do those that require changes to color. The use of mathematical functions to do so only underscores the association. Color, on the other hand, is accompanied by a very different set of associations.

Color

Interventions that change contrast rarely come under scrutiny by either those within the astronomical community or those outside of it; however, the use of color has raised far more questions, even accusations. More than a decade after the Hubble's launch, Allison Heinrichs, a journalist for the *Los Angeles Times,* proposed that its images were fakes:

> The Hubble images are the sharpest and most detailed of the cosmos ever seen; snapshots of cataclysmic events occurring billions of light-years away in a dance of color and light that seem almost too good to be true. They are. The planets, nebulae and galaxies really are out there but their breathtaking colors are, in most cases, exaggerated. They are the product of a team of NASA astronomers, computer artists and public-relations folk who touch up and color Hubble's photographs.[46]

Members of the astronomical community understandably bristled at the accusations by Heinrichs and others.[47] While the telescope does return monochromatic images and astronomers and image specialists add color to them, Heinrichs's account overlooked the complex use of color in the images. Instead, she presented color as seductive, a classic case of what David Batchelor has called chromophobia, or the fear that color corrupts.[48] Astronomers are not immune to it, and no other aspect of image processing receives as much attention in their explanations of how to make a Hubble image.

Even with the aid of a telescope, human eyes cannot identify color when observing the faint light of distant nebulae and galaxies. As many an astronomer has argued, "the question of *true color* becomes largely moot since we can't perceive it in the first place."[49] Nonetheless, the Hubble images have conditioned us to see the universe in vivid hues. To create images with a full spectrum of colors, astronomers and image specialist assign different colors—red, blue, and green—to three exposures and then create a composite. If additional observations are available, they may combine more than three images, choosing a fourth or fifth hue for the additional

exposures. This requires them to make a series of choices about what color should signify.[50] Both the reporter's claims of fakery and the answer that true color is imperceptible depend on a definition of truth that rests on human perception; but color carries a greater range of meanings. As the information design guru Edward Tufte proposes, color can be used to label, to measure, to represent or imitate reality, or to enliven or decorate.[51] Furthermore, it incorporates both objective and subjective elements. Although we can measure the stimuli that produce different colors, individual perception of them varies. In addition, colors have symbolic and emotional meanings that, although powerful, are not universal and often contradictory. The color of the Hubble images has all of these valences as it also illuminates the structure of the cosmos and communicates aspects of the data.

History and convention account, in part, for astronomers' discomfort with color. As I described in the first chapter, the multiple hues of the Hubble images distinguish them from older astronomical images. Color is a relatively recent addition to astronomical photography. The first successful experiments with color astronomical photography came only in 1959 when William Miller, staff photographer at Mount Wilson and Palomar Observatories, used newly introduced high-speed film to produce color pictures. The increased speed of the film made feasible the long exposures necessary for observing astronomical objects; however, Miller still had to intervene. The emulsions for different wavelengths of light responded differently, with those for red and green becoming less sensitive over the long exposures; to compensate, Miller used color correction filters during the initial exposure or the development process to restore color balance. In order to create, in Miller's words, "pictures . . . as true as the photographic art now permits," he had to determine the degree of color filtration necessary for each film type as well as monitor for variations introduced through subtle differences within film lots, changes in temperature and humidity, and other variables.[52] When Miller explained his method, he carefully cautioned that astronomical color photography was in its infancy. But color slides of his photographs became standard teaching tools in basic astronomy courses, and they helped to establish standards for how to see the universe in color and provided inspiration for the Heritage Project.

Miller's success also led to further experiments with color photography,

including the adoption of an additive process that combined blue, green, and red photographic negatives to produce a full-color photograph. Although not the first, David Malin, the staff photographer at the Anglo-Australian Observatory in Siding Springs, was the most significant practitioner and advocate of the approach.[53] The additive process had some advantages over the reliance on color film, namely it took advantage of astronomy's practice of observing in different wavelengths and it did not require the tedious calculations to ensure color balance. This did not mean that the color balance was necessarily more accurate but simply that it was easier to give each color equal weight within the image. The effect on the appearance of the ultimate image is perhaps more remarkable. Miller's photographs of the galaxies and nebulae exhibit a muted color palette and diffuse light that contrasts with the brilliant and saturated hues of Malin's work.

Starting in the mid-1970s Malin produced a series of articles and books that showcased his vivid astronomical images, and much like the Hubble images they gained a reputation for their aesthetic appeal. Although Malin pointed to some scientific benefits for making color photographs, the opening paragraph of an early paper on the process made the audience for the images clear:

> In recent years the demand for colour photographs of astronomical objects has increased dramatically. Numerous books, magazines and popular articles on all aspects of astronomy find a ready market, the more so if they are colourfully illustrated. The astronomical community benefits from a widespread public interest in its activities, an interest which is encouraged by the wide availability of colour photographs used to illustrate complex phenomena in a direct and convincing way.[54]

Malin presented again the standard position within astronomy: color photographs are more appealing than their black-and-white counterparts, and therefore they are primarily useful as promotional tools.

Technological change, namely the adoption of digital technology, made it easier to produce color images, but astronomers accustomed to viewing the cosmos in black and white had to adapt to the rainbow hues available with the new

medium. For many Hubble images, processing ends with scaling the data to enhance the contrast. In a broad sense, astronomers could compare the accuracy of a black-and-white image against what they saw when observing through telescopes as well as against an archive of astronomical photographs. Color forces a more complex analysis to determine its accuracy. As a result, the black-and-white digital images, despite the subjective choices made in scaling data, retain an aura of objectivity absent in color images. As mentioned in previous chapters, economics also influences the reliance by astronomers on black-and-white images. Frequently, professional journals charged fees for color images, while they printed black-and-white pictures without additional costs to the authors.[55] The strength of the association between color and aesthetics is also demonstrated in the reverse. In 2004, the Hubble Heritage Project introduced a collection of black-and-white images on their Web site. They privately called it "the Ansel Adams gallery," a nickname that confirms their adherence to a broad tonal range and high contrast as well their embrace of the sublime. Although long planned, the collection appeared quietly on their Web site and without the usual press release from the STScI press office. Whether because of this lack of institutional effort to reach a larger audience or an absence of interest by the public, these images did not circulate as widely as the color examples or attract as much attention.

The uncertainty about color also has something to do with how it was first used with digital imaging and the adoption of an unfortunate label: false color. As Villard and Levay write, "The terminology is something of a minefield and to the layman implies chicanery!"[56] Idiomatically, it describes a pirate ship that sailed under a stolen flag. In older astronomical articles, false color refers to artifacts of the instruments, spots of color that might appear before the eyes of an observer. With the invention of film sensitive to infrared light, the term was used when light beyond the visible range was translated into a color that could be seen. In digital false color, the phrase refers to the arbitrary assignment of a color to different regions or properties. In other words, the hues need not have any relationship to the visual appearance of the phenomena or the wavelengths of light registered by the instrument. Instead, different colors might indicate another dimension of the data—for example, a continuum from red to yellow might represent differences in light intensity. In addition

to what the color indicates, false color has come to describe a particular color palette—flat, garish hues that do not resemble natural phenomena in our world. The Hubble Heritage Project eschewes both the phrase and the approach, preferring a method that takes into account the wavelength of light measured by different filters and that presents the cosmos as colored in a manner akin to our world.

Because different filters in the Hubble's cameras register distinct wavelengths of light, each exposure contains what can be described as color information. For some images, the colors approximate visual experiences as understood by the wavelengths of light. If the filters used to observe an object register light within the optical range, astronomers typically will choose appropriate corresponding hues in the color spectrum. A filter that records wavelengths that fall within the blue range would be assigned to blue, those within the green range to green, and so on. Astronomy's long practice of observing with filters for blue light and yellow-green light, a convention that arose from the differing sensitivities of the human eye and photographic plates, eased the assignment. The Heritage Project's images of planets, star fields, and galaxies often follow this principle (Figures 31 and 32). The Hubble's instruments also register ultraviolet and infrared light, which lie beyond the color spectrum of the human eye. Many Heritage images combine visible light and other wavelengths. For example, in addition to red and green images, the Heritage Project's image of a Seyfert galaxy includes observations in ultraviolet, which are rendered in blue (Figure 34).

Astronomers also outfitted the Hubble's cameras with narrow-band filters, thus enabling it to register very specific wavelengths of light that correspond to the spectral signatures (or the locations of the brightest emission lines when viewed through a spectroscope) of different glowing gases. By using such filters, astronomers record the chemical makeup of nebulae and galaxies. Both of the Heritage Project's images of the Whirlpool Galaxy—the one made to celebrate the Hubble's fifteenth anniversary in 2005 and the one created in 2001—are composites of exposures taken in the blue and green range with exposures taken to detect the presence of hydrogen and near-infrared light. Because the spectral signature of hydrogen in its first excited state features a bright-red line and the filter corresponds to the wavelength of that

line, astronomers assigned the exposure for hydrogen to red. Although it does not reflect a visual experience of color, the choice indicates the wavelength of the light, and this could be considered a scientific definition of red.

Astronomers and image processors cannot adhere to this close correspondence between optical light and images for all full-color pictures. An observation program might include two filters that correspond to the same color. For example, more than one filter may detect an element with a red spectral signature or within the red wavelength range. In order to see the distinctions between the two images, one must be assigned to another color. To return to an image discussed in chapter 2, the Eagle Nebula was made from just such a set of exposures (Figure 6). Jeff Hester, the astronomer who produced the image, requested observations through filters for oxygen, which falls in the blue range, as well as sulfur and hydrogen, both of which fall in the red range. In such situations, the filter corresponding to the shortest wavelength of light will be associated with blue and the one with the longest wavelength of light will be associated with red. The one in the middle will be assigned to green. This approach has the advantage of also representing the relative excitation temperatures in a fashion that corresponds to the black body spectrum, a scientific model of electromagnetic radiation; red indicates the coolest regions and blue the hottest.

When used in this fashion, color maps the physical properties of the nebulae; for those who know the key it becomes possible to read it accordingly. The astronomers' experiences of the images, though, are much more complex. Hester offered two explanations for the use of the color in the Eagle Nebula:

So what do you do with the colors? There are lots of ways to think about this. One is that, okay, you can go from most energetic to least energetic, going from blue to red. And that's in fact the ordering of those colors. The O[xygen] III, the most energetic line, is in the blue. The H[ydrogen]-alpha, the kind of intermediate line, is in green. The sulfur II, the cool line, is in red. That's one way to think about it. Another way to think about it is that that's as close to a realistic color palette as you can come up with those data, it turns out. That is, of those various lines, the bluest of the lot is the O III, so let's put that down on the blue end of things. The reddest of the

lot is sulfur II, so let's put that up on that end of things. And it turns out that the H-alpha, there's both a red line, but there's also the H-beta line, that's down close to O III, down in the blue-green, and so green is actually not all that obnoxious a color to put that in. Again, given that you can't really do it right.[57]

The first explanation Hester offered is relatively straightforward: relative energy levels understood as wavelengths correspond to and determine the colors. The second justification, though, is more complex and relies on knowledge of the full set of emission lines in hydrogen's spectrum. In addition to the line in the red range, it also includes one that falls in the blue-green range. Although the filter would not show that light, Hester seemed to propose that the color assignment can remind the viewer of the chemical signature of glowing hydrogen. At the very least, it is a compromise that does not conflict with the characteristics of that element.

Explanations provided to those outside the astronomical community typically emphasize that color has some relationship to physical phenomena, but they also allow for the possibility of other options. Accounts on the Hubble Heritage Project's Web site, magazine articles, and other sources tend to limit the number of exposures in a composite to three. However, almost all the Heritage Project images—including the two anniversary images and those of the Keyhole and Dumbbell Nebulae—are combinations of four or more exposures and therefore include more hues than just red, blue, and green. As explicated in the *Astronomical Journal,* "It is important to use a different color for each data set. Otherwise, distinct information from each of the data sets is lost."[58] The principle of assigning color based on the relative wavelength of each filter can still be employed, meaning that ultraviolet may be assigned to purple to indicate the relative wavelength of the light. Or, if three exposures fall between green and red, hydrogen might be displayed as orange. (This would conflict with Hester's second explanation.) When the different layers are combined together into a composite image, the colors mix and blend together.

If color cannot fully reflect visual experience and a possibility of arbitrary color choices exists, what limits the Heritage Project's exploration of a variety of color schemes? When Jayanne English was a member of the Heritage Project, she

used her background in art to expand the conversation surrounding color choices. She and other Heritage members debated different color schemes.[59] In articles in which she was the sole author, English advocates an approach that uses color to "engage the viewer and hold their attention" as well as illustrate the scientific content, and she acknowledges that this may require bending scientific conventions.[60] In the paper on image processing that she coauthored with other Heritage team members, she contributed a section on the color wheel and the advantages of complementary color schemes. The discussion relies heavily on Johannes Itten's color theory, which he developed while teaching at the Bauhaus in the 1920s and that influenced art school curricula for several decades after he published his book on the subject in 1961.[61] The discussion of color in the coauthored paper also acknowledges the more conventional associations of temperature and color as well as the emotional interpretations attached to different hues. Despite this awareness, the approach of the Heritage Project to color remains, as its members acknowledge, somewhat conservative.

An experience early in the history of the Heritage Project illustrates one reason for this. For its second release, the Hubble Heritage team chose a planetary nebula, NGC 3132 (Figure 15). Howard Bond, one of the Heritage Project founders, had researched planetary nebulae extensively, and his observations of the Ring Nebula inspired his idea to create a program to develop aesthetic images. The image is familiar from chapter 1, in which I discussed the comparison made between the colors of the gaseous clouds around the exploded star and a hot spring in Yellowstone National Park.

Traditionally, color in images of planetary nebulae maps the relative temperatures in different regions according to temperature scale rather than mimetically representing the hues of the object. As the caption for the Heritage Project's NGC 3132 image explained, their version follows this pattern: "In the Heritage Team's rendition of the Hubble image, the colors were chosen to represent the temperature of the gases. Blue represents the hottest gas, which is confined to the inner region of the nebula. Red represents the coolest gas, at the outer edge."[62] Before releasing this rather conventional depiction of NGC 3132, the Heritage team seriously considered a strikingly different interpretation that combined three filtered observations to create a pink-and-purple image that highlights the intricate structure of the object

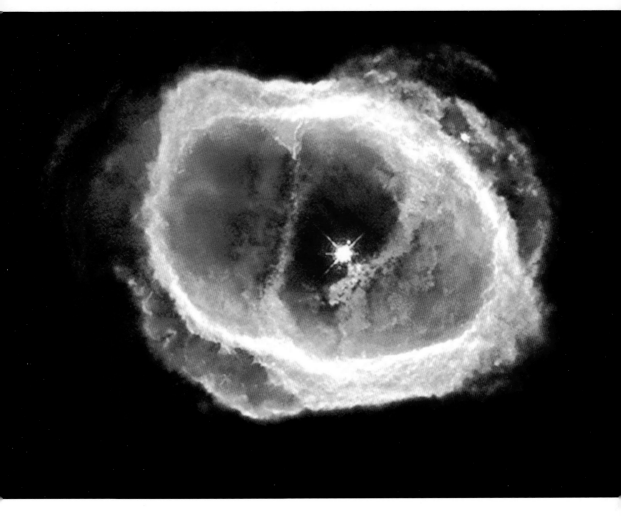

Figure 45. Before releasing a more conventionally colored version of planetary nebula NGC 3132, the Heritage Project considered a more radical color scheme. Courtesy of The Hubble Heritage Project.

(Figure 45).[63] The star at the center glows with an intense blue light. Before releasing this unusual rendering, the group reconsidered and developed the more standard view. The first version did appear on the project's Web site as part of the collage that introduced each month's release, but it was not given the same prominence.

Although quite different in appearance, neither image could be described as an incorrect representation of NGC 3132; rather, each accentuates different aspects of the object. Astronomers could readily compare the conventional version to other

images of planetary nebulae and reaffirm their understanding of temperature gradients; however, the pink-and-purple version makes the structures across the center of the nebula more visible. Hubble's precise resolution enables the detection of such detail, and, arguably, it is more apparent with the contrasting colors of the rejected version.

In describing how the Heritage team members reached a consensus on an image, Keith Noll remembered the response to NGC 3132:

> We tend to look for things that "look right." And exactly what looks right is maybe a little hard to quantify. But I remember early on, one of the first things we did was a planetary nebula, which are these gas clouds around stars that are at the end of their lives. We'd already done the Ring Nebula, and we did that in a more classic representation. So in fact, the colors looked fairly similar to the colors of previous representations of the Ring. This was a different nebula that in some ways is fairly similar to the Ring. So we played around with the idea of, well, maybe we should do this in really wild colors, so we had pinks and yellows. It somehow just didn't feel right to us, so we ended up going back to a representation very similar to the way we represented the Ring Nebula. And somehow that felt more natural.[64]

Noll's word choice—quantify—draws attention to the value that science places on numeric representation. Mapping color according to temperature symbolizes the measurements that underlie the observations. In this case, previous representations also helped to determine what "looks right." Noll's uneasiness about color parallels that of Hester, and both seem to seek an explanation that they are not able quite to articulate, something that goes beyond the mere representation of data to encompass the visual experience of the phenomena.

English suggested that more was at stake than the preferences of the team. Although the images were intended for a larger audience, the Heritage Project was also concerned about the response of the scientific community. Such a radical deviation from the typical representation of a planetary nebula, especially so early in the project's history, would have had unintended consequences. "We would have lost

our reputation amongst all our colleagues and we wouldn't have had their support for making images, which would have been detrimental to keeping the support from the observatory as well," she said. "So it seemed that Hubble Heritage had a role within the observatory which was different than really exploring art and scientific images. That would have to be explored somewhere else."[65] English expressed some disappointment that the Heritage Project would not have the freedom to explore more fully the artistic possibilities of the images.

Although not completely arbitrary, colors have shifting meanings within Hubble images. They may map physical properties or mirror visual perceptions, or combine both of these approaches. The art historian E. H. Gombrich succinctly defined the distinctions between these two modes of representation: "Maps give us selective information about the physical world, pictures, like mirrors, convey to us the appearance of an aspect of the world as it varies with the conditions of light and may therefore be said to give information about the optical world."[66] In their use of contrast and color, Hubble data do register changing conditions of light, but it is light beyond our optical limits. To make them into a picture, only selected information can be displayed. The images are both pictures *and* maps, and, to complicate the situation further, many of those that use color to map information look the most pictorial.

The views of the Eagle Nebula, NGC 3132, and many others simultaneously invite two interpretations. As maps they portray the physical properties of the object and the presence of gases at different wavelengths or temperatures. Such an interpretation appeals to reason and rationality. On the other hand, the color schemes also evoke Romantic landscapes by suggesting the buttes of the American Southwest or the hot springs of Yellowstone, and in doing so they engage the senses and imagination. The images oscillate before our eyes as we rely on both reason and the imagination as a means to interpret them. Through their use of color as a doubled reference, linking the images to both physical properties and to an aesthetic sensibility, the Hubble images replay the tension that Kant considered fundamental to the sublime. They simultaneously engage both the faculty of reason and of imagination. Training the eye to see as an astronomer does therefore not undercut the aesthetic experience but instead reaffirms it.

Cosmetics

After color assignment Heritage images undergo another phase of processing in-tended to erase any remaining artifacts of the instrument, camera, and detector. Stray cosmic rays, differences in background color across the exposures, and over-exposed regions called "bleeds" are all carefully removed, typically using the tools available in Photoshop. These tools copy pixels from one region and paste them in another or blend them with surrounding pixels. Although executed by algorithms within the program, the hand of the image processor determines the regions to treat in this fashion. Heritage members guard against introducing artifacts, often working with a duplicate image that they compare to the noisy version. They call the process "cosmetic cleaning" and argue that flaws can distract the viewer from what is repre-sented, maintaining that a "successful image keeps the viewer's mind focused on the content of the image, not on how it was created."[67]

Despite this careful attention to creating a polished image, astronomers and image processors typically retain one type of artifact: diffraction spikes. These rays of light that appear to radiate from bright stars are caused by reflections within the optical systems of telescopes. (Stars with distinct diffraction spikes cluster around the top of the Cone Nebula and in the center of NGC 602 [Figures 9 and 17].) Although caused by the instrument, the symbolic association with a starry sky grants them aes-thetic resonance. In some cases, members of the Heritage Project even cut and paste a diffraction spike from one side of the star to replace one that has been flawed by over-exposed pixels.[68] In the striking example of Barnard's Merope Nebula, the diffraction spikes become the subject of the picture (Figure 46). As the Heritage Project's Web site explains, "The colorful rays of light at the upper right . . . are an optical phenomenon produced within the telescope, and are not real," but the more substantial looking form at the bottom left is.[69] The accidental interaction between the diffraction spikes and the glowing gases becomes an object for aesthetic contemplation.

Figure 46. The Heritage Project's image of Barnard's Merope features distinctive diffraction spikes, an artifact of the telescope, in the upper right. December 6, 2000; WFPC2. Courtesy of NASA and The Hubble Heritage Team (STScI/AURA).

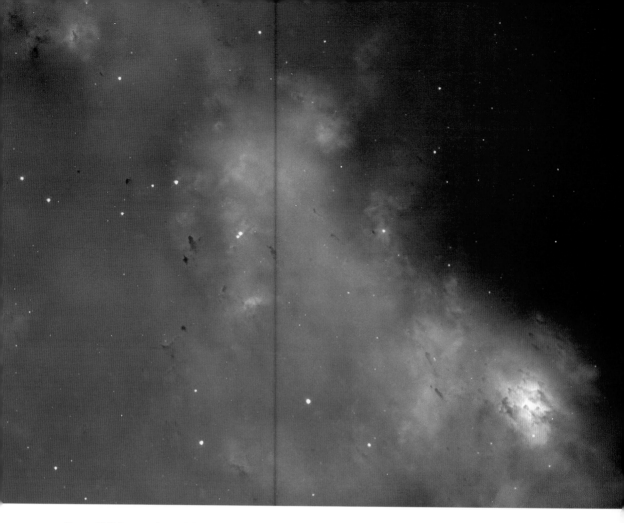

Figure 47. Before members of the Hubble Heritage Project produced their version of the Dumbbell Nebula, astronomers published another version in the *Astronomical Journal.* June 2002; WFPC. Courtesy of C. R. O'Dell, NASA, ESA, and the Space Telescope Science Institute.

As one studies the two images, the aesthetic nuances of the Heritage Project's version become increasingly more evident. O'Dell's Dumbbell Nebula displays its status as a product of technology. A dark seam where two CCDs meet divides the image in half. Saturated regions in the lower right and smudgy blacks on the upper right make evident the limits of the representational medium. The bright blue is flat, lacking any texture in several areas. In contrast, the colors of the Heritage Project's Dumbbell Nebula are rich and varied throughout the image. There is no trace of the detector: no seam and no areas beyond the limits of the representation. Together the

color palette, the texture, and the orientation create an image that looks realistic in the sense that it resembles the world we see around us.

The resemblance encourages a misunderstanding of how Hubble images represent reality. Instead of reading the image as an abstraction of data, something akin to a map, we may see it as a projection of a visual experience. We assume that the representations of the Eagle Nebula, Dumbbell Nebula, and Whirlpool Galaxy might look this way if we could see them with our eyes. As the images circulate to wider and wider audiences, they are often separated from the training manuals provided by the Heritage Project to guide the reading of the images. It is no surprise that many conclude that Hubble images are mimetic, mirroring the cosmos in vivid splendor.

It is a productive slippage, one that allows the Hubble images to appeal on multiple levels. However, to take advantage of that multiplicity, the viewer must recognize it. Mimetic images enthrall us with their ability to imitate visual experience. Yet if we judge Hubble images on their correspondence to our limited visual experience we will always be disappointed; first with the images and then with our perceptual limitations. But the real link between representation and phenomenon consists not of a mirroring of what we could see but of a complex series of steps that translate numeric data into a picture.

The translation from data to image is often described as a necessary tool because it enables astronomers to communicate with a wider audience. Jeff Hester, the astronomer who made the Eagle Nebula image, spoke of the need to make scientific content accessible:

> [Science] demands a rigorous vocabulary, the vocabulary of mathematics. It demands that you learn to think in that vocabulary. That's not a vocabulary that's accessible to a lot of people. And so, one of the reasons that there seems to be, to so many people, this divide between the arts on the one hand and science on the other hand, is a vocabulary issue. And so when you communicate this kind of stuff to an audience other than just scientists—and sometimes even when you're communicating it to an audience of scientists, by the way—it really matters that you find a way to get around the vocabulary problem.[77]

However, as Hester would have undoubtedly acknowledged, the act of translating numbers into images accomplishes more than a re-presentation of scientific facts in another form.

When discussing the importance of images, Noll repeated Hester's concerns that not everyone has the mathematical literacy necessary to grasp the data, and he also proposed that the images might convey something more:

> I'm trying to communicate a sense of awe and wonder. I could sit down and explain to you what the size of galaxies and the size of the universe is. Since I've got a good grounding in mathematics . . . all the exponential notation actually has some meaning for me. But I think, for most people that don't have that kind of background, it's more difficult and it can be confusing. So this [an image] is a different way of communicating that in a non-verbal, non-literal language.[78]

Noll explicitly stated that he intended to encourage a viewer not only to understand the scale of the cosmos but to respond to that knowledge. Awe and wonder are feelings, emotions that depend, in this case, on the recognition of not only the immensity of the universe but also the relative insignificance of humans in relation to it. By presenting the cosmos with recognizable visual characteristics, as akin to the Romantic landscape, the images promote another level of interpretation beyond simply determining the realism of the object—scientific or otherwise. They promise a view of something more elusive, a fuller sense of the cosmos.

Within the context of literature, Walter Benjamin argues that the act of translation offers a profound potential, a glimpse of truth that lies beyond the limits of ordinary language. Many have presented literary translation as a choice between preserving the substance of the original text, its exact meaning, or retaining the style and tone. Similarly, the translation of data in images also falls on a continuum between retaining the precise numeric values and presenting an approximation that captures some essential aspects of them. Benjamin, however, elevates translation above both of these concerns. His account of translation exhibits the characteristics that mark many of his ideas. He understood it as a dialectical process, and the moment of synthesis

is accompanied by both idealism and a desire for transcendence. He proposes that all languages (and therefore all works of literature) fail to achieve the level of pure language, which is the site of absolute truth, even revelation. The act of translation, however, engages that elusive, pure linguistic realm. In the movement from one language to another, in the effort to identify the object or concept that two words intend to express—in Benjamin's example, the shared reference of *Brot* and *pain* to the idea, the concept, of bread—it is possible to see the pure and absolute. As Benjamin writes:

> In translation the original rises into a higher and purer linguistic air, as it were. It cannot live there permanently, to be sure, and it certainly does not reach it in its entirety. Yet, in a singularly impressive manner, at least it points the way to the region: the predestined, hitherto inaccessible realm of reconciliation and fulfillment of languages. The transfer can never be total, but what reaches this region is that element in a translation which goes beyond transmittal of subject matter.[79]

Benjamin claims that the translator can get at some notion of truth, a notion of truth that is expressed neither in the original nor in the translation but in the movement between them. While Benjamin does not introduce the notion of the sublime, the possibility of transcending imposed limits and reaching another realm of knowledge shares certain characteristics with the Kantian sublime.

Benjamin's account of translation contains three elements: an original work of literature in one language, a translation of that work into another language, and pure language. If mapped to the translation of Hubble data to images, the data are analogous to the original literary text, and the images are the translation into another mode of expression. The cosmos itself—the nebulae, galaxies, and stars—are akin to pure language. While data record them to the best of our abilities, they are inevitably less than the celestial object itself. So too are the images. Neither can adequately express the pure and absolute truth of the universe. However, for Benjamin, the translation improves upon the original. "A real translation is transparent," he writes. "It does not cover the original, does not block its light, but allows the pure language, as though reinforced by its own medium, to shine upon the original

all the more fully."[80] Considered in Benjamin's terms, the translation from data to image lifts the data to another level, bringing it closer to the concept under study; closer, in this case, to a more absolute notion of the complexity and vastness of the cosmos. Making data visible requires astronomers to reflect on what the numeric values reveal about the galaxy or nebulae they represent and in doing so to glimpse a more absolute notion of the cosmos.

At moments, Benjamin's account suggests that the experience of truth occurs only for the translator. If only the act of translation, the engagement with two modes of expression, leads to a fleeting vision of the ideal, then the astronomers who craft images from data would alone experience it. However, Benjamin also writes that "it is the task of the translator to release in his own language that pure language which is under the spell of another, to liberate the language imprisoned in a work in his re-creation of that work."[81] It is not enough to glimpse that ideal notion of the cosmos in the effort to make data visible, but the translator must also discover a means to retain a trace of that insight in the image. And for Benjamin, who elsewhere writes that "history decays into images, not into stories," images might well be better suited to the task of conveying truth than language.[82] If the Hubble images preserve the insight that astronomers find when moving between two modes of representation, it may be that in the Hubble images themselves we too can glimpse the truth of the cosmos.

FROM UNKNOWN FRONTIERS TO FAMILIAR PLACES

The Landscape

Astronomers hold complex attitudes toward images, and they have carefully crafted the images from the Hubble Space Telescope in a manner that satisfies their need for a scientifically valid representation of the data as well as their desire to evoke a particular aesthetic response. The resulting views of the cosmos engage both reason and the senses, and to grasp them fully we must allow the images to activate both faculties, thereby replaying the experience of the sublime.

At this point I want to revisit the Romantic depiction of the American West and consider its symbolic value for the Hubble images. The landscapes came out of a particular moment in the history of the American West, one associated with scientific exploration, and they also carry with them a set of myths and ideals that contribute to definitions of American identity. The Hubble images, through their adoption of the visual tropes of the older views, interact with this history and repurpose aspects of it. The reference to the sublime shapes our very notions of the cosmos, and by evoking the American landscape and its associations with exploration and the frontier, the images bring the aesthetic experience to the ending that Kant proposed. Instead of a universe that leaves us only with a sense of our insignificance, it becomes a place that we experience as both overwhelming *and* within our grasp.

The attention to the symbolic value of the landscape matters, because without it the visual comparison that I used to open this book might be just one among many possibilities. Given the large number of Hubble images, one could find exam-

ples that seem to owe a debt to other artists and periods. Michael Lynch and Samuel Edgerton, for example, began their study of digital image processing in astronomy because they saw a visual correspondence between early abstraction and astronomical images from the 1980s.[1] They compare the colorful concentric rings of planetary nebulae to Wassily Kandinsky's color studies, and the pixellated images of Halley's comet flyby in 1986 remind them of Georges Seurat's experiments with pointillism. Lynch and Edgerton argue that the machine aesthetic of modernism had so permeated our culture as to be a natural choice for astronomical images that depended on technology at every level—from data collection to display on a computer screen. However, several of the visual similarities they identify as linking astronomical images to modernist painting, namely, geometric blocks of colors and a flattening of the visual field, are not common to the Hubble images. As the authors themselves note, astronomers frequently intervened to eliminate some of these features. With the Hubble images, the increased resolution of digital detectors and greater sophistication in image processing has largely eliminated them. Given the opportunity, astronomers discarded the modernist aesthetic with its interest in pure form and color, geometry and machines, for an aesthetic of naturalism.

On the other hand, modernism's quest for purity might seem an attractive approach because it could free the Hubble images from the potentially confusing resemblance to the world we see around us. In addition, the critical and artistic conversation that accompanies abstraction echoes the debates within science about the value of numbers over images. As with the embrace of quantitative modes, the interest in abstraction derives in part from its ability to move beyond historical or subjective associations into a realm of pure form. But the landscape enters through the back door. W. J. T. Mitchell identifies a commonality in modernism's quest for a pure visual language of abstraction and the search for a perfect mirror of the landscape. He compares them, writing that "on the one hand, the goal is nonrepresentational painting, freed of reference, language, and subject matter; on the other hand, pure hyperrepresentational painting, a superlikeness that produces 'natural representations of nature.'"[2] Both efforts strive to achieve the truest representation, an absolute translation of the world into an image.

Abstract expressionism offers another possible set of comparisons. In the Heritage Project's Veil Nebula, filigrees of colored light bend and twist through the image, and one could imagine it as an electrified version of Jackson Pollock's drips and splashes (Figure 48). Supernova Remnant E0102 in the Small Magellanic Cloud with its shifts in color—browns that bleed into pinkish orange and then purple—might suggest a tilted version of one of Mark Rothko's paintings, which are characterized by horizontal blocks of layered colors that merge and vibrate (Figure 49). The vertical forms of the Eagle Nebula or Keyhole Nebula combine Rothko's nebulous rectangles and Clyfford Still's jagged vertical studies in color. Here again the comparison need not break the connection to the nineteenth-century landscape or the sublime. The art historian Robert Rosenblum describes abstract expressionism as a reprise and extension of the older tradition.[3] In another example of the recurring use of the cosmos to explain the sublime, he writes: "Pollock invariably evokes the sublime mysteries of nature's untamable forces. Like the awesome vistas of telescope and microscope, his pictures leave us dazzled before the imponderables of galaxy and atom."[4]

Despite the possible connections to other visual modes, the landscape comparison seems unavoidable, and with good reason. At a cultural and symbolic level it has great resonance with the history of astronomy and exploration, both terrestrial and cosmic. In addition, it is a relationship acknowledged and even encouraged by the astronomers who craft the Hubble images. They do not make comparisons to abstract paintings, nor do they consider themselves to be engaged in a study of pure form or color. Instead, they strive to understand objects that exist within the cosmos, even if they cannot be seen exactly as represented in the Hubble images.

But it would be far too simplistic to assume that the landscape as representation directly correlates to the landscape as physical environment. Although not entirely divorced from the sites they depict, landscape paintings and photographs are products of a certain way of seeing and representing the natural world. Mitchell argues that the landscape is "a cultural medium" that "naturalizes a cultural and social construction, representing an artificial world as if it were simply given and inevitable" as it simultaneously "greets us as space, as environment, as that within which 'we' (figured as 'the figures' in the landscape) find—or lose—ourselves."[5]

Figure 48. The Heritage Project's Veil Nebula shows a portion of the supernova remnant in brilliant color. July 31, 2007; WFPC2. Courtesy of NASA, ESA, and The Hubble Heritage Team (STScI/AURA)–ESA/Hubble Collaboration.

Figure 49. The layers of color in the Hubble Heritage Project's view of Supernova Remnant E0102 call to mind the color field paintings by Mark Rothko. July 11, 2006; ACS/WFPC2. Courtesy of NASA, ESA, and the Hubble Heritage (STScI/AURA)–ESA/Hubble.

As such, the landscape carries with it historical and ideological meanings, and perhaps no landscape is more powerfully suggestive than the American West. By the last decades of the twentieth century, the West had become as the photographer and critic Deborah Bright suggests, "a complex construct." For some, she writes, it is "the locus of the visually spectacular, culled from the total sum of geographic possibilities and marketed for tourist consumption," while for others it represents "the romantic dream of a pure, unsullied wilderness where communion with Nature can transpire without technological mediation."[6] In other cases, and despite scholars' efforts to revise the standard account of western settlement, the West remains a symbol of the frontier and American exceptionalism. Nineteenth-century landscape paintings and photographs are used to support and forward all of these views of the American West.

The resemblance of the Hubble images to the Romantic landscape reanimates its symbolic and cultural significance. For the astronomers who produced them as well as for viewers within and outside the scientific community, the visual allusion speaks to the place of science and technology in the contemporary world as it also celebrates the ideals of scientific exploration. By alluding to the landscape of the American West, the Hubble images recall an earlier period of exploration, one that paintings by Thomas Moran and Albert Bierstadt and photographs by William Henry Jackson and Timothy O'Sullivan helped to promote and popularize. They also hint at some nostalgia for an older approach to exploration. By the end of the nineteenth century, mountaintops became the preferred location for astronomical observatories, and astronomers themselves lived and worked in the landscapes depicted to such dramatic effect by artists and photographers. In doing so, astronomers acted as pioneers.

Finally, the reference to the American West brings into play the frontier. As a historical, metaphorical, and phenomenological concept, the frontier is a consistent presence in the rhetoric that circulates around space exploration. By invoking the frontier landscape, the Hubble images make use of both its profound popularity and its ability to describe science's quest to better understand the universe. Furthermore, the Hubble images make the alien familiar while also, and somewhat paradoxically, promising the thrill of new discoveries. They have transformed the amorphous space

of the cosmos into a place that can be explored, known, and understood. To return to Mitchell's words, it is through the act of creating such representations that astronomers position themselves—and us—in relationship to these places.

A Celebration of Scientific Exploration

The nineteenth-century landscapes by Moran and Bierstadt, Jackson and O'Sullivan require further context in order to make it evident that their relationship to the Hubble images goes beyond that of formal resemblance or aesthetic convention. To varying degrees, the paintings and photographs that I have compared to twentieth-century views of the cosmos were products of the scientific exploration of the Western Territories. They were the "pretty pictures" that helped to promote scientific exploration and study while also documenting both the features of the western terrain and the efforts to map it. As occurred more than a century later with the Hubble images, many questioned the scientific value and the aesthetic appeal of the landscapes made as part of the surveys, thereby affirming that the uncertainty about the role of images (and the senses) is a long-established position. But the relationship between the two sets of images does more than merely underscore the complexity of communicating new discoveries or simply demonstrate the function of images in science. In both cases, the collaboration of government, scientists, and image makers generated new ways of representing spaces that had previously been beyond view. First the views of the landscape and later those of the universe became means of celebrating American scientific exploration.

Before the Civil War, expeditions to the West focused on territorial gains and establishing settlements; a scientific understanding of the region became the foremost concern in the last several decades of the nineteenth century.[7] Between 1867 and 1879, survey parties explored the territory that stretches from present-day Montana to New Mexico and Colorado to California. Four multiyear expeditions, now known as the Great Surveys because of the large geographical area they covered and the comprehensive nature of their efforts, were established to gather this data. Ferdinand Vanderveer Hayden, working for the Department of the Interior, led the U.S. Geological and Geographical Survey of the Territories. The Department of War sponsored two expeditions: the U.S. Geographical Exploration of the Fortieth

Parallel headed by Clarence King and the U.S. Geographical Survey West of the One Hundredth Meridian led by George M. Wheeler. Finally, John Wesley Powell initiated a study of the Grand Canyon, which later became the U.S. Geographical and Geological Survey of the Rocky Mountain Region.[8] The surveys catalogued the flora and fauna, recorded meteorological conditions, studied the topography and geology, searched for fossil remains, and mapped the area.

Although artists accompanied earlier explorations of the American West, the Great Surveys delivered a richer visual record than any previous efforts. Visual documentation increased exponentially during the dozen years that Hayden, King, Wheeler, and Powell traveled the West, and photography was critical to the growth in picture making. Not every survey leader initially employed a photographer, but all eventually did. King, who had worked with Carleton Watkins when both participated in an earlier survey of California, hired Timothy O'Sullivan for the first season of the Fortieth Parallel Survey in 1867, and the photographer returned for the next two years and then again in 1872. Hayden, who also ventured out for the first time with federal support in 1867, traveled without a photographer until 1870, when he recruited William Henry Jackson. Once established, the relationship between the two men was long and fruitful, with Jackson continuing to work for Hayden until the team was disbanded completely in 1879. Powell made his first trip through the Grand Canyon in 1869 without a photographer, but he added E. O. Beaman to the survey party the following year. Beaman stayed for only half a season, and Powell had difficulty finding a dependable photographer. He ultimately settled on one of his crew members, J. K. Hillers. Wheeler, whose efforts did not begin until 1871, hired O'Sullivan, and with the exception of 1872, when the photographer returned for his third expedition with King, he continued with the team until 1875.

Painters, most famously Thomas Moran and Albert Bierstadt, were also attached to the surveys, although their associations were looser.[9] They often joined as guests rather than official members, and their aim was to search for scenery that they could rework into dramatic paintings for eager audiences in the East. Moran journeyed with Hayden in 1872 and 1874 through Yellowstone and Colorado, respectively, and he worked alongside Jackson. For the season in between, he joined Powell in the Grand Canyon. Bierstadt was invited to join Hayden's survey during

Moran's first year, but he declined. However, King guided him through the Sierra Nevada in 1872, and after the trip he completed several paintings, including *Autumn in the Sierras.*

Congress appropriated funding for the surveys annually, requiring the leaders to lobby for support on a regular basis. All four leaders quickly learned that images were valuable tools for promoting their endeavors. Each incorporated engravings based on photographs in reports on the expeditions.[10] (Hayden also included prints derived from Moran's drawings.) Both O'Sullivan and Jackson dedicated their winters to making photographic prints that King, Wheeler, and Hayden then distributed to congressmen and other interested individuals as well as universities and libraries in an effort to encourage continued funding from governmental and scientific institutions.

Although painters were not employed by the surveys, their work also brought great attention to the expeditions. In 1872, Congress purchased Moran's *The Grand Canyon of the Yellowstone,* and then in 1875 his *The Chasm of the Colorado* (Figures 50 and 19). The two paintings hung in the Capitol building where congressmen could easily see them and congratulate themselves on the decision to finance the surveys. Bierstadt's *Autumn in the Sierras* temporarily hung alongside Moran's work, representing King's explorations in that region.[11] When the survey leaders lobbied for additional funding, all three paintings testified to the returns that supporting such scientific expeditions could deliver. They displayed for members of Congress the wonders that scientific exploration could bring within reach, both visually and intellectually. A critic in *Scribner's Monthly* wrote of Moran's *The Chasm of the Colorado* as follows: "It is not paint that one sees; it is a description so accurate that a geologist need not go to Arizona to study the formation. This is geology and topography."[12]

Representations of the American West reached a wide audience through a range of venues and forms.[13] Paintings and photographs based on the study of the West were prominently displayed at the Centennial Exhibition in Philadelphia, an event that drew nearly ten million visitors.[14] Those who did not travel to see the full-scale images in person could have easily found reproductions in smaller formats. O'Sullivan and Jackson both took numerous stereographs during their travels. Stereoscopes were wildly popular visual amusements of the period, common in middle-class parlors.

But neither survey leader recognized the artists' drawings and paintings as part of the scientific return of the survey, even as they made use of them in their annual reports. In Hayden's description of the 1871 expedition he identified Moran as a guest and noted the artist's interest in the scenery of Yellowstone, but the geologist did not credit him for the woodcuts illustrating the report. Instead, he thanked the editors of *Scribner's Monthly* who had financed Moran's trip and the production of the prints, writing that they "have done and are continuing to do so much to spread a knowledge of the remarkable scenery and resources of the far West among the people."[24] Hayden's report from 1874 again made no mention of the artist despite the several engravings by Moran that appeared in the publication. Instead, Hayden acknowledged the publisher, D. Appleton and Co. As with the earlier prints the survey did not pay for their production but rather used engravings that were commissioned for another project. In this case, Moran's work was intended for the two-volume *Picturesque America,* an illustrated tour of America's landscapes. Hayden's reuse of other images may have reflected his frugality: Why pay an artist when others were willing? It also speaks to the different positions of painters and photographers within the survey. Although used for promotion, the artist's work was less critical to the scientific pursuits of the surveys, and the artist had access to other resources to support his efforts.

Although the landscape paintings were not used for scientific analysis, contemporaries judged them with an eye toward their scientific validity. Bierstadt journeyed through the West several times, and he based *A Storm in the Rocky Mountains, Mount Rosalie* on sketches made while traveling the Colorado Rockies in 1863 (Figure 16). Although accounts suggest he saw a dramatic storm move through the valley, the scene's combination of mountains, Indians, and weather were the product of Bierstadt's brush more than a direct recording of the landscape.[25] In response, a critic invoked science when assessing the painting:

The law of gravitation leagues itself with geological law against the artist. . . . Now, let him work out a problem in arithmetic: The hills over which he looks are, as we are told, three thousand feet high; right over the hills tower huge masses of cloud which carry the eye up to ten to twelve

thousand feet higher; above these jut the two "spurs"; what is the height of Mount Rosalie? Answer: Approximately, ten thousand miles or so. Impossible. Then these "spurs" are not affected by nature's law of gravitation, but float up in the air by some artistic license.[26]

The critic's complaint rested not on Bierstadt's choice to create a composite view but on his defiance of geological laws.

The reviewer was not alone in his assertion that Bierstadt exchanged grandeur for realism. King, the artist's guide through the Sierra Nevada, lampooned such critics and the artist in his folksy chronicle of his travels through California, *Mountaineering in the Sierra Nevada.* King recounted a meeting with a fictional painter who commented on the artists of the day, ending with Bierstadt: "It's all Bierstadt and Bierstadt and Bierstadt nowadays! What has he done but twist and skew and distort and discolor and belittle and be-pretty this whole doggonned country? Why, his mountains are too high and too slim; they'd blow over in one of our fall winds."[27] King offered no defense of Bierstadt's work, leaving the reader to guess as to whether or not he agreed with the character he conjured. Nonetheless, he made clear that Bierstadt could not be trusted to paint the landscape with scientific accuracy.

The choices made in translating Hubble data into images have given rise to criticism that echoed King's statement about Bierstadt. Although using different words, critics have argued that Hubble images "skew and distort and discolor and belittle and be-pretty." Although astronomers would never move an element within a Hubble image with the freedom that the artists exercised, they too followed a set of pictorial standards when they chose to remove most artifacts but retain, even enhance, diffraction spikes.

While Bierstadt's uncertain geology consistently raised questions, Moran's work was more frequently praised for its truthful depiction of nature. However, even as critics of the day applauded Moran's attention to detail they questioned whether the harsh landscape depicted in *The Chasm of the Colorado* was appropriate for an artistic picture. According to at least one critic the validity of the geology did not ensure the merit of the painting:

We are not at all sure, however, if Mr. Moran has done wisely in choosing so pronounced a subject for his picture. Of course, he must be limited by the facts of the place, for, if he be not true to them on the whole, or even in details, he might as well call his picture by any other name. And he has been so conscientiously true to the facts that the temptation is strong in the mind of the ordinary spectator to see nothing in the canvas but a geological and geographical statement, another of those painted photographs of which we already have too many, and which have done so much to give our landscape art a name for childishness and journey-work.[28]

While Bierstadt took too much artistic license, Moran's approach was considered overly factual. Here, though, not only was the artist's method called into question, but the very subject of the painting.

Despite such criticisms, Moran placed a high value on the accuracy of his paintings, and he solicited comments from Hayden and Powell on the canvases depicting Yellowstone and the Grand Canyon. Scholars have not located a written response from Hayden, but Powell praised Moran's portrayal of the canyon: "It required a bold hand to wield the brush for such a subject. Mr. Moran has represented depths and magnitudes and distances and forms and colors and clouds with the greatest fidelity. But his picture not only tells the truth, it displays the beauty of the truth."[29] Unlike the art critics, Powell equated Moran's honest portrayal of the landscape with a deeper recognition of truth, one that went beyond a simple recording of the landscape.[30] In his assessment, one might hear a claim similar to that of Benjamin: translating from one form to another affords us a glimpse of truth.

Late in his career, Moran wrote of the need for knowledge in order to represent the landscape:

In condensed form, this is my theory of art. In painting the Grand Canyon of the Colorado and its wonderful color scheme . . . I have to be full of my subject. I have to have knowledge. I must know the geology. I must know the rocks and the trees and the atmospheres and the mountain torrents and the birds that fly in the blue ether above me.[31]

Moran's knowledge of the landscape came not only through his careful observations but also from his years in the company of scientists who studied it. Nonetheless, Moran's paintings were as constructed as those from Bierstadt's hand. No vantage point precisely matches the vista Moran presented in either *The Grand Canyon of the Yellowstone* or *The Chasm of the Colorado;* instead, he combined perspectives, rearranging them to form the most advantageous composition.[32] The artist acknowledged as much when describing his painting of Yellowstone Falls:

> Every form introduced into the picture is within view from a given point, but the relations of the separate parts to one another are not always preserved. For instance, the precipitous rocks on the right were really at my back when I stood at that point, yet in their present position they are strictly true to pictorial nature; and so correct is the whole representation that every member of the expedition with which I was connected declared, when he saw the painting, that he knew the exact spot which had been reproduced. My aim was to bring before the public the character of that region. The rocks in the foreground are so carefully drawn that a geologist could determine their precise nature.[33]

Moran's description—which alternates between a defense of the picture's accuracy and refutation of the need for any such relationship—reveals the complexity of his realism. Communicating the character of Yellowstone rather than mirroring its every feature was the primary goal; still, the rocks exhibit a scientific precision. Members of the Heritage Project attempt to find a similar balance in their images as they adjust contrast and color such that their images convey a larger sense of the cosmos rather than exactly mirroring it. Neither Moran nor those who crafted the Hubble images felt compelled to preserve precise relationships between different elements in nature. Moran measured truth against the standard of "pictorial nature," creating an idealized composition that improves upon the actual arrangement to present nature in a more perfect form. Despite this manipulation, those who were his fellow eyewitnesses to the scene—and at this point, only a few outside the survey party

could claim to have visited the site—recognized it immediately, thus validating the truthfulness of his depiction.

The scientific visual culture and practices of the late nineteenth century and those of more than a century later are strikingly similar. The nineteenth-century landscapes and the Hubble images are not two sets of representations that simply look alike but rather images that confront common issues about how to represent and communicate the character of unfamiliar worlds. With this end in mind, the older paintings and photographs go beyond merely evoking the sublime; they present the landscape in a manner that encourages exploration and excites a sense of curiosity. Frequently, Moran painted diminutive figures in the landscape. In *The Grand Canyon of the Yellowstone,* two men stand at the edge of a cliff, one pointing toward the majestic falls. Acting as surrogates for the viewer, they issue an invitation to join them in the shared experience of exploring the landscape. To do so, our eyes travel along a rocky pathway that begins in the middle of the canvas and zigzags to where they stand. Even when Moran did not include figures in the scene, he still provided a means for the viewer to imagine entering the space depicted on the canvas. By figuratively providing a place to stand in their foregrounds, *The Chasm of the Colorado* and *The Tower of Tower Falls* encourage the viewer to imagine moving into the landscapes. Bierstadt's *A Storm in the Rocky Mountains, Mt. Rosalie* also incorporated a pathway that weaves from the right side of the painting down to the valley floor. The artist's attention to the details of the flora and fauna can only be appreciated through close study of the large canvas. The viewer is pulled toward the image, asked to examine the precise rendering, and rewarded for the effort.

The Hubble images also reward close study. By examining the glowing forms in the background of the Tadpole Galaxy one can find galaxies of different shapes and sizes—each an echo of the larger object that dominates the frame (Figure 23). As described in the first chapter, the Hubble images convey a sense of depth that pulls the viewer into the space of the image, much as the paths composed by Moran or Bierstadt in their paintings. But even more fundamentally, through their very reference to landscapes they remind the viewer of the pleasures and rewards of exploration. Unlike science fiction illustrations or artists' renderings of spacescapes, the

Hubble images can never include a figure as a surrogate. However, the resemblance to the landscape itself makes it possible to identify a familiar visual experience. We have looked at paintings and photographs of landscapes; we have visited the places that the Eagle Nebula, Keyhole Nebula, and others resemble. We know how we are supposed to respond to such scenes. The Hubble images symbolize the curiosity and wonder associated with vistas that are not yet fully known. By employing similar visual techniques, they position the viewer at the threshold between the known and the unknown, drawing the viewer into new spaces, new worlds, new discoveries.

Even as debates about their contribution to scientific knowledge continue, both sets of images celebrate the value of exploration, and especially the place of scientific exploration in America. During the decades of the Great Surveys, the United States was experiencing a period of hardship. The scars inflicted during the Civil War remained; the country experienced an economic depression; and the presidency of Ulysses S. Grant was marred by corruption. Nonetheless, it was also a time of promise, as perhaps best illustrated by the 1876 Centennial Exhibition in Philadelphia. The event celebrated the hundredth anniversary of the nation's founding, and it also fostered a sense of nationalism. Similar fairs had been held previously in the great cities of Europe, with London hosting the first in 1851, quickly followed by others in Paris and Vienna. This was the first international exhibition in the United States, and it marked the country's entrance onto the world stage. President Grant opened the fair with a speech that commented on all that had been accomplished in one hundred years, noting the hard work entailed in forming a nation. Despite the necessity of dedicating time to clearing forests and building homes, factories, and roads, as well as founding schools, churches, and libraries, he asserted that "we have yet done what this Exhibition will show, in the direction of rivaling older and more advanced nations in law, medicine and theology; in science, literature, philosophy and the fine arts."[34]

The success of the exhibition depended, as did the Hubble Space Telescope's success more than one hundred years later, on cooperation between government, private industry, and the scientific community. Congress authorized the fair and its location in Philadelphia; wealthy businessmen purchased stock in the fair; and scientists planned many of the exhibitions. The surveys were featured prominently, and the visual records of the efforts to map the Western Territories were displayed

in multiple locations. Those who toured the Memorial Hall, which housed art from around the world, saw works by Thomas Moran and Albert Bierstadt. Moran sought permission to exhibit *The Chasm of the Colorado* and *The Grand Canyon of the Yellowstone,* but Congress did not agree to the loan. Instead, three other paintings based on his travels with the survey teams along with chromolithographs of Yellowstone made his relationship to scientific exploration evident. Bierstadt contributed six paintings to the gallery, all depicting scenes from the American West. In the United States Government Building, visitors viewed photographs by both Jackson and O'Sullivan. Hayden even gave Jackson the task of overseeing the entire exhibit for his party's survey. Although far from the only examples, the visual records of the survey were prominent reminders of the artistic and scientific promise of the United States.

In the final decades of the twentieth century one could argue that the nation seemed to have fulfilled the dreams of scientific progress that had begun to flourish at the time of the Centennial Exhibition. Rather than competing with other nations the country now enjoyed an incomparable success, and the Hubble Space Telescope could easily be seen as evidence of America's scientific and technological achievements and its unique position in the global community. When the telescope was launched in 1990, the United States was emerging as the world's sole superpower. As a nation, it had extensive economic resources, a successful space program, advanced technological know-how, and an unrivaled university system. The European Space Organization contributed to the Hubble's construction and astronomers from around the world could (and did) use the telescope, but only the United States could have imagined, launched, maintained, and supported such an audacious endeavor.

Considered in this context, the Hubble images bear a strongly nationalist ideology, remaking the universe in the image of the American landscape and affirming its unique status in the world. But this status was fleeting. In the relatively short lifetime of the Hubble Space Telescope, twenty years and counting, the faith in America's unique ability to forward scientific exploration has come into question. The Hubble continued to deliver spectacular views of the cosmos, but the space shuttle program that enabled the telescope's success came to an end without a clear plan for future human space travel to replace it. Plans for the James Webb Space Telescope, the intended successor to the Hubble, have been much delayed and threatened with

cancellation. Frequently, scientific findings have been challenged and attacked, and universities have faced steep budget cutbacks. In such a climate it becomes possible to speculate that the images that celebrated America's accomplishments will come to mark the country's more diminished position in the world. If the Centennial Exhibition and its celebration of American technological and scientific know-how ushered in a new era of American exploration, the Hubble images may come to commemorate its close. The shared aesthetic becomes a prescient choice, bracketing a period of great scientific achievement that may not continue into the future.

Aesthetics of Observation

Whether scientific or otherwise, exploration has become deeply connected to the American West, especially for those residing in the East. Although the Hubble Space Telescope orbits high above such regional divisions and can be used by astronomers from anywhere in the world, the institutions that run it are centered in the East with NASA in Washington, D.C., and STScI in Baltimore.[35] Several members of the Heritage Project have lifelong ties to the East: Howard Bond and Zolt Levay both grew up in Maryland; Keith Noll spent his childhood in Delaware. All three identified the American West as a landscape that they liked to visit because it is exotic and different; it is a place for exploration. Bond took regular rafting trips through the Grand Canyon, repeating the journey of Powell's survey team.[36] Noll recalled hiking in and around Tucson, Arizona, where he had a postdoctoral fellowship, and he noted the differences between the desert landscape and the scenery of the East Coast.[37] Levay described the Southwest as an area he liked to photograph. Because of the contrast with his familiar surroundings, it made him more attentive to his visual experience:

> Growing up here [the East] it is just such a different landscape, you know, that exotic nature of it, I guess, and that starkness in the forms that you get in the landscape are so different. And it's probably different for people that grew up there. It's more normal for them. But it's also a varied landscape. You go from flat to rolling to very mountainous to very steep terrain, a lot of steep terrain, and different forms of things. It just seems very varied. There's also the difference in light and the air, probably because of the different latitude,

altitude, humidity, etc. To anyone attuned to light and landscape, there is a surprisingly noticeable difference in the quality of the light.[38]

As the experiences of these astronomers suggests, the western landscape continues to represent a distant, even strange place that offers opportunities for new discoveries, albeit on a more personal level.

The association also has roots in the history of astronomical observing. As mentioned earlier, beginning in the nineteenth century observatories were perched atop mountain peaks in the midst of the very landscapes that inspired the Romantic paintings and photographs of Moran, Bierstadt, Jackson, and others. At the same time that nineteenth-century painters and photographers traveled through the West and produced their sublime views, astronomers journeyed to some of the same regions to observe the heavens from above the obscuring layers of the atmosphere. The experience of observing was also draped in Romantic trappings. It occurred during the blackest hours of the night as a lonely observer communed with a giant telescope. From such settings, astronomers recorded the sublimity of their experiences as observers of the heavens and the earth.

Astronomers who use the Hubble Space Telescope—as well as other large ground-based telescopes in operation in the twenty-first century—have a different relationship to both the instrument and the location of the observatory than did their predecessors. They no longer travel to distant and hard to reach locations or spend cold nights staring through the eyepiece of the telescope. Instead, observing occurs remotely. They write proposals, which staff members at STScI or one of the other major observatories then schedule and carry out in a manner that optimizes the use of the telescope. Astronomers receive their data in the comfort of their offices. Such changes have fundamentally shifted what it means to practice astronomy. As one astronomer said in the mid-1990s, "We have a new definition of astronomer now. Astronomer doesn't mean you go to the telescope and push the buttons yourself. It means that you deal with the data."[39] The Hubble images, however, bear the trace of the older aesthetics of astronomical observing. Their resemblance to mountain scenes reflects scientific practices that in the recent past brought together the landscape and the spacescape.

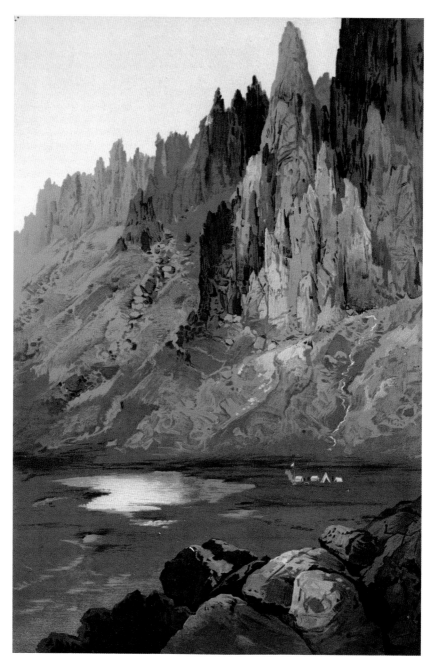

Figure 51. A print based on Thomas Moran's sketch *Mountain Camp, Mount Whitney* illustrated Samuel P. Langley's account of his journey to the summit, which he undertook in 1881 to make solar observations.

Among the most daring efforts to explore both landscape and cosmos occurred in 1881, when the astronomer Samuel P. Langley chose Mount Whitney, the highest peak in the continental United States, as the site for observations of solar heat. The mountain had only been successfully scaled a mere eight years earlier.[40] It was, as Langley wrote, "far from any railroad, in a wild region, and it had been ascended so rarely, and with such difficulty, that it was not certain that heavy instruments could be transported to the extreme summit."[41] After braving earthquakes, extreme temperatures, severe sunburn, and an arduous climb, Langley and a small party of astronomers and guides established a mountain camp at twelve thousand feet, "beautifully placed on a nearly circular and well-watered meadow . . . while an amphitheater of very precipitous cliffs . . . rose immediately from its northern and eastern sides and was continued by others more remote on the south."[42] When he published the scientific results of the expedition, a series of observations on the amount of solar heat transmitted to earth, Langley illustrated the report with a print by Moran (Figure 51). While the artist traveled with the survey teams, there's no evidence that he accompanied Langley's expedition or even saw the top of Mount Whitney, so he must have based his portrayal on photographs or the astronomer's descriptions. In Moran's rendering, pinnacles surround the mountain camp, reaching beyond the frame of the picture and dwarfing the small tents in the meadow. The artist also piled boulders in the foreground of the image; it is a strange framing device, giving the viewer the security of a protected location but also functioning as a barrier that prevents the viewer's eye from moving easily into the scene. Instead, we stumble over the rocks much as Langley and his band of researchers would have clambered over the difficult terrain of the Sierra Nevada.

Langley did not limit his use of the print to a single paper but reproduced it in his widely read popular astronomy book, *The New Astronomy*, one of the earliest arguments for integrating physics into the study of astronomy. Including the representation of Mount Whitney ensured that many saw it, and the picture helped to establish a connection between astronomers and such sublime landscapes, places that were difficult to reach and inspiring to behold. Langley also encouraged the reader to see earthly and cosmic landscapes as analogous. He compared the harsh conditions of Mount Whitney to those he imagined on the surface of the moon. Although Langley

does not call attention to it, the reader could not help but notice the similarities shared by a picture of Mount Whitney and an illustration of the lunar landscape, one based on James Nasmyth's photographs of plaster models of the moon's surface.

Although Langley's trip lasted only a few months, by the end of the nineteenth century astronomers had established permanent mountaintop observatories. When completed in 1888 atop four-thousand-foot Mount Hamilton outside San Jose, California, Lick Observatory was the first of its kind in the world and it became home to a small group of astronomers and their families. On the mountain they lived much like pioneers, sometimes lacking sufficient water or fuel.[43] While the hardships were undeniable, the observatory was envied by astronomers around the world. Astronomers in residence, especially E. E. Barnard and James Keeler, made dramatic photographs of the Milky Way and galaxies that showed them in impressive detail.

While living on and traveling to Mount Hamilton, astronomers observed not only the cosmos but also the surrounding scenery. *The Handbook of Lick Observatory,* a guidebook written by its first director, Edward S. Holden, indicates the importance of the scenery. The text discussed the history of the observatory, the telescopes, and astronomical photography, among other topics. The illustrations made no promises about what one might see through the telescope; published in the same year as the observatory's opening, representations of the stars were noticeably absent. (In this it contrasts with images of the Hubble Space Telescope that predated its launch.) Instead, the images focused on the mountain scenery and the buildings. Stagecoach advertisements at the back of the publication further emphasized the aesthetic appeal of the landscape. They repeatedly referred to the "unsurpassed" mountain views enjoyed during the journey.

In an article for *Atlantic Monthly* (and readers in the East), Ethel Fountain Hussey, a resident on Mount Hamilton and the wife of one of the astronomers, described the panoramic vista that would greet those who reached the top:

> From the summit sweeps a view that is unsurpassed; the pale white haze of the sea over Monterey; the flashing Point Reyes Light on the headlands far beyond San Francisco; the first white peaks at the Lassen Buttes two hundred

miles to the north; thence the magnificent Sierras, circling the east and dip-
ping lower and lower till they meet the cross ranges. . . . in the far southeast,
an unbroken arc of perpetual snow exceeding the distance from Boston to
Baltimore, and equaling that between Philadelphia and Cleveland.[44]

For the astronomers, the expansive views, the extension of vision enabled by the
heights of the mountain, paralleled the experience of looking through the observa-
tory's telescope and seeing farther into the heavens than ever before. The landscape
and the technologies employed for observing meet in a photograph from the 1930s
that depicts the sweeping expanse of the Sierra Nevada. The staff photographer
J. Fred Chappell took the photograph as part of a series of experiments with infrared
photography, perfecting techniques for astronomical research by first turning his
camera to the landscape. Although made in the service of science, the photograph
hung in the main hall of the observatory for many years and copies were sold to
tourists who visited Lick Observatory.

Life on the mountaintop offered more than a visual encounter with vast dis-
tances, at least according to Hussey. She proposed that living in a community of sci-
entists was itself a transcendent experience. While she did not deny the hardships of
life on the mountaintop, she had a ready answer for anyone who looked at her with
pity. "Here the air we drink is crystal pure; here is no one aged or poor or sick; here
each man does what he most would do, and money is not the goal: these are condi-
tions unique, to be read of in philosophers' dreams."[45] While other accounts of the
early years at Lick Observatory presented it as far less idyllic, Hussey painted a vision
of an ideal community, one that has separated itself from the mundane concerns of
life below and dedicated all its efforts to the pursuit of knowledge.[46]

When in 1904 George Ellery Hale built an observatory on Mount Wilson, a
six-thousand-foot peak outside Pasadena, he took the notion of an ideal community
a step further and only provided housing for astronomers on the mountaintop, a
structure aptly nicknamed "The Monastery." By leaving their families behind, he
hoped scientists would pursue their all-night observing without interruption. Many
of those who came to Mount Wilson during its initial years had worked with Hale at
Yerkes Observatory in southern Wisconsin, and their encounters with the mountain

landscape of California had a profound impact. Among these early scientists was Ferdinand Ellerman, a longtime assistant to Hale and the first astronomer to join him at Mount Wilson. Several decades later his fellow astronomer William Adams reflected on their early years together at the observatory:

> As was the case with the other members of the small Yerkes group, the somewhat wild and primitive conditions at Mount Wilson were quite new to Ellerman and he enjoyed them greatly. He had seen but few mountains previously, and the views with their outlook upon the valley and the deep canyons, the new trees and flowers, and occasional glimpses of wild animals all made a strong appeal to his love of nature. He would have ranked high on John Buchan's criterion that "there is something wrong with the man who sees a high mountain and does not want to climb it," for Ellerman was an ardent mountain climber. The occasional rattlesnake and the almost mythical mountain lion provided the element of excitement, and he made elaborate preparations for meeting them.[47]

Ellerman's enchantment with the landscape was paired with an enthusiasm for photography and he made numerous photographs of the scenery, several of which were published in the 1908 issue of *National Geographic.*[48]

The photographs selected for the article followed the model established by the Romantic landscape paintings and photographs of a few decades earlier, and they focus on the vast size, scale, and power of nature. In *Sea of Fog: From Mount Wilson* a thick layer of fog extends to the horizon, merging with the clouds above it (Figure 52). The blurring of these distinctions calls to mind the efforts of earlier painters and photographers to represent the infinite. Another image, *A Storm in the Mountains,* captures the interaction between clouds and mountains (Figure 53). The storm obscures the distant vista, but the encroaching dark clouds promise an exhibit of nature's strength. In addition to rehearsing the familiar tropes of the sublime landscapes, Ellerman's photographs also position the astronomer as participating in an experience of the sublime. By climbing to the heights of Mount Wilson, they have literally transcended the obscuring fogs and clouds. It was a theme Adams

SEA OF FOG: FROM MOUNT WILSON

Figure 52. As an astronomer at Mount Wilson Observatory, Ferdinand Ellerman took numerous photographs of the landscapes, including *Sea of Fog: From Mount Wilson* (1908).

reiterated in his memories of Hale, noting that "nothing pleased him more than to leave Pasadena on a summer morning when the valley was covered in fog, and half-way up the trail to burst out into the bright sunshine and see the distant mountain peaks outlined against the deep blue sky."[49]

For a person of the late nineteenth or early twentieth century to experience the mountaintop observatories as sublime may say no more than that they are people of

A STORM IN THE MOUNTAINS

Figure 53. Ferdinand Ellerman's photograph *A Storm in the Mountains* (1908) recalls the paintings of a similar subject by Albert Bierstadt.

their time. The visual culture of the day, the tales of other travelers, and the landscape images that circulated during the same period would have conditioned them to see and describe it in such terms. But the association continued as astronomers sought out higher and higher mountain perches for their research, aided by improvements in communication, travel, and lodging. A 1962 article from *Popular Mechanics* told of scientists "setting up shop in the sky." The means to reach these "stratospheric eyries

perched on rocky pinnacles above the clouds" sound almost like a scene from a James Bond film, as scientists "dangle over alpine peaks in aerial cableways. They grind upward in cog rail cars through tunnels and shafts carved in the living rock of 18,000-foot mountains. They hairpin their way up jagged snow-swept slopes in tracked vehicles and multiwheeled lorries, and ski along razor-edged rims of breath-taking cols that drop away in sheer 3000-foot cliffs to white altiplanos below.[50]

Today the international observatories on Mauna Kea in Hawaii are at a dizzying altitude of more than fourteen thousand feet. Instructions for visitors warn of the risks of altitude sickness and harsh climates. But unlike their colleagues from the last century, astronomers no longer live at the observatory. Instead, they visit for a brief time or sometimes not at all. In most cases, observing occurs remotely, reliant on the cooperation of staff, computers, and communication networks to carry out and deliver the data to astronomers at their home institutions. Observing has become what Patrick McCrary has called "point-and-click astronomy."[51] In many ways, the Hubble Space Telescope and the STScI pioneered this approach. The location of the telescope, of course, made it impossible to visit. As an expensive international observatory that many astronomers wanted to use, STScI needed to establish an efficient system for allocating time. With its success and the increased dependability of communication networks, the approach soon spread to other institutions and thereby changed the practice of astronomy.[52]

Despite the change, astronomy is still envisioned as an experience of communing with the night sky, not only among those outside the field but those within it. Astronomers often tell similar stories about how they became interested in studying the heavens. For many it began in childhood with a moment under a dark sky or a glimpse through a telescope that allowed them to see more than they had expected. Keith Noll remembered standing outside with his mother, looking up at the sky. "And I saw this sort of green, glowing disc move across the sky, and a few seconds later heard this loud boom. And that was pretty dramatic. I thought this thing had crashed out in the street in the front!" he recalled. "And in later years, I understood what that was. I'd actually seen a meteor large enough to have a disk. It was green, as they often are, and the sound I heard was the sonic boom."[53] Jeff Hester reminisced about his first experience of looking through a telescope, a small one that belonged to a boyhood

friend. "And I remember looking at the rings of Saturn. You know how when things turn out to be significant in your life, they stick?" he said. "I can still remember going around the side of his house into his back yard, and the first look of looking through this little telescope, which of course to me at the time, was just, 'Gee, this is cool! It's a telescope!' Looking through the telescope and there's Saturn!"[54] While they did not point to specific memories, Zolt Levay, Howard Bond, Jayanne English, and others all spoke of having and using a telescope as kids and teenagers. The commonality of such stories attests to the phenomenological pleasures of observing the cosmos. More than a profession, astronomy is presented as a vocation, a calling that comes not in the form of a vision, but an experience of vision that engages the imagination.

Some of the astronomers also remembered fondly trips to mountaintop observatories. Noll credited observing at Mauna Kea during graduate school as the experience that ensured his commitment to astronomy. He described how, after landing in Hilo, "you drive for an hour or so on this road—at the time it was a one-lane, pock-marked, really bad condition road. Then you go up the mountain and you stay at these observer facilities at about 9,000 feet." He continued by noting, "From there you can't see any other sign of human construction at all. And then another half-an-hour up a dirt road to the summit, and you're on top of the mountain, you're above the clouds. Stars are there, panoramic splendor."[55]

Noll's concluding words are significant. He did not say that one could see more stars from the high vantage point but rather that the stars were there. The trip up the mountain has little significance when calculating the distance to even the closest star, but the experience creates a sense that the stars are closer, that they are nearer at hand. For astronomers at the beginning of the twenty-first century, their childhood experiences of studying the sky for new phenomena or looking through the eyepiece of a telescope is primarily a fond memory or something they pursue outside of their research. The romanticism of a cold, lonely night spent alone under the dome of a telescope, only to emerge to a sunrise over a sweeping mountain vista, is no longer. (And some might argue it was never so thrilling, and instead more bone-chilling and exhausting than pleasurable.) Remote observing neither replays the childhood dreams of reaching the stars nor the historically based notion of what it means to be an astronomer.

When considered alongside this history, the resemblance between Hubble images and landscape paintings and photographs gains new significance. Not only do they encourage the viewer to respond with awe and wonder, they hearken back to the romanticism that accompanies the act of looking through a telescope on a dark night. The spires of the Eagle Nebula are not simply reminiscent of mountain peaks but are akin to those that Langley saw camped atop Mount Whitney. Bierstadt's *A Storm in the Rocky Mountains, Mount Rosalie* is echoed first by Ellerman's photographs from Mount Wilson and then by the Hubble's view of NGC 602. The panoramas glimpsed from mountaintop observatories around the world deliver an experience of vastness that is seen again in the expansive view of the Whirlpool Galaxy. Perhaps the Hubble images hint at nostalgia for an older definition of what it means to be an astronomer. While the virtual journey to the distant reaches of the cosmos affords astronomers a far better view, it lacks the adventure and the moments of transcendence that accompanied the trip to the mountaintop observatory.

The Frontier

Nostalgia for the past and a desire to make the unknown familiar intertwine in one of the strongest associations with the nineteenth-century landscape depictions: the frontier. As they circulated through the forms discussed earlier in the chapter, the paintings and photographs transformed Yellowstone, the Grand Canyon, Yosemite, and other regions from unknown or rumored spaces into places that could be studied within the comfort of a nineteenth-century home. The pictures drew settlers, miners, and tourists from the East to these exotic western regions. As such, the images contributed to the rhetoric of American expansion, a subject of intense debate in the years immediately before the launch of the Hubble Space Telescope. It is during this period that scholars began using terms like the "magisterial gaze" and the "panoptic sublime" to describe the point of view presented in nineteenth-century landscapes. With *The West as America,* an infamous art exhibition at the Smithsonian National Museum of American Art in 1991, efforts to reconsider how nineteenth-century paintings promoted the frontier myth reached an audience outside the academy.

Through its wall texts and catalogue, the exhibition argued that the paintings, which included landscapes by Moran and Bierstadt as well as many others from

the period, justified westward expansion and presented it as a natural and undeniably positive undertaking. In the opening essay of the catalogue, curator William Truettner encouraged viewers to critique the ways that images contributed to the frontier rhetoric:

> Images of the frontier are among the most potent and moving invented by American artists during the nineteenth century. Decade after decade they return with new force and meaning for our national life. So efficiently do they function as ideological statements that we grasp their import without even realizing it, making them devastating as hidden persuaders but even more intriguing as works of art.[56]

The Smithsonian's exhibition and its rethinking of the paintings were widely and angrily criticized.[57] Some pointed to a rigid focus on an ideological interpretation of some paintings, which did not seem to allow for the possibility that artists might have held ambiguous attitudes about the settlement of the frontier and that sometimes was at odds with the complexity of the paintings themselves. Others objected to the preachy and politically correct tone. Still others, though, quite vehemently opposed the entire revisionist endeavor, both because of a desire to preserve a sense of awe and wonder and because of a wish to retain a beloved view of American history. As the journalist Ken Ringle wrote in the *Washington Post,* the exhibition "effectively trashes not only the integrity of the art it presents but most of our national history as well, reducing the saga of America's Western pioneers to little more than victimization, disillusion and environmental rape."[58] The debate became heated enough that some senators threatened funding cuts for the Smithsonian Institution, the wording of some wall texts was changed, and the exhibition did not travel to the other cities it was scheduled to visit.[59]

As residents of Baltimore and Washington, D.C., who were concerned with the funding decisions of Congress, the astronomers who crafted the Hubble images only a few years later may well have been aware of the controversy and the lasting cultural currency of the frontier. And it is tempting to speculate that a savvy astronomer or NASA official might have seen the enthusiasm for the older frontier

images and the enduring attachment to them as an opportunity for the Hubble Space Telescope. What better way to redeem the instrument's spotted history than by making use of a time-tested symbol and one that was already associated with space exploration? Even those who critique the frontier myth cannot help but marvel at its endurance. As the historian Patricia Nelson Limerick, who is well known for her reinterpretations of Western American history, writes:

> As a mental artifact, the frontier has demonstrated an astonishing stickiness and persistence. It is virtually the flypaper of our mental world; it attaches itself to everything—healthful diets, space shuttles, civil rights campaigns, heart transplants, industrial product development, musical innovations. Packed full of nonsense and goofiness, jammed with nationalistic self-congratulation and toxic ethnocentrism, the image of the frontier is nonetheless universally recognized, and laden with positive associations. Whether or not it suits my preference, the concept works as a cultural glue—a mental and emotional fastener that, in some very curious and unexpected ways, works to hold us together.[60]

Given the malleability of the concept, the ease with which it is co-opted in multiple situations, the trick is to pull apart the threads that are relevant for the Hubble images. What makes it meaningful in this situation? What aspects of the concept resonate for these images and how do they shape our reading of them? And furthermore, why would such a contested concept be adopted at all? Imperialistic expansion remains relevant for the Hubble images, but it is complicated by the vast distance that separates the scenes from the viewer. But to avoid the frontier would be to eliminate what all parties acknowledge to be a potent symbol and one, to return to Limerick's words, "laden with positive associations." The question then becomes whether it is possible to recuperate the frontier, whether it is possible to steer a course between the codependent twins of jingoistic embrace or absolute rejection. Ultimately, the Hubble images combine several different ideas that circulate around the frontier, taking up the historical, the metaphorical, and the phenomenological understandings of the concept. Through its layers of sedimented meanings the reference to the

frontier introduces a paradox. The Hubble images show the cosmos as sublime, and therefore require us to stretch beyond the limits of the human imagination. Simultaneously, they depict it as a place that we can come to know.

A frontier is a border or an edge, a line between what is known and what remains beyond humanity's grasp. Along this line, two realms confront each other. The aesthetic experience of the sublime depends on the existence of a frontier, a limit that must be transcended. Within an American context, the frontier has also become freighted with nationalistic significance and the construction of American identity. The historian Frederick Jackson Turner formalized these associations at the annual meeting of the American Historical Association in Chicago in 1893. In his highly influential paper he wrote of the frontier in terms of population density, the availability of free land, and as open space, but in all cases he emphasized that it was the setting for transformation. The frontier functioned as the line between civilization and savagery, and Turner argued that living along this demarcation changed European immigrants into Americans with democratic ideals. With his frontier thesis, Turner challenged earlier understandings of American history—which focused on slavery or the country's relationship to England—by shifting attention to the frontier. Although he delivered his paper to mark the closing of the frontier in the United States, as declared by the 1890 census, his theory was among the most influential statements on the role of the frontier in America.[61] Unlike some topics of scholarly debate, Turner's frontier thesis filtered into the popular culture, becoming, as Henry Smith Nash suggested, part of "the fabric of our conception of our history."[62]

Turner used the rhetoric of science to assert the validity of his argument, and he relied on metaphors that engage with both Darwinian evolution and theories of geology.[63] He wrote of a continuous rebirth along the frontier line as "a recurrence of the process of evolution in each Western area reached in the process of expansion."[64] Even as a region became civilized its past as a frontier had a lasting influence, and Turner likened the westward-moving frontier in the United States to the "successive terminal moraines [that] result from successive glaciations."[65] Such markers of the frontier became the means for understanding the history and economics of the region because, according to Turner, "colonial settlement is for economic science what the mountain is for geology, bringing to light primitive stratifications."[66]

Turner's reliance on geological metaphors recalls the attention to rock forma-
tions in the nineteenth-century paintings and photographs. The shared reference
invites another interpretation of the precisely rendered rocks and strata in Moran's
paintings or the fascination with large rock outcroppings in O'Sullivan's and Jack-
son's photographs. Instead of transcriptions of the scenery or recordings of unusual
features, they become symbols of the frontier and its enduring positive influence on
American culture. To extend this to the Hubble images, the visual allusion to rocky
buttes and cliffs in the views of the nebulae similarly function as reminders not just
of the appearance of the western landscape but the forward motion of the frontier,
a striving toward new heights. The cosmos is not depicted as a place of stasis in the
Hubble images but rather one that evolves and changes over time, even if that time
scale far exceeds our own.

According to Turner, the frontier formed not only the society but also the
individual. He described in glowing terms its influence on the intellectual traits of
Americans:

> That coarseness and strength combined with acuteness and inquisitiveness,
> that practical, inventive turn of mind, quick to find expedients, that mas-
> terful grasp of material things, lacking in the artistic but powerful to ef-
> fect great ends, that restless, nervous energy, that dominant individualism,
> working for good and for evil, and withal that buoyancy and exuberance
> which comes with freedom, these are traits of the frontier, or traits called
> out elsewhere because of the existence of the frontier.[67]

Turner did not use the word, but others might well call such person a pioneer. The
qualities of that individual, which contributed to America's progress as a nation,
hinged on the presence of the frontier. While Turner did not overtly propose an al-
ternate to replace the frontier—his was not a call for imperialism—he did assert that
such an intellect "will continuously demand a wider field for its exercise."[68]

Turner's use of scientific language and his assertion that Americans will search
for other frontiers foreshadowed the adoption of the idea by the scientific com-
munity. In this new context, the frontier became a metaphor for progress rather

than a literal account of moving forward into new territory. Although not the first instance of its use in a scientific setting, the engineer and administrator Vannevar Bush's *Science, the Endless Frontier* offers a compelling example. It was written a year before Lyman Spitzer forwarded the idea of an orbiting telescope, a coincidence noted by an STScI astronomer at a 1996 meeting.[69] Although recent scholarship has focused on Bush's experiments with early computers, he had an equally significant influence on government support of science.[70] After a successful academic career at MIT, Bush spent the years immediately before and during World War II directing scientific research for the war effort. With the end of the war, he was concerned that government funding for science would lag and with it scientific progress. In an effort to circumvent such a situation, he approached President Franklin D. Roosevelt with a plan to make recommendations on how to continue scientific research during peacetime. The president agreed, and Bush began his study, publishing it in 1945.

With the book's title Bush embraced the frontier trope, and his introduction continued in a similar manner: "The pioneer spirit is still vigorous within this Nation. Science offers a largely unexplored hinterland for the pioneer who has the tools for his task." Further, he promised material returns would follow from such a pursuit: "The rewards of such exploration both for the Nation and the individual are great. Scientific progress is one essential key to our security as a nation, to our better health, to more jobs, to a higher standard of living, and to our cultural progress."[71] Unlike Turner, who believed that the frontier fostered the innovative pragmatism of the pioneer, Bush saw these traits as already in existence and simply in need of a means of expression. Bush echoed some of the earliest advocates of science, notably Francis Bacon and René Descartes, when he promised that the pursuit of science would better the human condition.

Bush argued for a national board to oversee scientific research, and his recommendation eventually, and under somewhat different circumstances, led to the formation of the National Science Foundation. As a result, government involvement with scientific study and innovation dramatically increased, and ambitious projects like the Hubble Space Telescope became possible. Again, Bush used the history of frontier exploration to bolster his position:

It has been basic United States policy that Government should foster the opening of new frontiers. It opened the seas to clipper ships and furnished land for pioneers. Although these frontiers have more or less disappeared, the frontier of science remains. It is in keeping with the American tradition—one which has made the United States great—that new frontiers shall be made more accessible for development by all American citizens.[72]

Although Bush did not specifically point to the nineteenth-century surveys of the American West, the expeditions closely matched his ideal of government support for exploration. They also might have functioned as a bridge between the two meanings of the frontier that Bush employed as he shifted from the settlement and exploration of land and sea to the more abstract frontier of science. Instead of pioneers traveling to new places, scientists would conquer ideas and gain a better understanding of the world. Such advances would benefit large numbers of people, but only a select, highly educated portion of the population would participate in the discovery process. Despite this limitation, science offered the advantage of endless discoveries whereas physical exploration had been exhausted more than fifty years earlier.

Space exploration has been imagined as combining the frontier as the physical movement into new territories with the acquisition of new knowledge. Further, the concept has been an integral part of the rhetoric surrounding the space program in the United States. Presidents repeatedly have relied on images of pioneers and America's frontier when rallying support for space exploration. The analogy manifested itself in imaginative visions of space travel, most memorably in the opening lines of every *Star Trek* episode, and also in more educational forums such as Carl Sagan's popular PBS series *Cosmos*.[73] Associations with America's history of exploration and settlement have also been actively pursued by NASA. In 1962 the agency sponsored a study of the nineteenth-century railroads as a historical analogy for space exploration.[74] Further, spacecraft carry names like Pioneer, Discovery, Pathfinder, and Voyager that evoke the history of exploration.[75]

Of all these examples the most hyperbolic rhetoric may be the 1986 report of the National Commission on Space, formally entitled *Pioneering the Space Frontier*

but more frequently referred to as the Paine Report.[76] In a lavishly illustrated book dedicated to the crew of the space shuttle *Challenger* the commission put forth a plan for space exploration for the next fifty years. Although dampened by the disaster, the history of space program to that point could be seen as a steady series of steps forward: the Apollo missions sent humans to the Moon; the Viking and Voyager missions had conducted reconnaissance of Mars, Jupiter, and Saturn; the space shuttles were regularly sending astronauts into orbit. The logical and clear next step was manned missions to other planets, and the Paine Report made an argument for the exploration and settlement of the solar system.

Repeatedly the text referenced "America's pioneer heritage" and compared the past settlement of the western frontier to the proposed settlement of space. Not surprisingly, it positioned the space frontier as a place that promised material returns, stating that "the immediate benefits from advances in science and technology and from new economic enterprises in space are sufficient in our view to justify the civilian space agenda we propose." The authors also argued for great immaterial benefits: "We believe that the longer-term benefits from the settling of new worlds and the economic development of the inner Solar System will prove even more rewarding to humanity." Further, they freely praised older examples of conquest as a means to justify these future plans:

> What was the true value of developing and settling North and South America, Australia, and New Zealand? Today more people speak English, Spanish, and Portuguese in the New World than in Europe, and they have built economies surpassing those of Europe. But the contributions to humanity from Columbus' "New World" are surely far beyond its material returns, impressive as they are. We believe that in removing terrestrial limits to human aspirations, the execution of our proposed space agenda for 21st-century America will prove of incalculable value to planet Earth and to the future of our species.[77]

In the light of revisionist approaches to the frontier that were common in the same period, the naïveté of the Paine Report is surprising. The words gloss over the

effect of conquest on native peoples, the impact of development on the environ-ment, and other negative aspects of the frontier. Scholars have sharply criticized NASA's unthinking adoption of the frontier as a symbol, arguing that the frontier is a deeply flawed analogy and one that should be avoided or at least used only with an eye toward learning from the mistakes it exemplifies.[78]

If we set aside the appearance of the Hubble images for a moment, the telescope has not been directly associated with such extreme frontier rhetoric. None of the as-tronomers who have produced Hubble images contributed to the Paine Report. When it was written, the observatory waited in storage for launch. While the text mentioned the Hubble Space Telescope in passing, little was written about expectations for it, and only two pages were dedicated to future space observatories that build on its technol-ogy. The report concentrated on the opportunities within the solar system rather than what lay beyond. In fact, the section on space science with its interest in nebulae, galaxies, and stars too distant for humans or mechanical emissaries to reach—at least in the foreseeable future—remained largely free of the grand claims that colored the rest of the report. The authors of the Paine Report envisioned human space travel and planetary sciences as motivated by expanding human settlement and identifying ex-ploitable natural resources. Although the metaphorical aspects of Bush's concept of the frontier still applied to the study of the cosmos enabled by the Hubble, it is difficult to identify the immediate pragmatic benefits to humanity gained from researching the formation of stars in nebulae far beyond the reach of humans.

Those involved with making and circulating Hubble images were, however, well aware of the successful efforts of the earlier planetary missions, which encour-age connections between frontier rhetoric and space exploration. Although in less overt manner than the language of the Paine Report, older images of Jupiter and Saturn from the Viking and Voyager missions proposed a new frontier that could be crossed, at least by our technological surrogates. Ray Villard, STScI news chief, pointed to the Jet Propulsion Lab, the research center that oversaw many of the planetary missions in the 1980s, as a model for distributing images and promot-ing the Space Telescope Science Institute.[79] Both founders of the Heritage Project, Howard Bond and Keith Noll, identified the images from these same explorations as precursors of Hubble Heritage Project images.[80] The astronomers viewed the

planetary images as successful because they excited the public's enthusiasm and interest in the idea of exploring another world.

Succeeding with the Hubble images then required presenting the universe not as distant and unreachable but as something parallel to our own world, a place we could know. The resemblance between the Hubble images and the western landscapes makes clear that the analogy to the frontier became the means to do so. But there is a significant difference between the type of exploration proposed by the Paine Report and that conducted by the Hubble Space Telescope. Rather than a physical conquest with all the attendant ethical and logistical problems that accompany such a pursuit, the Hubble images adopt the frontier for its phenomenological power. The images become an invitation to continue our scientific exploration and study of the cosmos; conquest occurs at the level of understanding, not through physical settlement. Hubble images reimagined astronomical phenomena as if they were akin to the frontier on earth, but without ever promising that we would travel to these distant realms.

Doing so requires another shift in our understanding of the frontier, this time a directional one. In an essay on landscape gardening, the art historian Stephen Bann considers what he calls the "semantic recoil" of three different ages of discovery: Columbus's travels to the Americas, Captain Cook's circumnavigation of the globe, and space exploration. His argument looks at the ways that changing ideas about exploration informed manmade landscapes and what this suggests about the relationship between humans and nature. His analysis of the interplay between space exploration and twentieth-century gardens focuses on the work, both the gardens and writings, of the French landscape architect Bernard Lassus. Bann emphasizes Lassus's interest in a change in direction, a move from the horizontal to the vertical. Having circumnavigated the globe, humans shifted the direction of their gaze, and as Bann writes, "the immeasurable in the horizontal dimension is succeeded by the approach to the immeasurable verticals: the conquest of space, of the depths of the sea, and the earth."[81] Bann's argument replays aspects of Turner's frontier hypothesis by proposing that there is something profoundly human (not just American) about the desire for exploration, especially the freedom afforded by an infinite prospect. A turn to the vertical "restores the sense of limit and unlimitedness which has been

lost in the horizontal domain."[82] In other words, it reestablishes a frontier, a realm that lies beyond our knowledge.

The Hubble Space Telescope embodies this shift, both in its position orbiting above the earth and its observations of far-distant celestial realms. Two well-known images not yet considered—the Deep Field and the Ultra Deep Field—illustrate the Hubble's potential to change the axis of exploration (Figures 54 and 55). Each observation was made over a series of days and the cumulative time enabled astronomers to study "galaxies to the faintest possible limits with the greatest possible clarity from here out to the very horizon of the universe."[83] For many astronomers, these images are among the more fascinating ones returned by the telescope, stretching the instrument to its observational limits. Conceptually, they are images of the frontier: the limits and boundaries of human vision, the limits of the universe, the limits of time. Despite the great depths represented, it is impossible to see these limits in the images; we can know them, but they are not made visible to us. Galaxies speckle the blackness and one gains a sense of the vast number of objects that populate the cosmos, but their distance from us and relative to each other remains visually indeterminate. Additional data, namely the red shift value for each galaxy, are needed to calculate it. Although they represent the vertical frontier, the images resist our efforts to see them as such.

The cultural critic Michel de Certeau argues that "there is no spatiality that is not organized by the determination of frontiers."[84] By reframing other Hubble images to look like landscapes, astronomers reestablished not only a conceptual frontier but a visual one as well. The purposefulness with which the images reassert a horizontal frontier is perhaps most vividly demonstrated by the Heritage Project's tenth anniversary image, a section of the Carina Nebula that the press release described as a celestial landscape (Figure 56).[85] A jagged horizon stretches across the picture, silhouetted against a cloud-streaked azure sky complete with twinkling stars. A luminous line separates the sky from the form below, making it seem as if some unseen light source lies just beyond view. The region immediately below the brilliant glow appears in reddish shadow, while areas farther down brighten to light green. On the left side of the picture, the patches of green slope gently downward; on the right side, they plunge more steeply. Together the modulations in color and

tone give the form a sense of three-dimensionality and mass. The image does suggest a landscape—notably that of a mountain range profiled against a deep blue sky with its peaks backlit by the final light of the setting sun, the shadows and colors revealing cliffs and valleys—and it is only the presence of the stars scattered over the "mountains," especially the beacon that shines from the summit at the center, that disrupts such an interpretation.

The Heritage Project's Web site also features an animation that simulates movement into the region depicted in the image.[86] The series of four images, taken through different telescopes, also traces the transformation from vertical to horizontal. The journey begins with a view of the sky above the earth, dotted with stars. As with the Hubble Deep Field, there is no means to discern the distance to the objects, although some are larger and brighter than others. The Carina Nebula is among them, appearing as a glowing red region on the right side of the image (Figure 57). As the image transitions into another, the viewer travels into space and a magnified view of the nebula comes into focus (Figure 58). Although horizontally oriented on the computer screen, the movement is reminiscent of the classic planetarium show: a vertical trip into the heavens showing its denizens at greater and greater magnification. As the animation zooms into a smaller cloudy region, the orientation of the nebula rotates subtly. In the penultimate image—a shot from a ground-based telescope—a sweeping ring of clouds fills the frame (Figure 59). It remains an image that implies that the viewer peers up at the sky. However, when the frame tightens around the small section of clouds that comprises the Heritage Project view, the image gains a horizon. What had been a view upward into the sky becomes one with a visible frontier.

Figure 54. The Hubble Deep Field combined 342 exposures taken over ten consecutive days to deliver the deepest look into space available at the time of its release. January 15, 1996; WFPC2. Courtesy of NASA, R. Williams, and The Hubble Deep Field Team (STScI).

Figure 55. Improvements in the cameras aboard the Hubble Space Telescope led to a deeper look into the cosmos: the Hubble Ultra Deep Field. March 9, 2004; ACS. Courtesy of NASA, ESA, S. Beckwith (STScI), and The Hubble Deep Field Team Team.

54

55

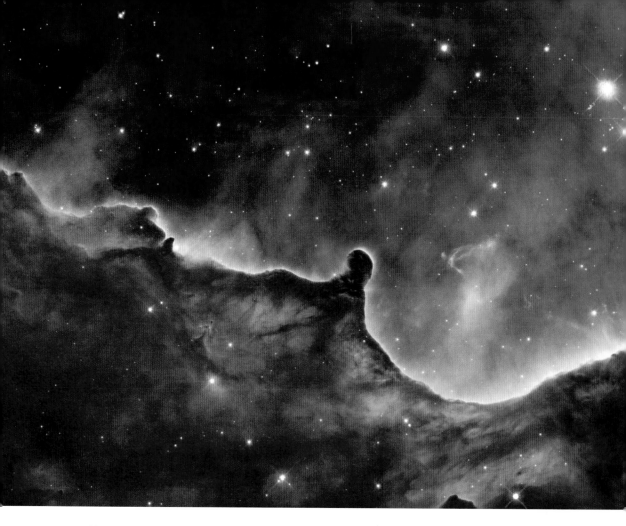

Figure 56. Members of the Hubble Heritage Project crafted NGC 3324, a view of a star-forming region in the Carina Nebula, to celebrate the tenth anniversary of the project. October 2, 2008; ACS/WFPC2. Courtesy of NASA, ESA, and The Hubble Heritage Team (STScI/AURA).

In effect, through the use of images the unfamiliar and unimaginably vast is translated into something known, or at least something we could come to know and appreciate. Instead of the undefined space of the Deep Field images, the views of nebulae and galaxies offer a means for humans to position themselves in relationship to the cosmos. The philosopher and geographer Yi-Fu Tuan in his phenomenological account of the relationship between space and place proposes that "what begins as undifferentiated space becomes place as we get to know it better and endow it with value."[87] Tuan writes of the spatial experience of the physical world, describing

the gradual process of exploration by which the alien and strange become familiar. His description of moving somewhere new illustrates the process. "A neighborhood is at first a confusion of images to the new resident; it is a blurred space out there. Learning to know the neighborhood requires the identification of significant localities, such as street corners and architectural landmarks, within the neighborhood space," Tuan writes. "Objects and places are centers of value. They attract and repel in finely shaped degrees. To attend to them even momentarily is to acknowledge their reality and value."[88] For the Hubble images, the cosmic neighborhood gains familiarity through its resemblance to the earthly landscape. Instead of a confused space, it becomes a place into which we can mentally travel.

Figure 57. A ground-based view of the Carina Nebula that was the starting point for zooming into the details of NGC 3324. Copyright Akira Fujii/David Malin Images.

Figure 58. A second image takes the viewer closer to the section seen in the Heritage Project's picture. Courtesy of NASA, ESA, Digitized Sky Survey, and Z. Levay (STScI).

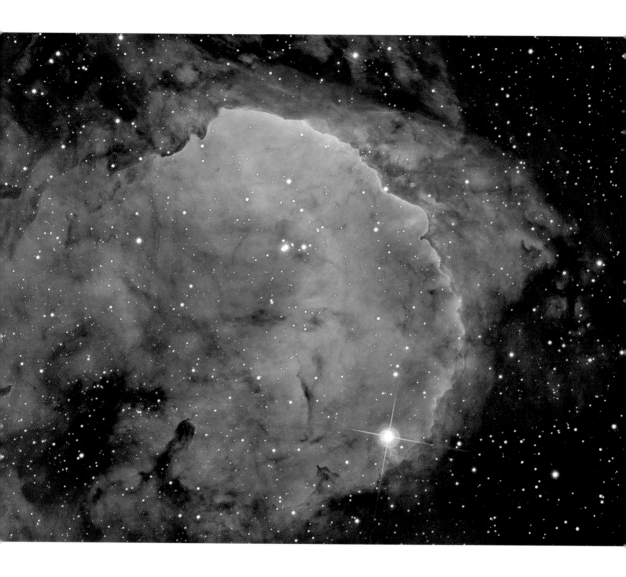

Figure 59. A third image moves the viewer still closer to the nebula. The orientation shifts to form a horizon line with the Heritage Project's view. Courtesy of Brad Moore.

For those who work most closely with the Hubble images, this sense of humanity's position relative to the cosmos can encourage a range of insights. Zolt Levay spoke of a desire to engender a new regard for the terrestrial world, as well as for the distant nebulae, galaxies, and star fields. He admired Ansel Adams's photographs not only for their appearance but also because they had acted as advocates for preservation: "People like Ansel Adams, for example, had a mission to instill in people an appreciation for the landscape so that they would preserve it." Although the notion of ecological land usage was not a consistent agenda for the artists or the surveys, the nineteenth-century landscapes contributed to the formation of national parks, and they too have become deeply intertwined with the conservation movement. Levay hoped that the Hubble images would inspire viewers "in the same way [as do Adams's photographs]—not that we are polluting other galaxies—but at least to have an appreciation that this is a larger place than just the world we inhabit, and to be able then to maybe just preserve the night sky, for example, and know that there is stuff to see and experience out there." His comments alluded to the experience of the sublime, as he continued by stating: "It would be wonderful to expand people's world view to include more than their day-to-day existence, to appreciate that we are a very small part of a much larger universe."[89] The frontier, the knowledge of limits and border, not only creates distinction but also enables one to recognize continuity as it blurs the lines between the terrestrial and the celestial. The Hubble images then become mirrors for looking back at the world. By seeing the earthly landscape within them, we might grasp the cosmos as a coherent whole.

The astronomer Jeff Hester spoke of a desire to have images like the Eagle Nebula inspire a greater understanding of scientific exploration, especially for those outside the scientific community. "I want them to realize, when they look at images like that [the Eagle Nebula] that what they are looking at is humans acting on this urge within us," he said. "[Humans] going out there and proactively building the technology and the tools that allow us to reach out with our minds and our aesthetic and our imaginations and our sense of wonder and our sense of curiosity and all of those things, and reach out there and grab hold of the universe and make it ours." Hester's comments reiterate the importance of the sublime too, the sense that we

must reach with all that we are—mind, imagination, and what he calls aesthetics—if we hope to comprehend that which at first seems to be beyond our grasp.

Hester continued to describe what he hoped the images will convey, emphasizing that he understands the pursuit of knowledge as fundamental to what it means to be human: "I want people to look at those images and to at least get some inkling in their gut of that process." Through studying representations of the cosmos, we may come to recognize "that these things are not just nicely aesthetic, but that these things are testaments to what we as people are able to do." That testament comes in the form of images that appeal first to the senses. Again, as Hester stated, humans are able "to take images of columns of clouds of gas and dust several thousand light-years away in which stars are forming, and to bring them home and to make that part of the universe known to us, to extend the sphere of the human mind and imagination out to encompass those things. I want people to feel that when they look at these images."[90] The effort to gain such an understanding involves a movement in two directions. Science and technology bring the heavens to us in a form that elicits a response from imagination and reason, which in turn allows the human mind to extend its reach to distant corners of the universe. The Hubble images function as bridges that enable us to cross a frontier. To take de Certeau's assertion a step further, it seems that not only spatiality requires a frontier but so too does the acquisition of new knowledge. What had been beyond the frontier of our understanding becomes a place that humans can know, contained within the frame of an image, documented in multiple forms, and analyzed by human tools.

The Epistemological Sublime

The reference to the frontier introduces another oscillation. As I stated in the first chapter, the Hubble images resemble both clouds and landscapes. Within the culture of science, they function as a means to communicate scientific findings and as scientific data. Through their status as digital images, they combine quantitative measurement with pictorial representation. Their appearance often makes that hybridity visible by simultaneously mapping physical attributes and proposing that the images offer a mimetic view of the nebulae, galaxies, and star fields. By referencing the vast spaces of the American West, they present a cosmos of overwhelming

size and scale. That same aesthetic choice also aligns them with the transformative potential of the frontier, and they visually promise that we can come to know such distant realms. To understand the Hubble images fully requires us to allow all of these interpretations to resonate together, even as they may contradict each other.

The complexity of the Hubble becomes apparent only when we take images seriously, even—and maybe especially—when some voices suggest that they are not important enough to merit such attention. By looking closely at their appearance, examining the attitudes and events that led to their production, unpacking the process used to craft them, and situating them within a larger visual history, it becomes possible to appreciate the multifaceted views of the universe they offer.

Through their appropriation of the aesthetics of the sublime, the Hubble images invite us to see the cosmos as vast, wondrous, and awe inspiring, while also proposing that it is not as distant and alien as one might assume. The human mind can come to know and understand the universe. But unlike a purely quantitative representation, the images give us a means to position ourselves in relationship to it. They confront us with a metaphorical and phenomenological frontier, a threshold that we are encouraged to cross, not bodily but mentally through the extension of our sensory imagination, and when this falters, our rational minds.

As such, the sublime functions as more than an aesthetic system for the Hubble images; it proposes an epistemology. By insisting that the viewer employ both reason and the senses, the Hubble images force those who contemplate them to think beyond the categories or hierarchies that can limit efforts to gain knowledge and insight. They blur the boundaries between different modes of seeing and comprehending, and this can be misleading unless one recognizes what the Hubble images demand of us. They push the viewer to understand the universe not in a limited manner that relies on a single approach to the acquisition of knowledge but one that engages all human capacities. In doing so, they encourage the viewer to transcend the narrow definitions of art or science. In the end, the Hubble images propose that it is only in doing so that we can begin to know the most encompassing and interconnected of all forms, the cosmos.

A VERY DISTANT
AND PEACEFUL STAR

As way of closing, I would like to consider a short story by the writer and chemist Primo Levi. "A Tranquil Star" is, as its author suggests, "a fable that awakens echoes, and in which each of us can perceive distant reflections of himself and of the human race."[1] In a few concise pages, Levi tells the tale of a very distant and peaceful star around which several planets orbit. For whatever unknown reason, the star is not a typical one. In what he terms the "convulsive death-resurrection of stars," it becomes a nova, exploding in a matter of hours and consuming the planets that surround it. Levi recounts the destructions without embellishment, yet the facts—boiling oceans, crumbling mountains, vaporized worlds—have traditionally been associated with the sublime. Among those destroyed, he speculates, may have been "all the poets and wise men who had perhaps examined the sky, and had wondered what was the value of so many little lights, and had found no answer" (160). For Levi, the answer seems to be, at least in part, a recognition of the insignificance of any one of those poets or wise men.

Levi also uses the story as an opportunity for an extended reflection on the inadequacy of language. Try as we might, words cannot quite capture that which exceeds the human scale. A phrase like "very big" cannot do justice to a star several times the size of the sun, which itself is several times the size of the earth. Even our own planet overwhelms our sense of scale and "we can," Levi writes, "represent it only with a violent effort of the imagination" (157). He acknowledges that mathematics may do better, but language remains necessary. Because without it, he writes, the story he tells

would not be the same; it would not be a fable about what it is to be human. The very limits of language make it possible for this story to echo and reflect.

The Hubble images are similarly inadequate to what they represent. As vivid and detailed as they are, they translate inhumanly large clouds of gas and dust at unimaginable distances and make them visible to our relatively weak eyes and the proscribed terms of their vision. They use landscape as a means by which to communicate that size and scale, that insignificance, that fragility. The Hubble images also remind us of humanity's recurring attempts to grapple with concepts—whether on earth or in the heavens—that human senses can grasp only through intense effort.

Insignificance and inadequacy may seem to present a bleak picture, one that speaks to our fragility and powerlessness in the face of sudden and unexpected devastation.[2] And understood in those terms, Levi's story can seem very different from the exuberant and celebratory aspects of the Hubble images. However, the story has another side, and it is not an accident that Levi labels the star's massive explosion as its death-resurrection. As much as "A Tranquil Star" is a history of a distant and destroyed solar system, it is also an account of observing that star. First, a diligent Arab from an unspecified time in the past studies the sky with his naked eye and tracks the star's strange fluctuations, its cycles of brightening and dimming. Levi praises his open-eyed examination of the sky and cautions against following the example of Europeans from the same age who were so convinced of the immutability of the heavens that they were blind to the star's changes.

The Hubble images hold the same dangerous potential to limit our ability to see. In some ways the landscape reference is a crutch: a return to the familiar to make sense of that which is not. We can question whether this confines our imagination and that of astronomers, even closes our eyes to certain ways of seeing the cosmos. However, analogies also serve a valuable function, aiding us in our effort to gain new knowledge, new understanding. And perhaps the unsettled nature of the Hubble images, their potential to engage both reason and the senses, to vibrate between art and science, and to picture simultaneously the infinite and the contained, guards against the tendency to read them in only one way. In their complexity they may urge us forward rather than letting us fall back on what we can know and identify with certainty.

For Levi, it may be that writing a story or observing a star or representing one in an image is its own reward. His tale closes in the 1950s when, to use Levi's

terms, news of the distant star's destruction reaches earth. A Peruvian astronomer stationed at a mountain observatory equipped with a high-power telescope and a photographic camera observes, almost by accident, the traces of the distant death-resurrection. The astronomer is a very human character with two charming children, a complicated relationship with his wife, and a love of collecting shells. In the midst of planning a family outing, he looks for a second time at a photographic plate on which he had recorded the previous night's observations, and he sees there a spot that wasn't evident in a photo from only a week before:

> When something like this shows up, ninety-nine out of a hundred it's a speck of dust (one can't be too clean in the workplace) or a microscopic defect in the emulsion; but there is also the minuscule probability that it's a nova, and one has to make a report, subject to confirmation. Farewell, outing: he would have to retake the photograph on the following two nights. What would he tell Judith and the children? (162)

One being's catastrophe is another's inconvenience. And so Levi ends the story.

But the reader can only assume that the astronomer will be dutiful and make the additional observations. The star's death-resurrection will replay on the photographic plates. Even such inadequate representations are worth the effort. That small speck of dust becomes a record, however small, of an event of great magnitude. The Arab's careful observations of the star's fluctuations are another. In them reside the echoes, the reflections of the "delicate and subtle works that the combined labor of chance and necessity, through innumerable trials and errors, had perhaps created there" on the distant tranquil planet (160).

It is through trials and errors that the Hubble images have come into being as a labor of both chance and necessity. They need not look as they do, but they must be legible to our senses and imagination. We can find in them the echoes of the cosmos and reflections of humanity. By evoking the Romantic sublime and the American frontier, they promise a universe of possibilities, a world of exploration, an experience of striving to comprehend. They remind us—as insignificant as we may be—of the potential to go beyond that which may at first seem to limit us.

ACKNOWLEDGMENTS

This book has been many years in the making, and I am grateful to all those who helped me along the way. It began as my dissertation in the History of Culture program at the University of Chicago, where I was encouraged and influenced by a number of professors, especially W. J. T. Mitchell, Robert S. Nelson, and Adrian Johns. They helped to shape its original form, and I benefited greatly from their insightful guidance both as a graduate student and afterward as the project became a book. They modeled the life of a scholar for me, and I continue to strive to reach the standards they set. The idea to study the aesthetics of astronomical images came from a class taught by Barbara Maria Stafford, and I am grateful to her for starting me on this path.

The oral history interviews that form the core of the book were conducted while I was a Guggenheim Predoctoral Fellow at the Smithsonian Institution National Air and Space Museum. The curators of the Space History Division offered an incredibly supportive environment for pursuing research, and they have continued to support the project in the years since. I am especially grateful to David DeVorkin for reading multiple drafts of the manuscript and always providing words of encouragement. He and Robert W. Smith kindly invited me to contribute a chapter to *Hubble: Imaging Space and Time,* giving my research its first large audience.

I could not have written this book without the cooperation of the astronomers and staff at the Space Telescope Science Institute who willingly agreed to interviews, patiently answered my questions, and encouraged my interest in the work

of crafting astronomical images. The members of the Hubble Heritage Project were especially generous, and particular thanks go to Keith Noll, Howard Bond, Jayanne English, Zolt Levay, and Lisa Frattare for digging through old files to find proposals, notes from meetings, and other invaluable resources. I sincerely hope they will find this book a compelling account of their endeavors.

I am indebted to many who read and responded to manuscript drafts and proposals. They pushed me to take my ideas further, and I can only hope that I have managed to deliver. Thanks to John Bender, Scott Bukatman, Martin Collins, Lynn Cunningham, Emine Fetvaci, Hannah Higgins, Susan Jarosi, Robert Kendrick, Roger Launius, Michael Marrinan, Jennifer Marshall, Travis Rector, and Fred Turner. Special thanks go to Paul Stern for enthusiastically reading the entire manuscript and helping me to see some of the key themes that thread through the book. I am extremely grateful to the two anonymous readers who reviewed the final manuscript. Their thoughtful engagement with the text and constructive suggestions for improvements made this a far stronger book. The comments of the editorial board at the University of Minnesota Press aided me during the final revisions.

I am thrilled that the book is so richly illustrated. Thanks go to Zolt Levay and Lisa Frattare for creating high-resolution versions of several Hubble Heritage images that were not otherwise available. C. R. O'Dell, David Malin, Brad Moore, Don Dixon, and Rick Sternbach provided images as well. And special thanks to Tad Bennicoff at the Smithsonian Institution Archives for digging through files to find the originals of the Lockheed and Martin Marietta images. I am also grateful for a research grant from Ursinus College that helped to cover the cost of permissions.

I thank Richard Morrison, executive editor at the University of Minnesota Press, for his enthusiasm for the project, his valuable editorial guidance, and his recognition of the importance of images to the book. Thanks also go to Laura Westlund, Jean Brady, Daniel Ochsner, Anne Wrenn, and many others at the Press.

Finally, I thank my family. My siblings, Bob, Bill, and Carolyn, provided welcome distractions when I most needed them, whether a joke, a vacation, or a phone conversation. My husband, Scott Bukatman, has been a steadfast supporter of my endeavors, a loving companion, and my toughest reader. I am lucky both personally and professionally to have him as my partner in life. Finally, I thank my parents,

Bob and Sue Kessler. They fostered my curiosity and encouraged my ambitions. Although they could not have known how it might find expression, they created an environment that made it possible for this project to germinate. Their proclivity to use proper terminology when discussing their shared interest in medicine gave me the confidence to read scientific articles. Their interest in the arts—from photography to opera—taught me to find meaning in aesthetic experiences. Their unceasing love and dedication to their family encouraged my desire to pursue what I found fulfilling. With love, I dedicate this book to them.

NOTES

Introduction

1. "Hubble Celebrates 15th Anniversary with Spectacular New Images," HubbleSite, http://hubblesite.org/newscenter/archive/releases/2005/2005/12/.

2. Elkins, *Six Stories at the Edge of Representation,* 87. Elkins also discusses the relationship between art and science in *The Domain of Images* and *Visual Practices across the University.*

3. For a compelling study of another case of astronomical images that must balance similar demands, see Vertesi, "Seeing Like a Rover."

4. These older oral histories are part of the Space Telescope History Project at the Smithsonian National Air and Space Museum, and are archived at the museum. For a catalogue, see "Oral History on Space, Science, and Technology," National Air and Space Museum, http://www.nasm.si.edu/research/dsh/ohp-introduction.html. They also form the basis for Smith's detailed history of the Hubble Space Telescope's early years. See Smith, *The Space Telescope.*

5. This is an argument frequently made by the science photographer Felice Frankel. See *Domain of Images,* 46–48, for Elkins's response to it. For Frankel's work, see *On the Surface of Things* and *Envisioning Science.*

6. On the constitutive place of both art and science in culture, see Jones and Galison, *Picturing Science, Producing Art.*

7. Clark, *God—or Gorilla,* 133.

8. For an overview of the literature on the interdisciplinary conversation, see Henderson, "Editor's Introduction: I. Writing Modern Art and Science—An Overview; II. Cubism, Futurism, and Ether Physics in the Early Twentieth Century."

9. See Mitchell, "Showing Seeing."

10. On this question, see Jay, *Downcast Eyes;* Stafford, *Good Looking;* and Latour and Weibel, eds., *Iconoclash.*

11. I discuss the optical problems that surfaced soon after the Hubble's launch as well as the story of the Pillars of Creation in the second chapter.

12. More than a century before Lord Rosse made his observations, Immanuel Kant proposed an "island theory" of the universe. Kant was a philosopher though, not an observer, and astronomers gave little credence to his theory. Until Rosse's Leviathan, observations by astronomers provided no support for what is now the accepted view of the universe: a vast number of galaxies scattered throughout the cosmos.

13. One backup might seem like more than enough, but NASA had recurring problems with the Hubble's gyroscopes. Astronauts had replaced them on previous missions, and gyroscope failures had already put the telescope into "safe mode," a state that uses two gyroscopes to keep the telescope in orbit but does not allow for observing, several times throughout its history, including in the months after the final mission's cancelation. Faced with the possible loss of gyroscopes and no repair mission, in 2005 engineers developed new ways to operate the telescope that only relied on two gyroscopes. For two years they used this method as a safe, but inefficient, way of guiding the telescope.

14. The circulation of the Eagle Nebula and the Whirlpool Galaxy images speak to tensions within NASA regarding the decision to cancel the space shuttle mission. Many within the organization disagreed with the choice. It also illustrates the nature of the relationship between STScI and NASA. The functioning of STScI is that of a contractor, one of many that NASA uses, but its primary business is the Hubble Space Telescope and the James Webb Telescope, scheduled for launch in 2018. When the Hubble was threatened, STScI could not act independently to service it, but it could be at least a little rebellious.

15. Several scientists have taken up the opportunity, and the Hubble Space Telescope Data Archive maintains a list of papers based on it. See "HST/ACS Mosaic of M51: HST Proposal 10452," Multimission Archive at STScI (MAST), http://archive.stsci.edu/proposal_search.php?mission=hst&id=10452.

Chapter One: The Astronomical Sublime and the American West

1. See Edgerton, "Galileo, Florentine 'Disegno,' and the 'Strange Spottedness of the Moon,'" 225–32.

2. Ihde, *Technology and the Lifeworld,* 56.

3. In addition to the cameras, the telescope also houses the Space Telescope Imaging Spectrograph, the Cosmic Origins Spectrograph, and Fine Guidance Sensors. The first two instruments collect data about very specific wavelengths of light that are not translated into pictures and the last instrument does not collect data for analysis, but is used to align the telescope with a target and continue tracking it while gathering data. The array of instruments has changed over the history of the Hubble Space Telescope, with each servicing mission involving the repair or replacement of different components of the observatory. In the initial mission, to address a focusing problem, astronauts swapped the WFPC and WFPC2 and installed the Corrective

Optics Space Telescope and Axial Replacement (COSTAR). They introduced the Advanced Camera for Surveys during a maintenance mission in 2002, and WFC3 was added in 2009. Past instruments include the Faint Object Camera, the Faint Object Spectrograph, the Goddard High Resolution Spectrograph, and the High Speed Photometer. For technical information on instruments currently in use as well as those that have been retired, see "HST Instruments," Space Telescope Science Institute, http://www.stsci.edu/hst/HST_overview/instruments. For more general information, see "The Science Instruments," HubbleSite, Space Telescope Science Institute, http://hubblesite.org/sci.d.tech/nuts_.and._bolts/instruments.

4. I am using the term "galaxy"; however, Lord Rosse would have called M51 a nebula. Even though scientists recognized it as a galaxy at the time of the Palomar observation, it was still frequently labeled as a nebula.

5. See Hoskin, "The First Drawing of a Spiral Nebula"; and Schaffer, "The Leviathan of Parsonstown" and "On Astronomical Drawing."

6. Ihde, *Technology and the Lifeworld*, 50.

7. See Miller, "First Color Portraits of the Heavens," 679. For a more technical account of the process, see Miller, "Color Photography in Astronomy." See also Malin, "Colour Photography in Astronomy"; and Malin and Murdin, *Colours of the Stars*.

8. The literature on nineteenth-century American landscape painting and photography is extensive. For an introduction, see Novak, *Nature and Culture;* Miller, *Empire of the Eye;* Wilton and Barringer, *American Sublime;* and Naef, *Era of Exploration*. Moran's life and career are well documented in Anderson, *Thomas Moran*. For similar coverage on Bierstadt, see Anderson and Ferber, *Albert Bierstadt*. On Jackson, see Hales, *William Henry Jackson and the Transformation of the American Landscape*. For discussion of O'Sullivan, see Kelsey, *Archive Style*.

9. Joni Louise Kinsey has identified several motifs that Moran uses repeatedly in his paintings, including the arch, the tower, rocks, and trees. Although she acknowledges that the artist originally based these forms on observations of the landscape, she demonstrates that Moran uses them as types to be inserted into his large-scale canvases. See Kinsey, *Thomas Moran and the Surveying of the American West*, 23–40.

10. For a detailed history of Moran's work on *The Yellowstone National Park* portfolio, see Kinsey, *Thomas Moran's West*.

11. I have used examples taken by two of the best-known photographers of the American West, but any number of photographers documented similar features. Others include Carleton Watkins, Jay Hillers, William Bell, Charles Savage, and A. J. Russell.

12. For a close reading of Jackson's photograph as well as its place in the photographer's career, see Hales, *William Henry Jackson and the Transformation of the American Landscape*.

13. See Arnheim, *Art and Visual Perception*.

14. For the Eagle and Trifid Nebulae, north is located diagonally to the left. For the Keyhole Nebula, north is straight down.

15. "A Celestial Landscape in Celebration of 10 Years of Stunning Hubble Heritage Images," Hubble Heritage Project, http://heritage.stsci.edu/2008/34/caption.html. "Hubble's New Camera Delivers Breathtaking Views of the Universe," Hubble Space Telescope News, Space Telescope Science Institute, http://hubblesite.org/newscenter/archive/releases/2002/2002/11/.

16. "M16—Star Birth in the Nest of the Eagle Nebula," HubbleSite, http://hubblesite.org/newscenter/newsdesk/archive/releases/1995/44/astrofile/. In their oral histories, both the astronomer who made the observations, Jeff Hester, along with the head of STScI's press office, Ray Villard, claim credit for the comparison. Determining who described it this way first seems less relevant than noting it seems so appropriate that more than one person is willing to take credit.

17. "NGC 3132: Imaging Through Filters," *Hubble Heritage Project*, June 3, 2009, http://heritage.stsci.edu/1998/39/supplemental.html.

18. The observations of the Orion Nebula were unique. The astronomer who commissioned them, C. Robert O'Dell, had led the Hubble development team from 1972 to 1982, which gave him a large bank of guaranteed observing time on the telescope. He chose to use some of it in dramatic fashion to produce this detailed study of one of the most familiar regions of the sky. For more details on how the image was produced, see O'Dell and Wong, "Hubble Space Telescope Mapping of the Orion Nebula. I. A Survey of Stars and Compact Objects."

19. "Panoramic Hubble Picture Surveys Star Birth, Proto-Planetary Systems in the Great Orion Nebula," HubbleSite, http://hubblesite.org/newscenter/newsdesk/archive/releases/1995/45/image/a.

20. See Wallach, "Making a Picture of a View from Mount Holyoke"; and Boime, *The Magisterial Gaze.*

21. Majorie Hope Nicolson analyzes how developments in astronomical thought contributed to shifts in how such landscapes were perceived and appreciated; see her *Mountain Gloom and Mountain Glory.*

22. Monk, *The Sublime,* 4. Monk's study remains an important history of the concept of the sublime. See also James T. Boulton's introduction to Burke's *A Philosophical Enquiry into the Origin of Our Ideas of the Sublime and Beautiful.*

23. Burke, *A Philosophical Enquiry into the Origin of Our Ideas of the Sublime and the Beautiful,* 57.

24. Kant, *Critique of Judgment,* 98.

25. Ibid., 120.

26. Burke, *A Philosophical Enquiry into the Origin of Our Ideas of the Sublime and the Beautiful,* 112.

27. Kant, "Universal Natural History and Theory of the Heavens," 65.

28. Emphasis in the original. Kant, *Critique of Judgment,* 98.

29. Ibid., 113.

30. Ibid., 115. On the importance of the oscillation between the senses and reason, see Crowther, *The Kantian Sublime.*

31. Kant, *Critique of Judgment,* 113.

32. Noll, Oral History Interview, 27.

33. Novak, *Nature and Culture,* 97.

34. Noll, Oral History Interview, 27.

35. Bond, Oral History Interview, 5.

36. Howard E. Bond, Space Telescope Science Institute, http://www-int.stsci.edu/~bond/.

37. See Rosenblum, *Modern Painting and the Northern Romantic Tradition;* and Cheetham, *Kant, Art, and Art History.*

38. For a general discussion of the relationship between representations and tourism, see MacCannell, *The Tourist;* and Urry, *The Tourist Gaze.*

39. Levay, Oral History Interview, 6.

40. See Buscombe, "Inventing Monument Valley." See also Cowie, *John Ford and the American West.*

41. Miller, "The Archaeology of Space Art," 141.

42. McCurdy, *Space and the American Imagination,* 45 (emphasis is mine).

43. Bukatman, "The Artificial Infinite," 93.

44. For a discussion of several examples of films that use Monument Valley, Death Valley, and other western landscapes, see Sobchack, *Screening Space.*

45. Ibid., 87.

46. The image was one of a set of four released to announce the successful installation of ACS. See chapter 2 for discussion of the other images in that set and their significance in the Hubble Space Telescope's history.

47. Levay, Oral History Interview, 25.

48. Ibid.

49. Ibid., 21.

50. Beckwith, Oral History Interview, 16.

51. Noll, Oral History Interview, 19.

52. The invitation even hinted that in future generations, researchers might read the messages. Everything moves faster in the contemporary world.

53. All quotes are taken from "Messages to Hubble," where it is possible to read past submissions and add your own. See "Messages to Hubble," HubbleSite, http://hubblesite.org/hubble_20/message/.

54. Novak, *Nature and Culture,* 7–8.

55. Ibid., 9.

56. Kant, *Critique of Judgment,* 105.

57. Damisch, *A Theory of /Cloud/,* 187.

58. On the history of Howard's work and its influence, see Hamblyn, *The Invention of Clouds.*

59. Novak, in her classic work on American landscape painting, *Nature and Culture* (47–100), dedicates a chapter to geology and a second to meteorology, introducing the scientific advances in each field and the artistic responses to them.

60. Damisch, *A Theory of /Cloud/*.

61. "The Lord preceded them, in the daytime by means of a column of cloud to show them the way, and at night by means of a column of fire to give them light. Thus they could travel both day and night. Neither the column of cloud by day nor the column of fire by night ever left its place in front of the people" (Exodus 13:21–22).

62. Damisch, *A Theory of /Cloud/*, 61.

Chapter Two: Ambivalent Astronomers and the Embrace of Hubble Images

1. Emphasis in the original. Talbot, "The Pencil of Nature," 87.

2. Galison first explored these two modes of representation through the material culture of particle physics and an analysis of the instruments employed in this context. While some instruments were image-making devices, others were logic devices, which counted phenomena. See Galison, *Image and Logic*. Galison identified the same tension in other physical sciences in a later essay titled "Images Scatter into Data, Data Gather into Images."

3. Galison, "Images Scatter into Data," 301.

4. Ibid., 300.

5. See Schaaf, *Out of the Shadows*.

6. See Lynch and Edgerton, "Aesthetics and Digital Image Processing."

7. The phrase is not unique to astronomy but used in other scientific disciplines as well. Also, the idea of producing one set of images for scientific analysis and another for public display has a long history that crosses disciplinary boundaries. For one example, see Jennifer Tucker on Victorian images of bacteria in *Nature Exposed*, 159–93.

8. For a longer reflection on prettiness in the Hubble images, see Kessler, "Pretty Sublime," 57–74.

9. Kant, *Critique of Judgment*, 126. One might also align prettiness with kitsch, which the art critic Clement Greenberg also described as an easily consumed sensory pleasure with no effect on culture. Greenberg, however, opposes kitsch with the avant-garde. While I have already demonstrated the value of the sublime for understanding the Hubble images, with their reliance on established visual tropes they could not be considered avant-garde.

10. Kant, *Critique of Judgment*, 173.

11. Elkins, *Six Stories from the End of Representation*, 89. See also his introduction to *Visual Practices across the University*, 9–57.

12. See Nye, *American Technological Sublime*.

13. See O'Dell, "The Large Space Telescope Program." O'Dell's article was not the very first to appear on the subject, but it was the first written by a NASA official for an audience outside the scientific community. The artist's rendition from *Sky and Telescope* shares many features with the sketch that came out of a study group at Goddard Space Flight Center and was published a few months earlier in Underhill, "The Large Space Telescope Instrumentation."

14. The headquarters for NASA are in Washington, D.C., but the agency also staffs field centers

throughout the United States. The headquarters focuses on administrative matters and relies on the field centers to oversee development and operation of projects. The field centers often contract with industry for engineering and construction tasks. As a result, large projects like the Hubble Space Telescope link a network of government and industry that can include participants in several states (or, in a political context, congressional districts).

15. For a detailed account of the Hubble's development, see Smith, *The Space Telescope*. This period is also described, although less exhaustively, in Zimmerman, *The Universe in a Mirror*.

16. Spitzer aspired to broad and ambitious goals: "The chief contribution of such a radically new and more powerful instrument would be, not to supplement our present ideas of the universe we live in, but rather to uncover new phenomena not yet imagined, and perhaps to modify profoundly our basic concepts of space and time." The text was reprinted after its significance was clear. See Spitzer, "Astronomical Advantages of an Extra-Terrestrial Observatory," 139.

17. Not coincidentally, Spitzer chaired the committee, which included both astronomers and NASA administrators. See *Scientific Uses of the Large Space Telescope, Report of the Space Science Board ad hoc Committee on the Large Space Telescope*.

18. Smith, *The Space Telescope*, 85.

19. O'Dell, "The Large Space Telescope Program," 370.

20. The period from 1972 through 1977 involved numerous developments and changes. In 1974, Congress refused to approve the telescope's budget because of the great expense. The size of the mirror was reduced to lessen the cost, and NASA formed a partnership with the European Space Agency with the intention of offsetting some of the cost. Both of these decisions had a significant impact on the telescope that was built. It is also noteworthy that during this period astronomers actively lobbied Congress for their support of the project, an effort that was led by Lyman Spitzer and an astronomer from Princeton, John Bahcall. For further details, see Smith, *The Space Telescope*.

21. As is the custom, the Hubble Space Telescope did not receive its full name until after first light (or the first use of the telescope). During most of its development it was called simply the Space Telescope. For the sake of consistency, I have referred to it as the Hubble Space Telescope throughout the text.

22. Lockheed Missiles and Space Company, "Large Space Telescope Support Systems Module: Phase B Definition Study" (July 28, 1975); Martin Marietta Corporation, "Final Study Report: Space Telescope/Support Systems Module" (March 15, 1976), National Air and Space Museum Archive. Lockheed was awarded the contract for this critical element of the telescope. Both bidders for the contract had extensive experience building reconnaissance satellites, and their expertise in military and defense systems impacted the design of the Hubble. See Smith, *The Space Telescope*, 223–25.

23. Ihde, *Technology and the Lifeworld*, 76.

24. Lockheed ad, the *Washington Post*, November 30, 1977, final ed., A21.

25. *Science Digest* published the painting in July 1983 and *Sky and Telescope* featured it on the cover of its April 1985 issue, which had several articles on the space telescope. The different magazines changed the cropping and made some small modifications (astronauts work on the telescope in the version published in *Science Digest*), but they all shared the same view of the telescope and its setting.

26. My thanks to Scott Bukatman for pointing out this relationship.

27. "The Working Group identified a set of three core scientific instruments, the definition of which was that they were the most important scientific instruments and that the Space Telescope would not be a full observatory without them. This set of core scientific instruments included a Wide Field Camera, a Faint Object Spectrograph, and a High Resolution Camera (presumed to be provided by the Europeans). The Working Group then recommended that the Space Telescope not be flown without these instruments, sidestepping the hypothetical situation where one of the instruments might fail immediately before launch when delay costs are extremely high" (O'Dell, "The Space Telescope," 173).

28. The reliance on photographic plates continued until well into the 1980s. The second National Geographic–Palomar Observatory Sky Survey, which began observations in 1985, used glass photographic plates. The data have since been digitized.

29. Smith covers these debates in his history of the Hubble Space Telescope. Additional detail can be found in Smith and Tatrewicz, "Replacing a Technology."

30. For a brief history of CCDs and an explanation of how they work, see Kristian and Blouke, "Charge-Coupled Devices in Astronomy."

31. The Wide Field Planetary Camera team included W. A. Baum, Lowell Observatory; A. D. Code, University of Wisconsin; D. G. Currie, University of Maryland; G. E. Danielson, California Institute of Technology; J. E. Gunn, California Institute of Technology; J. A. Kristian, Carnegie Institution of Washington; C. R. Lynds, Kitt Peak National Observatory; P. K. Seidelmann, U.S. Naval Observatory; and B. A. Smith, University of Arizona. Smith, *The Space Telescope,* 409.

32. For more information on the Galileo mission (which ended in 2003), and especially the imaging technology, see "Galileo: Solid State Imaging Team," December 3, 2005, Jet Propulsion Lab, http://www2.jpl.nasa.gov/galileo/sepo.

33. Westphal, Oral History Interview, 40.

34. Presumably, JPL's Image Processing Lab could have suggested methods for reducing the data to make it visible, but such steps would not typically have been necessary for the planetary images. The introduction of CCDs, as noted earlier, also expanded the dynamic range.

35. Westphal, Oral History Interview, 64.

36. See Westphal et al., *Wide Field/Planetary Camera for Space Telescope.* My thanks to David DeVorkin and Robert W. Smith for helping me locate a copy of the proposal.

37. Westphal, Oral History Interview, 67. Nancy Evans worked as archivist at JPL; Ed Danielson was a planetary and instrument scientist. On the decision to include the photographs, see also Danielson, Oral History Interview, 40.

38. A photographer at Palomar Observatory, William C. Miller, was among the first to use high-speed color film to photograph the cosmos in color. For a collection of his early photographs, see Miller, "First Color Portraits of the Heavens." I discuss the importance of color, especially as it pertains to Hubble images, in greater detail in the next chapter.

39. Westphal, Oral History Interview, 70.

40. Although the expense and delay make the Space Telescope an easy target for criticism, it was completed. Many other scientific and technological efforts of similar scale do not reach a final stage, remaining always projects and never becoming objects, to borrow Bruno Latour's terminology in his analysis of the never-completed Aramis project. See Latour, *Aramis, or the Love of Technology.*

41. See Fienberg, "HST," 372.

42. Chaisson recounts this incident in an extremely polemical fashion in *The Hubble Wars.* Although his emotion means his account should be taken with considerable caution, my conversations with others confirm his statements in this case.

43. Astronomers frequently mentioned this story in interviews, even several decades after it occurred. See Hester, Oral History Interview, 16. Zimmerman covers it in detail in *The Universe in a Mirror,* 121–23.

44. See "Harvesting the Universe," A30; and Sawyer, "Hunting the 'Blueprint of Eternity.'"

45. Sawyer, "Hunting the 'Blueprint of Eternity,'" A26.

46. Sawyer, "Early Release of Telescope Data Set," A9.

47. In an afterword in the paperback edition of his history of the Hubble, Smith covers the events immediately after first light in careful detail. See Smith, *The Space Telescope,* 399–425. See also Zimmerman, *The Universe in a Mirror,* 118–56.

48. The media extensively covered the Hubble's problems and plans for repair. For articles on the discovery of the flaw, see Sawyer, "Defect Ruins Focus of Space Telescope," A1; and Leary, "Hubble Space Telescope Loses Large Part of Its Optical Ability," A1. On the congressional hearings, see Sawyer, "House Panel Examines NASA's 'Midlife Crisis,'" A4.

49. Problems at National Aeronautics and Space Administration, Senate Hearing before the Committee on Appropriations, One Hundred First Congress, Second Session, July 18, 1990, 6.

50. Hearing before the Committee on Science, Space, and Technology, U.S. House of Representatives, July 13, 1990, 29.

51. Villard, Oral History Interview, 31.

52. See Sawyer, "Hubble Discovers Star Group," A3; Wilford, "First Hubble Findings Bring Delight," B10; Leary, "Exhibit A in Hubble Defense," A21; Sawyer, "Big Storm on Saturn Scrutinized," A5.

53. Quoted in Sawyer, "New Space Images Reflect Hubble Telescope's 'Glory and Tragedy,'" A3.

54. This approach was somewhat determined by earlier NASA decisions. Through the years in development, budget cuts had shaved away replacement parts and instruments, meaning a failure at any point could be fatal to the project. Concerned about the absence of any redundancy in the Hubble and the potential loss of expertise as the instrument teams dispersed, NASA decided to introduce a minimal level by commissioning a replacement for the most critical instrument on the telescope: the Wide Field Planetary Camera. No replacement for the other instruments existed, meaning that developing a single solution that could correct the optics of the remaining instruments was an efficient and cost-effective, if somewhat risky, approach.

55. Wilford, "NASA Pronounces Space Telescope Cured," A1; Sawyer, "Given New Focus, Hubble Can Almost See Forever," A1.

56. This is an early example of releasing astronomical images online, a practice that is now commonplace. See "Astronomers View Comet Impact with Jupiter," HubbleSite, Newscenter, http://hubblesite.org/newscenter/archive/releases/1994/29/. Lisa Parks discusses the impact in great detail, arguing that the images were imbued with earthly significance although they documented events on another planet. Unfortunately, some aspects of her argument are marred because she incorrectly states that the comet crashed into Jupiter billions of years ago. See Parks, "Satellite Panoramas," in *Cultures in Orbit*, 139–66.

57. For sample of Voyager's views of Jupiter, see Voyager: The Interstellar Mission, http://voyager.jpl.nasa.gov/index.html.

58. See Wilford, "A Stunning View Inside an Incubator for Stars," D19; Sawyer, "Hubble Sends Images of Unborn Stars," A1, A10; Hoverstein, "Hubble Snaps Pillars that Sculpt Stars," A1; Adler, "Witness at the Creation," 70–71; "7,000 Light-Years Away, Stars Are Born," 29; and Lemonick, "Cosmic Close-Ups," 90–99.

59. See Parks, *Cultures in Orbit*, 147–51; Barrow, *Cosmic Imagery;* Greenberg, "Creating the 'Pillars'"; Frankel, "Seeing Stars"; Elkins, introduction to *Visual Practices across the University;* and Marsching, "Orbs, Blobs, and Glows."

60. See "Who Art in Heaven?" 23, for a transcript of a segment of *CNN Today* during which callers described what they saw in the Eagle Nebula. For theological commentary, see Farrell, "We Willed Divinity to Visit Our Planet," 12. References in literary works include McPhee, *The Center of Things;* and West, *Master Class*. Self-help books include Brehony, *After the Darkest Hour;* and Schafer, *Play Therapy with Adults*.

61. Elkins's statement is a pointed critique of Felice Frankel, a science photographer and advocate for the production of more "pretty pictures." In the same section, Elkins also discusses the Eagle Nebula as an example of a scientific image that is often presented as a thing of beauty and raises questions about what the aesthetic term means in this context. See Elkins, *Visual Practices across the University*, 10.

62. Even if he had wanted to observe the Orion Nebula, it is unlikely that he would have been the first to do so. Members of the Science Working Group had already identified the objects they wanted to observe, and C. R. O'Dell had chosen to use his time for observations of Orion.

63. Hester, Oral History Interview, 18. The original camera had a more conventional rectangular frame, and the decision to vary the resolution was part of cost-cutting measures made in the construction of WFPC2.

64. Hester, Oral History Interview, 20.

65. See Hester et al., "Hubble Space Telescope WFPC2 Imaging of M16."

66. Hester, Oral History Interview, 19.

67. Ibid., 18.

68. Ibid., 12–14. As mentioned above, astronomers who contributed to the telescope's development and construction were allotted a certain amount of "Guaranteed Observing Time." Originally, this time was to be used within the first year or so of the telescope's operation, but with its flawed vision some astronomers chose to delay their time until after the repair. As a member of the WFPC and WFPC2 teams, Hester was assured a significant amount of observing time early in the telescope's history.

69. For an example of the multiple versions that may arise from a single image, see my discussion of the Whirlpool Galaxy in "Resolving the Nebulae."

70. Hester et al., "Hubble Space Telescope WFPC2 Imaging of M16," 2360.

71. Hester, Oral History Interview, 22.

72. Villard, Oral History Interview, 8.

73. Hester, Oral History Interview, 23–24.

74. See Greenberg for a detailed account of the CNN broadcasts, including discussion of other faces and objects that viewers identified in the nebula.

75. Marsching, "Orbs, Blobs, and Glows," 62.

76. I am basing my analysis on an oral history interview I conducted with Hester. He made similar, although briefer, comments to Frankel. See Frankel, "Seeing Stars," 426.

77. Hester, Oral History Interview, 8.

78. See Kepes, *Structure in Art and in Science*. Elkins takes issue with Hester's connection of beauty and pattern by correctly arguing that they are not synonymous. However, if considered more broadly as an attempt to link aesthetics and neurobiology, Hester's comments might well intersect with the work of Barbara Stafford, John Onians, and Semir Zeki.

79. Hester, Oral History Interview, 18.

80. The missions were numbered by NASA in a slightly unusual fashion, labeling the 1999 and 2002 missions as Servicing Mission 3A and 3B. The final mission then was Servicing Mission 4, although it was the fifth time astronauts visited the telescope.

81. Noll, Oral History Interview.

82. Bond, Oral History Interview.

83. In her oral history interview Anne Kinney stated that she delayed working in public outreach until after receiving tenure because of how such activities might be perceived by those in positions to grant tenure.

84. Edwards, "Photography and the Material Performance of the Past," 131, 134.

85. Williams held the STScI directorship from 1993 to 1998.

86. Noll et al., "The HST Heritage Project," n.p. My thanks to Howard Bond for sharing a copy of the proposal with me.

87. Perhaps the best-known special projects are the Deep Field and Ultra Deep Field. These involve observations of one small area of the sky for extended periods, thereby allowing astronomers to observe the universe at much earlier points in time.

88. Noll et al., "The HST Heritage Project," n.p.

89. In subsequent years the memberships of the groups have changed. Noll, Bond, Christian, Levay and Frattare remain active members. For a full listing of participants see "Hubble Heritage Information Center: Team Bibliographies," http://heritage.stsci.edu/commonpages/infoindex/ourproject/teambio.shtml.

90. Beckwith, Oral History Interview, 13.

91. Villard, "HST News and Information Services," 6–7.

92. Noll et al., "Continuation of the Hubble Heritage Project," n.p. I am grateful to Noll for sharing with me a copy of this proposal.

93. Ibid.

Chapter Three: Translating Data into Pretty Pictures

1. Daston and Galison, *Objectivity,* 314.

2. Levay, Oral History Interview, 29

3. For an example of the kinds of translations Adams made, see John Sexton, "Moonrise, Hernandez: Ansel Adams Printing Notes—Translation," George Eastman House, http://notesonphotographs.eastmanhouse.org/.

4. Adams, *The Negative,* ix.

5. Levay, Oral History Interview, 30.

6. Ibid., 30.

7. See Kristian and Blouke, "Charge-Coupled Devices in Astronomy"; Janesick and Blouke, "Sky on a Chip"; and McLean, "CCDs."

8. Mackay, "Charge-Coupled Devices in Astronomy," 255.

9. See Geary and Latham, *Solid State Imagers for Astronomy.*

10. Janesick and Blouke, "Sky on a Chip," 238.

11. Kristian and Blouke, "Charge-Coupled Devices in Astronomy," 74.

12. Arp and Lorre, "Image Processing of Galaxy Photographs," 58.

13. See Ritchin, *In Our Own Image.*

14. Rosler, "Image Simulations, Computer Manipulations," 36.

15. Mitchell reiterates this point several times throughout the book. In a representative quote he writes, "The uses of digital imaging technology are becoming broadly institutionalized, and reciprocally, that technology is restructuring institutions, social practices, and the formation of belief. A worldwide network of digital imaging systems is swiftly, silently constituting itself as the decentered subject's reconfigured eye." Mitchell, *The Reconfigured Eye,* 85.

16. Ibid., 19.

17. Ibid., 225.

18. Ritchin, *In Our Own Image,* 14; and Mitchell, *The Reconfigured Eye,* 11–12.

19. For a current example of such ethical standards, see the guidelines on integrity by the *New York Times,* which state that "images in our pages that purport to depict reality must be genuine in every way." It then goes on to list the manipulations that are forbidden, including changing color or gray scale. "Guidelines on Integrity," *New York Times* Company, http://www.nytco.com/company/business_units/integrity.html. For a summary of the response of scientific journals, see "Don't Pretty Up that Picture Just Yet," 1866–68.

20. Noll et al., "The HST Heritage Project," n.p.

21. See Villard and Levay, "Creating Hubble's Technicolor Universe."

22. See Levay and Frattare, "Preparing Colorful Astronomical Images and Illustrations" and "Preparing Colorful Astronomical Images II"; and Frattare and Levay, "Preparing Colorful Astronomical Images III."

23. See Rector et al., "Image-Processing Techniques for the Creation of Presentation-Quality Astronomical Images."

24. Latour, *Pandora's Hope,* 71.

25. In an acknowledgment of the value of the Hubble's database and an effort to encourage more extensive use of it, STScI developed the Hubble Legacy Archive. The archive provides "enhanced" versions of the data—images that have been composited or colored with the intention of optimizing their use by scientists. Hubble Legacy Archive, http://hla.stsci.edu/hla_welcome.html.

26. Astronomers who submit the proposal have sole rights initially to use the resulting HST data. After a year, the data become publicly available.

27. FITS was developed in the 1970s within the astronomy community. Because it can accommodate data collected by a variety of different methods—optical and radio telescopes as well as spectrographs—it allows for interchanges and comparisons between different sources. For more information, see http://fits.cv.nrao.edu; and http://archive.stsci.edu/fits/users_guide/node6.html.

28. S. Baggett et al., *HST WFPC2 Data Handbook.*

29. Lev Manovich identifies automation as one of the defining principles of "new media," meaning digital media. The others he includes are numerical representation, modularity, variability, and transcoding. See Manovich, *The Language of New Media,* 27–48.

30. IRAF was developed by the National Optical Astronomy Observatories (NOAO), which, like STScI, is run by the Association of Universities for Research in Astronomy (AURA). For more information, see http://tucana.tuc.noao.edu/support.html. Interactive Data Language (IDL), a commercial software developed by Kodak, is another choice. For more information, see http://www.rsinc.com/idl/index.asp.The supplemental software is called Space Telescope Science Data Analysis System (STSDAS). More information about the program is available online at "STSDAS," *Space Telescope Science Institute,* http://www.stsci.edu/resources/software_hardware/stsdas. Originally, STScI planned to develop its own data analysis software for HST data. The complexity and size of the project became overwhelming, however, and they also realized that it made more sense to use a standard program. The result was the add-on to IRAF. For details, see Levay, Oral History Interview, 14.

31. The paper on the Orion observations provides an exceptionally detailed description of how the mosaic was made, including specific commands. This is probably because it was published when the process was still very new. See O'Dell and Wong, "Hubble Space Telescope Mapping of the Orion Nebula," 848.

32. For more details, see "Photoshop FITS Liberator," Space Telescope Science Institute, http://hubblesource.stsci.edu/sources/toolbox/entry/fits_liberator/.

33. On image processing at JPL, see Westwick, *Into the Black,* 112–17. The technological exchange between the space program, Hollywood filmmakers, and software developers is a topic that needs further study.

34. See Villard and Levay, "Creating Hubble's Technicolor Universe"; and Levay and Frattare, "Preparing Colorful Astronomical Images and Illustrations."

35. Photoshop allows for eight bits per pixel, a significant reduction from the thirty-two bits per pixel of the original FITS file.

36. Levay and Frattare, "Preparing Colorful Astronomical Images II," n.p. Printed materials from Levay's and Frattare's presentations to the American Astronomical Society are available online at http://opostaff.stsci.edu/~levay/color/index.html.

37. Rector et al., "Image-Processing Techniques for the Creation of Presentation-Quality Astronomical Images," 601.

38. Ibid., 602.

39. The *Astronomical Journal* article also proposes the possibility of using unsharp masking, a term borrowed from photography. To increase the contrast and sharpness of an image, a photographer would make a mask, typically by creating a blurry positive of the original negative. Mask and negative were then developed together. Photoshop has an algorithm for unsharp masking, but the Heritage Project members prefer to create masks rather than rely on an automated and opaque process. However, they do not point to any examples of images that use this technique, thus making it unclear how frequently they employ it. Rector et al., "Image-Processing Techniques for the Creation of Presentation-Quality Astronomical Images," 602.

40. Scoville et al., "High Mass, OB Star Formation in M51."

41. Levay, Oral History Interview, 26.

42. Ibid.

43. On the effect of light on spatial perception, see Arnheim, *Art and Visual Perception.*

44. Lichtenstein, *The Eloquence of Color,* 149.

45. Kant, *Critique of Judgment,* 71.

46. Heinrichs, "Colorizing the Universe," A1. The article also appeared in other newspapers through a wire service and inspired a smattering of editorials. See "Changing the Hue of the Heavens," 10; and Addis, "It's a Shame that a Natural Phenomenon Is Hollywood-ized," B1.

47. The Hubble Heritage Project responded swiftly to Heinrichs's article. Villard penned letters to editors. Levay posted a comment on photo.net to a message board where Heinrich had earlier raised questions about the Hubble images. Interestingly, Levay also posts some of his own photographs on the site. See "Manipulation of Astronomical Images," July 9, 2003, for Heinrichs's original query and September 15, 2003, for a response. "Re: Manipulation of Astronomical Images," Photo. net, http://www.photo.net/bboard/q-and-a-fetch-msg?msg_id=0060eq.

48. See Batchelor, *Chromophobia.*

49. Villard and Levay, "Creating Hubble's Technicolor Universe," 30.

50. On color, see John Gage, *Color and Meaning.*

51. Tufte, *Envisioning Information,* 81.

52. Miller, "First Color Portraits of the Heavens," 679. For a more technical account of the process, see Miller, "Color Photography in Astronomy."

53. For details on the process as well as its relationship to nineteenth-century color theory, see Malin, "Colour Photography in Astronomy"; and Malin and Murdin, *Colours of the Stars.*

54. Malin, "Color Photography in Astronomy," 219.

55. In 2006, the *Astronomical Journal* was charging $100 per page for color figures in the print edition. "Page Charges for the Astronomical Journal," *Astronomical Journal,* December 22, 2005, http://www.journals.uchicago.edu/AJ/pcharges.html.

56. Villard and Levay, "Creating Hubble's Technicolor Universe," 34.

57. Hester, Oral History Interview, 24.

58. Rector et al., "Image-Processing Techniques for the Creation of Presentation-Quality Astronomical Images," 609.

59. English, Oral History Interview; and Kinney, Oral History Interview.

60. See English, "Cosmos vs. Canvas."

61. English is one of the coauthors of Rector et al., "Image-Processing Techniques for the Creation of Presentation-Quality Astronomical Images." See Raleigh, "Johannes Itten and the Background of Modern Art Education."

62. "A Glowing Pool of Light," Hubble Heritage Project, http://heritage.stsci.edu/1998/39/caption. html.

63. The purple-and-pink version combines together observations for oxygen-I, sulfur-II, and nitrogen-II. The more conventional version is a composite of observations for oxygen-III, hydrogen alpha,

and nitrogen-II. Although the different set of filters undeniably affects the appearance of the object, the more radical difference derives from the choice of color assignments. My thanks to Lisa Frattare for pointing out the different sets of filters used in each image.

64. Noll, Oral History Interview, 22.

65. English, Oral History Interview, 20.

66. Gombrich, *Image and the Eye,* 176.

67. Frattare and Levay, "Preparing Colorful Astronomical Images III."

68. CCD bleeds and diffraction spikes often occur on the same star because both depend on the existence of a bright object.

69. "Ghostly Reflections in the Pleiades," Hubble Heritage Project, http://heritage.stsci.edu/2000/36/caption.html.

70. Arnheim, *Art and Visual Perception,* 344.

71. My thanks to Keith Noll and the other members of the Hubble Heritage Project for allowing me to observe one of their meetings.

72. Keith Noll cites NGC 6822 as an example of an image that did not satisfy the group but was released to meet a deadline. Noll, Oral History Interview, 35.

73. Although the team members seemed to interact relatively well, some tension existed around these decisions. English asserted a strong belief in "visual grammar," the idea that certain formal rules are tested and true. An affective image would follow those rules. The other members of the group were less aware of these principles and not as convinced of their applicability in all situations. The hints of the tension within the group are rather subtle, with none of the parties wanting to air any grievances. Comments by English and her departure from STScI are the most substantive evidence: "Composition, in the end, ends up being done by the team. So the composition in the end does not end up being based on visuals sometimes; it's based on politics. So there is one I really like, Hodge 301 . . . that we have the star cluster coming forward and the rest going back. That orientation doesn't support that image well, but Keith wanted it and he said at that point it was an executive decision on his part, so he said, 'You won the last time. My turn'" (English, Oral History Interview, 17).

74. Noll, Oral History Interview, 27.

75. The addition of a fourth layer to the composite probably does not account for all the difference between the images. In keeping with the attention to color, it is the one documented on the Heritage Project's Web site.

76. O'Dell et al., "Knots in Nearby Planetary Nebulae," 3339.

77. Hester, Oral History Interview, 30.

78. Noll, Oral History Interview, 24.

79. Walter Benjamin, "The Task of the Translator," 75.

80. Ibid., 79.

81. Ibid., 80.

82. Walter Benjamin, *The Arcades Project,* 476.

Chapter Four: From Unknown Frontiers to Familiar Places

1. They develop these comparisons in a second paper on the topic; see Lynch and Edgerton Jr., "Abstract Painting and Astronomical Image Processing."

2. Mitchell, *Landscape and Power,* 13.

3. Robert Rosenblum argued that Rothko's color field paintings were effectively a recasting of Caspar David Friedrich's *Monk by the Sea,* but without the small figure in the foreground. See Rosenblum, *Modern Painting and the Northern Romantic Tradition.* On the relationship between landscape and abstract paintings, see Mitchell, "Imperial Landscape," in *Landscape and Power.*

4. Rosenblum, "The Abstract Sublime," 111.

5. Mitchell, *Landscape and Power,* 2.

6. Bright, "Of Mother Nature and Marlboro Men," 129.

7. William H. Goetzmann describes this three-phase exploration process in *Exploration and Empire.* See also Barlett, *Great Surveys of the American West.*

8. In 1880, the different expeditions were consolidated as the U.S. Geological Survey under the leadership of King. He led the agency for a year, and then Powell took the position as head until he left in 1894.

9. Sanford Gifford traveled with Hayden in 1870, Jackson's first year as part of the expedition. Gifford, accustomed to the tamer landscapes of the East, seemed stymied by what he observed during his journey, and he painted no significant canvases depicting the landscapes he saw.

10. The leaders adopted different strategies for publishing their survey reports. Hayden quickly went to press, producing annual reports only months after returning from the field. King and Whitney were slower and more cautious, compiling several years of results and carefully reviewing them before publishing. They each produced multivolume reports that were years in the making. Powell's publications focused almost exclusively on geology.

11. In an interesting reversal, the artist may have attempted to use assumptions about the relationship between his work and the expedition to promote his paintings. Linda Ferber argues convincingly that Bierstadt's tribute to King was an effort to curry support for permanently installing the painting in the Capitol. See Ferber, "Albert Bierstadt," 51–52.

12. "Culture and Progress," 374.

13. The distribution of the photographs and their value for promoting the surveys is a widely discussed topic. For a general overview, see Naef, *Era of Exploration,* 70–76; and Sandweiss, *Print the Legend,* 155–206. For more details on Hayden and Jackson, see Hales, *William Henry Jackson and the Transformation of the American Landscape,* 119–30; and Cassidy, *Ferdinand V. Hayden,* 228–38. For discussion of O'Sullivan and Wheeler, see Kelsey, "Viewing the Archive." The circulation of the photographs in popular magazines is covered in Rindge, "Science and Art Meet in the Parlor."

14. On the Centennial Exhibition, see Rydell, *All the World's a Fair.*

15. Hales, *William Henry Jackson and the Transformation of the American Landscape,* 126.

16. The prints and text are reproduced in appendix 1 of Anderson, *Thomas Moran,* 326–48.

17. Beckwith, Oral History Interview, 19.

18. "The Hayden Survey," 1.

19. Ibid., 1.

20. Scholars continue to debate the value of the survey photographs for science on much the same grounds. O'Sullivan's plates, which were embraced as precursors of modern aesthetics, have been the center of much debate. Robin Kelsey's argument that he was influenced by the characteristics of the visual culture that surrounded him offers the most compelling response, effectively accounting for O'Sullivan's departure from the landscape aesthetics of his day. See Kelsey, *Archive Style.*

21. Wheeler, *Progress Report upon the Geographical and Geological Explorations and Surveys West of the One-Hundredth Meridian, in 1872,* 11.

22. Hayden, *Annual Report of the United States Geological and Geographical Survey of the Territories,* 7.

23. Smithsonian Institution, *Report of the Explorations in 1873 of the Colorado of the West and Its Tributaries, by Professor J. W. Powell, under the direction of the Smithsonian Institution,* 33.

24. Hayden, *Preliminary Report of the United States Geological Survey of Montana and Portions of Adjacent Territories,* 7.

25. Anderson and Ferber, *Albert Bierstadt,* 88–89.

26. *Watson's Weekly Art Journal,* March 3, 1866, 307–8. Quoted in Anderson and Ferber, *Albert Bierstadt,* 204.

27. King, *Mountaineering in the Sierra Nevada,* 223. Ironically, Bierstadt's *Among the Sierra Nevada Mountains, California* graces the cover of the 1997 reprint of the book.

28. "Art," 246.

29. Quoted in Kinsey, *Thomas Moran and the Surveying of the American West,* 112.

30. Powell may have been responding to the ways in which the canvas illustrated his theories regarding the importance of water in forming the landscape. See Childs, "Time's Profile"; and Bedell, *The Anatomy of Nature,* 139–40.

31. Moran, "Knowledge a Prime Requisite in Art," 14.

32. Kinsey carefully analyzes the composition of both paintings; see *Thomas Moran and Surveying,* 55–58, 117–24.

33. Quoted in Kinsey, *Thomas Moran and Surveying,* 55.

34. Quoted in Nicolai, *Centennial Philadelphia,* 53.

35. Although NASA has offices in a number of different locations throughout the country, its headquarters remain in Washington, D.C.

36. Bond, Oral History Interview, 7.

37. Noll, Oral History Interview, 2.

38. Levay, Oral History Interview, 5.

39. Boroson, "Discussion Session," 249.

40. Clarence King *thought* he reached the summit in 1871, leaving behind his barometer to mark his achievement and publicly proclaiming his success in articles in the *Atlantic Monthly* and in his own memoir, *Mountaineering the Sierra Nevada.* Unfortunately for King, due to a mapping error and bad weather he climbed a neighboring peak and did not realize his mistake until another group of explorers found his barometer and exposed his error in a lecture at the California Academy of Sciences. For a history of the exploration of Mount Whitney, see Farquhar, *History of the Sierra Nevada;* and Moore, *Exploring the Highest Sierra.*

41. Langley, *Researches on Solar Heat and Its Absorption by the Earth's Atmosphere,* 36.

42. Ibid., 40.

43. Holden, "Life at the Lick Observatory," 73.

44. Hussey, "Life at a Mountain Observatory," 29.

45. Ibid., 30.

46. By all accounts, friction between the staff astronomers and Holden ultimately led to his resignation from the position. Things did improve after his departure.

47. Adams, "Early Days at Mount Wilson," 220. (As a midwesterner who has lived in California, I identify with Ellerman's experience of the landscape, and I too am always hoping to see the elusive mountain lion.)

48. Patterson, "The Magic Mountain."

49. Adams, "Early Days at Mount Wilson," 221–22.

50. Dempewolff, "Science Climbs the Mountain Peaks," 146.

51. McCray's account of the Gemini telescope covers this transformation from classical observing to the new mode in detail. See McCrary, *Giant Telescopes,* 265–89.

52. It is a shift that has occurred in many fields. Galison documents how it happened in particle physics. Arguably, it happened much sooner in the world of art. Think of Duchamp and his claim that art should be more about concepts and ideas than about the craftsmanship.

53. Noll, Oral History Interview, 10.

54. Hester, Oral History Interview, 2.

55. Noll, Oral History Interview, 11.

56. Truettner, *The West as America,* 50.

57. As just one example, Deborah Bright's essay quoted earlier in this chapter predates the exhibition.

58. Ringle, "Political Correctness," G1.

59. The *Washington Post* extensively covered the exhibition and the ensuing criticism: see Burchard, "How the West Was Rewritten," N59; Forgey, "How The West Was Wrong," D1; and Master, "They Went Thataway," G1. For additional coverage, see Kimmelman, "Old West, New Twist at the Smithsonian"; and Trachtenberg, "Contesting the West."

60. Limerick, "The Frontier in the Twentieth Century," 94.

61. For discussion of the place of Turner's thesis in historical scholarship, see Nobles, *American Frontiers;* Smith, *Virgin Land;* and Cronon, Miles, and Gitlin, *Under an Open Sky.*

62. Smith, *Virgin Land,* 250.

63. Alan Trachtenberg argues that Turner uses this in an effort to represent the historian as a professional who could apply scientific approaches, such as Darwinian evolution, to understand society. Trachtenberg, *The Incorporation of America,* 14. For a more detailed discussion of the nature of Turner's relationship to the scientific discourse of the period, see Coleman, "Science and Symbol in the Turner Frontier Hypothesis," 22–49.

64. Turner, "The Significance of the Frontier in American History," 38.

65. Ibid., 39.

66. Ibid., 43.

67. Ibid., 61.

68. Ibid.

69. Brown, "HST and Beyond Study."

70. For details of Bush's life and career, see Zachary, *Endless Frontier.* On his role in the formation of the NSF, see Kevles, "NST and the Debate over Postwar Research Policy."

71. Bush, *Science,* 2.

72. Ibid., 11.

73. For more examples, see McCurdy, *Space and the American Imagination,* 139–61.

74. See Mazlish, *The Railroad and the Space Program.*

75. Not all American spacecraft and missions have names that connote aspects of discovery and exploration—for example, the Apollo missions. Nonetheless, while other space agencies have also used poetic names for their spacecraft and missions, the United States seems unusual in its reliance on metaphors of discovery and exploration. The European Space Agency chose to call its launcher system Ariane, the French form of Ariadne; the Japanese space program dubbed their spacecraft *Hayabusa,* or falcon; and the Russians named their rocket *Soyuz,* which translates as "union." The Soviet Union's first spacecraft, *Sputnik,* may come the closest to the American tradition, because the word can be translated as voyager. It also has a more literal translation of satellite.

76. The name honors one of the commission's members, Thomas O. Paine, who was NASA's third administrator (October 1968 to September 1970).

77. *Pioneering the Space Frontier,* 21.

78. See a collection of four papers in "Special Section"; and Limerick, "Imagined Frontiers."

79. Villard, Oral History Interview, 34.

80. Bond, Oral History Interview, 30; and Noll, Oral History Interview, 12.

81. Bann, "From Captain Cook to Neil Armstrong," 88.

82. Ibid., 89.

83. "Hubble's Deepest View of the Universe Unveils Bewildering Galaxies across Billions of Years," HubbleSite, http://hubblesite.org/newscenter/archive/releases/survey/1996/01/; "Hubble's Deepest View Ever of the Universe Unveils Earliest Galaxies," HubbleSite, http://hubblesite.org/newscenter/archive/releases/2004/07/.

84. De Certeau, "Spatial Stories," in *The Practice of Everyday Life,* 123.

85. "Star-Forming Region NGC 3324," Hubble Heritage Project, http://heritage.stsci.edu/2008/34/index.html.

86. "A Celestial Landscape in Celebration of 10 Years of Stunning Hubble Heritage Images," HubbleSite, http://hubblesite.org/newscenter/archive/releases/2008/34/video/b/.

87. Tuan, *Space and Place,* 6.

88. Ibid., 18.

89. Levay, Oral History Interview, 21.

90. Hester, Oral History Interview, 31.

Epilogue

1. Levi, "A Tranquil Star," 157. Additional citations of this work are given in the text in parentheses.

2. Levi is perhaps best known for his books and essays about his experiences as a survivor of the Holocaust, and this darker interpretation is in keeping with that body of work. However, as what follows demonstrates, I want to resist the temptation to limit Levi's story by reading it only through the lens of his experiences in the concentration camp.

BIBLIOGRAPHY

Adams, Ansel. *The Negative.* Boston: Little, Brown, 1981.

Adams, Walter S. "Early Days at Mount Wilson." *Publications of the Astronomical Society of the Pacific* 59, no. 350 (October 1947): 213–31.

Addis, Dave. "It's a Shame that a Natural Phenomenon Is Hollywood-ized." *Virginian-Pilot,* September 10, 2003, final ed., B1.

Adler, Jerry. "Witness at the Creation." *Newsweek* (November 13, 1995): 70–71.

Anderson, Nancy K. *Thomas Moran.* Washington, D.C.: National Gallery of Art, 1997.

Anderson, Nancy K., and Linda S. Ferber. *Albert Bierstadt: Art and Enterprise.* New York: Hudson Hill Press, 1990.

Arnheim, Rudolf. *Art and Visual Perception: A Psychology of the Creative Eye.* Berkeley: University of California Press, 1954.

Arp, Halton, and Jean Lorre. "Image Processing of Galaxy Photographs." *Astrophysical Journal* 210 (November 15, 1976): 58–64.

"Art." *Atlantic Monthly* 30 (August 1872): 246.

Baggett, S., et al. *HST WFPC2 Data Handbook,* vol. 4, edited by B. Mobasher. Baltimore: STScI, 2002.

Bann, Stephen. "From Captain Cook to Neil Armstrong: Colonial Exploration and the Structure of the Landscape." In *Projecting the Landscape,* edited by J. C. Eade, 78–91. Canberra: Humanities Research Centre, Australian National University, 1987.

Barlett, Richard A. *Great Surveys of the American West.* Norman: University of Oklahoma Press, 1962.

Barrow, John D. *Cosmic Imagery: Key Images in the History of Science.* New York: Norton, 2008.

Batchelor, David. *Chromophobia.* London: Reaktion Books, 2000.

Beckwith, Steven. Oral History Interview. October 20, 2003.

Bedell, Rebecca. *The Anatomy of Nature.* Princeton: Princeton University Press, 2001.

Benjamin, Walter. *The Arcades Project.* Translated by Howard Eiland and Kevin McLaughlin. Cambridge: Harvard University Press, 1999.

———. "The Task of the Translator." In *Illuminations: Essays and Reflections.* Edited by Hannah Arendt, translated by Harry Zohn, 69–82. New York: Schocken Books, 1968.

Boime, Albert. *The Magisterial Gaze: Manifest Destiny and American Landscape Painting, c. 1830–1865.* Washington, D.C.: Smithsonian Institution Press, 1991.

Bond, Howard. Oral History Interview, September 16, 2003.

Boroson, Todd. "Discussion Session." *New Observing Modes for the Next Century,* ASP Conference Series, vol. 87, 1996.

Brehony, Kathleen A. *After the Darkest Hour: How Suffering Begins the Journey to Wisdom.* New York: Henry Holt, 2000.

Bright, Deborah. "Of Mother Nature and Marlboro Men: An Inquiry into the Cultural Meaning of Landscape Photography." In *The Contest of Meaning: Critical Histories of Photography,* edited by Richard Bolton, 125–43. Cambridge: MIT Press, 1992.

Brown, Robert A. "HST and Beyond Study." *Science with HST II: Electronic Proceedings,* edited by H. Payne, September 22, 2005. Space Telescope Science Institute, http://www.stsci.edu/stsci/meetings/shst2/brownb.html.

Bukatman, Scott. "The Artificial Infinite: On Special Effects and the Sublime." In *Matters of Gravity: Special Effects and Supermen in the Twentieth Century,* 81–110. Durham, N.C.: Duke University Press, 2003.

Burchard, Hank. "How the West Was Rewritten." *Washington Post,* March 15, 1991, final ed., N59.

Burke, Edmund. *A Philosophical Enquiry into the Origin of Our Ideas of the Sublime and Beautiful.* Edited by James Boulton. Notre Dame, Ind.: University of Notre Dame Press, 1968.

Buscombe, Edward. "Inventing Monument Valley: Nineteenth Century Landscape Photography and the Western Film." In *Fugitive Images: From Photography to Video,* edited by Patrice Petro, 87–108. Bloomington: Indiana University Press, 1995.

Bush, Vannevar. *Science, the Endless Frontier: A Report to the President on a Program for Postwar Scientific Research* [1945]. Washington, D.C.: National Science Foundation, 1960.

Cassidy, James G. *Ferdinand V. Hayden: Entrepreneur of Science.* Lincoln: University of Nebraska Press, 2000.

Chaisson, Eric. *The Hubble Wars: Astrophysics Meets Astropolitics in the Two-Billion-Dollar Struggle over the Hubble Space Telescope.* New York: Harper Collins, 1994.

"Changing the Hue of the Heavens." *Tampa Tribune,* September 16, 2003, final ed., 10.

Cheetham, Mark A. *Kant, Art, and Art History.* Cambridge: Cambridge University Press, 2001.

Childs, Elizabeth C. "Time's Profile: John Wesley Powell, Art, and Geology at the Grand Canyon." *American Art* (Spring 1996): 7–33.

Clark, Constance. *God—or Gorilla: Images of Evolution in the Jazz Age.* Baltimore: Johns Hopkins University Press, 2008.

Coleman, William. "Science and Symbol in the Turner Frontier Hypothesis." *American Historical Review* 72, no. 1 (October 1966): 22–49.

Cowie, Peter. *John Ford and the American West.* New York: Harry N. Abrams, 2004.

Cronon, William, George Miles, and Jay Gitlin. *Under an Open Sky: Rethinking America's Western Past.* New York: Norton, 1992.

Crowther, Paul. *The Kantian Sublime: From Morality to Art.* Oxford: Oxford University Press, 1991.

"Culture and Progress: 'The Chasm of the Colorado.'" *Scribner's Monthly* 8 (July 1874): 373–74.

Damisch, Hubert. *A Theory of /Cloud/: Toward a History of Painting.* Translated by Janet Lloyd. Stanford: Stanford University Press, 2002.

Danielson, G. E. Oral History Interview, September 27, 1985. Space Telescope History Project, National Air and Space Museum.

Daston, Lorraine, and Peter Galison. *Objectivity.* New York: Zone Books, 2008.

de Certeau, Michel. *The Practice of Everyday Life.* Translated by Steven Rendall. Berkeley: University California Press, 1984.

Dempewolff, Richard. "Science Climbs the Mountain Peaks." *Popular Mechanics* 117 (Feburary 1962): 146.

"Don't Pretty Up that Picture Just Yet." *Science* 314 (December 22, 2006): 1866–68.

Edgerton, Samuel Y. "Galileo, Florentine 'Disegno,' and the 'Strange Spottedness of the Moon.'" *Art Journal* 44, no. 3 (Autumn 1984): 225–32.

Edwards, Elizabeth. "Photography and the Material Performance of the Past." *History and Theory* 48 (December 2009): 130–50.

Elkins, James. *The Domain of Images.* Ithaca: Cornell University Press, 2001.

———. *Six Stories at the Edge of Representation: Images in Painting, Photography, Astronomy, Microscopy, Particle Physics, and Quantum Mechanics, 1980–2000.* Stanford: Stanford University Press, 2008.

———. *Visual Practices across the University.* Munich: Wilhelm Fink Verlag, 2007.

English, Jayanne. "Cosmos vs. Canvas." *Horizon⁰*, no. 6 (January 2003), www.horizonzero.ca.

———. Oral History Interview, December 11, 2003.

Farquhar, Francis P. *History of the Sierra Nevada.* Berkeley: University of California Press, 1965.

Farrell, Michael J. "We Willed Divinity to Visit Our Planet." *National Catholic Reporter* 12 (December 1995): 12.

Ferber, Linda S. "Albert Bierstadt: The History of a Reputation." In *Albert Bierstadt: Art and Enterprise,* edited by Nancy K. Anderson and Linda S. Ferber, 21–68. New York: Hudson Hill Press, 1990.

Fienberg, Richard Tresch. "HST: Astronomy's Discovery Machine." *Sky and Telescope* (April 1990): 366–72.

Forgey, Benjamin. "How the West Was Wrong: In 'Images of the Frontier,' a Focus on the Negative." *Washington Post,* March 18, 1991, final ed., D1.

Frankel, Felice. *Envisioning Science: The Design and Craft of the Science Image.* Cambridge: MIT Press, 2002.

———. *On the Surface of Things: Images of the Extraordinary in Science.* Cambridge: Harvard University Press, 2008.

———. "Seeing Stars." *American Scientist* 92, no. 5 (September–October 2004): 426.

Frattare, L. M., and Z. G. Levay. "Preparing Colorful Astronomical Images III: Cosmetic Cleaning." Poster presented at the *American Astronomical Society,* 2003.

Gage, John. *Color and Meaning: Art, Science, and Symbolism.* Berkeley: University of California Press, 1999.

Galison, Peter. *Image and Logic: A Material Culture of Microphysics.* Chicago: University of Chicago Press, 1997.

———. "Images Scatter into Data, Data Gather into Images." In *Iconoclash,* edited by Bruno Latour and Peter Weibel, 300–23. Cambridge: MIT Press, 2002.

Geary, John C., and David W. Latham. *Solid State Imagers for Astronomy.* Washington, D.C.: SPIE: The International Society for Optical Engineering, 1981.

Goetzmann, William H. *Exploration and Empire: The Explorer and the Scientist in the Winning of the American West* [1966]. Austin: Texas State Historical Association, 2000.

Gombrich, E. H. *Image and the Eye.* Ithaca: Cornell University Press, 1982.

Greenberg, Joshua M. "Creating the 'Pillars': Multiple Meanings of a Hubble Image." *Public Understanding of Science* 13 (2004): 83–95.

Grossman, James R., ed. *The Frontier in American Culture.* Berkeley: University of California Press, 1994.

Hales, Peter Bacon. *William Henry Jackson and the Transformation of the American Landscape.* Philadelphia: Temple University Press, 1988.

Hamblyn, Richard. *The Invention of Clouds: How an Amateur Meteorologist Forged the Language of the Skies.* New York: Picador, 2001.

"Harvesting the Universe." *New York Times,* April 26, 1990, final ed., A30.

Hayden, F. V. *Annual Report of the United States Geological and Geographical Survey of the Territories.* Washington, D.C.: Government Printing Office, 1874.

———. *Preliminary Report of the United States Geological Survey of Montana and Portions of Adjacent Territories.* Washington, D.C.: Government Printing Office, 1872.

"The Hayden Survey: A Visit to the Office of the Surveying Corps." *New York Times,* April 27, 1875, 1.

Hearing before the Committee on Science, Space, and Technology, U.S. House of Representatives, July 13, 1990.

Heinrichs, Allison M. "Colorizing the Universe." *Los Angeles Times,* September 5, 2003, final ed., A1.

Henderson, Linda Dalrymple. "Editor's Introduction: I. Writing Modern Art and Science—An Overview; II. Cubism, Futurism, and Ether Physics in the Early Twentieth Century." *Science in Context* 17 no. 4 (December 2004): 423–66.

Hester, Jeff. Oral History Interview, December 9, 2003.

Hester, Jeff, et al. "Hubble Space Telescope WFPC2 Imaging of M16: Photoevaporation and Emerging Young Stellar Objects." *Astronomical Journal* 111 (1996): 2349–60.

Holden, Edward S. "Life at the Lick Observatory." *Scientific American* 46 (January 31, 1891): 73.

Hoskin, Michael. "The First Drawing of a Spiral Nebula." *Journal of the History of Astronomy* 13 (1982): 97–101.

Hoverstein, Paul. "Hubble Snaps Pillars that Sculpt Stars." *USA Today,* November 3, 1995, final ed., A1.

Hussey, Ethel Fountain. "Life at a Mountain Observatory." *Atlantic Monthly* 92 (July 1903): 29–32.

Ihde, Don. *Technology and the Lifeworld: From Garden to Earth.* Bloomington: Indiana University Press, 1990.

Janesick, James, and Morley Blouke. "Sky on a Chip: The Fabulous CCD." *Sky and Telescope* 74 (September 1987): 238–42.

Jay, Martin. *Downcast Eyes: The Denigration of Vision in Twentieth-Century French Thought.* Berkeley: University of California Press, 1993.

Jones, Caroline A., and Peter Galison. *Picturing Science, Producing Art.* New York: Routledge, 1998.

Kant, Immanuel. *Critique of Judgment.* Translated by Werner S. Pluhar. Indianapolis: Hackett Publishing Company, 1987.

———. "Universal Natural History and Theory of the Heavens; or an Essay on the Constitution and Mechanical Origin of the Whole Universe." In *Kant's Cosmogony.* Translated by W. Hastie. New York: Johnson Reprint Corporation, 1970.

Kelsey, Robin E. *Archive Style: Photographs and Illustrations for the US Surveys, 1850–1890.* Berkeley: University of California Press, 2007.

———. "Viewing the Archive: Timothy O'Sullivan's Photographs for the Wheeler Survey." *Art Bulletin* 85, no. 4 (December 2003): 702–23.

Kepes, Gyorgy. *Structure in Art and in Science.* New York: George Braziller, 1965.

Kessler, Elizabeth A. "Pretty Sublime." In *Beyond the Finite: The Sublime in Art and Science,* edited by Roald Hoffman and Iain Boyd Whyte, 57–74. Oxford: Oxford University Press, 2011.

———. "Resolving the Nebulae: The Science and Art of Representing M51." *Studies in the History and Philosophy of Science* 38 (2007): 477–91.

Kevles, Daniel J. "NST and the Debate over Postwar Research Policy." *Isis* 68 (1977): 5–26.

Kimmelman, Michael. "Old West, New Twist at the Smithsonian." *New York Times,* May 26, 1991, final ed., H1.

King, Clarence. *Mountaineering in the Sierra Nevada* [1872]. Lincoln: University of Nebraska Press, 1997.

Kinney, Anne. Oral History Interview, November 14, 2003.

Kinsey, Joni Louise. *Thomas Moran and the Surveying of the American West.* Washington, D.C.: Smithsonian Institution Press, 1992.

———. *Thomas Moran's West: Chromolithography, High Art, and Popular Taste.* Lawrence: University of Kansas Press, 2006.

Kristian, Jerome, and Morley Blouke. "Charge-Coupled Devices in Astronomy." *Scientific American* 247 (October 1982): 66–74.

Langley, Samuel Pierpont. *The New Astronomy.* Boston: Houghton Mifflin, 1884.

———. *Researches on Solar Heat and Its Absorption by the Earth's Atmosphere.* Washington, D.C.: Government Printing Office, 1884.

Latour, Bruno. *Aramis, or the Love of Technology.* Translated by Catherine Porter. Cambridge: Harvard University Press, 1996.

———. *Pandora's Hope: Essays on the Reality of Science Studies.* Cambridge: Harvard University Press, 1999.

Latour, Bruno, and Peter Weibel, eds. *Iconoclash: Beyond the Image Wars in Science, Religion, and Art.* Cambridge: MIT Press, 2002.

Leary, Warren E. "Exhibit A in Hubble Defense: Clearest Pluto Images." *New York Times,* October 5, 1990, final ed., A21.

———. "Hubble Space Telescope Loses Large Part of Its Optical Ability." *New York Times,* June 28, 1990, final ed.: A1.

Lemonick, Michael D. "Cosmic Close-Ups." *Time* (November 20, 1995): 90–99.

Levay, Zoltan. Oral History Interview, October 14, 2003.

Levay, Z. G., and L. M. Frattare. "Preparing Colorful Astronomical Images and Illustrations." Poster presented at the American Astronomical Society, 2001.

———. "Preparing Colorful Astronomical Images II." Poster presented at the American Astronomical Society, 2002.

Levi, Primo. "A Tranquil Star." In *A Tranquil Star,* translated by Ann Goldstein and Alessandra Bastagli, 156–62. New York: Norton, 2007.

Lichtenstein, Jacqueline. *The Eloquence of Color: Rhetoric and Painting in the French Classical Age.* Berkeley: University of California Press, 1993.

Limerick, Patricia Nelson. "The Adventures of the Frontier in the Twentieth Century." In *The Frontier in American Culture,* edited by James R. Grossman, 67–102. Berkeley: University of California Press, 1994.

———. "Imagined Frontiers: Westward Expansion and the Future of the Space Program." In *Space Policy Alternatives,* edited by Radford Byerly Jr., 249–62. Boulder, Colo.: Westview Press, 1992.

Lockheed advertisement. *Washington Post,* November 30, 1977, final ed., A21.

Lockheed Missiles and Space Company. *Large Space Telescope Support Systems Module: Phase B Definition Study* (July 28, 1975).

Lynch, Michael, and Samuel Y. Edgerton Jr. "Abstract Painting and Astronomical Image Processing." In *The Elusive Synthesis: Aesthetics and Science,* edited by Alfred I. Tauber, 103–24. Dordrecht: Kluwer Academic Publishers, 1996.

———. "Aesthetics and Digital Image Processing: Representational Craft in Contemporary Astronomy." In *Picturing Power: Visual Depiction and Social Relations,* edited by Gordon Fyfe and John Law, 184–221. London: Routledge, 1988.

MacCannell, Dean. *The Tourist: A New Theory of the Leisure Class* [1976]. Berkeley: University of California Press, 1999.

Mackay, Craig D. "Charge-Coupled Devices in Astronomy." *Annual Review of Astronomy and Astrophysics* 24 (1986): 255–83.

Malin, D. F. "Colour Photography in Astronomy." *Vistas in Astronomy* 24 (1980): 219–38.

Malin, David, and Paul Murdin. *Colours of the Stars.* Cambridge: Cambridge University Press, 1984.

Manovich, Lev. *The Language of New Media.* Cambridge: MIT Press, 2001.

Marsching, Jane D. "Orbs, Blobs, and Glows: Astronauts, UFOs, and Photography." *Art Journal* 62 (Fall 2003): 56–65.

Martin Marietta Corporation. "Final Study Report: Space Telescope/Support Systems Module," March 15, 1976.

Master, Kim. "They Went Thataway: At the NMAA, Revising the Revisionism of 'The West as America.'" *Washington Post,* June 2, 1991, final ed., G1.

Mazlish, Bruce. *The Railroad and the Space Program: An Exploration in Historical Analogy.* Cambridge: MIT Press, 1965.

McCrary, Patrick. *Giant Telescopes: Astronomical Ambition and the Promise of Technology.* Cambridge: Harvard University Press, 2004.

McCurdy, Howard E. *Space and the American Imagination.* Washington, D.C.: Smithsonian Institution Press, 1997.

McLean, Ian S. "CCDs: The First 20 Years." *Astronomy Now* 4, no. 10 (October 1990): 26–32.

McPhee, Jenny. *The Center of Things.* New York: Ballantine, 2002.

Miller, Angela. *Empire of the Eye: Landscape Representation and American Cultural Politics, 1825–1875.* Ithaca: Cornell University Press, 1993.

Miller, Ron. "The Archaeology of Space Art." *Leonardo* 29, no. 2 (1996): 139–43.

Miller, William C. "Color Photography in Astronomy." *Publications of the Astronomical Society of the Pacific* 74 (1962): 457–73.

———. "First Color Portraits of the Heavens." *National Geographic* 115 (May 1959): 670–79.

Mitchell, William J. *The Reconfigured Eye: Visual Truth in the Post-Photographic Era.* Cambridge: MIT Press, 1992.

Mitchell, W. J. T. *Landscape and Power.* Chicago: University of Chicago Press, 1994.

———. "Showing Seeing." In *What Do Pictures Want?* 336–56. Chicago: University of Chicago Press, 2005.

Monk, Samuel H. *The Sublime: A Study of Critical Theories in Eighteenth-Century England.* New York: Modern Language Association, 1935.

Moore, James G. *Exploring the Highest Sierra.* Stanford: Stanford University Press, 2000.

Moran, Thomas. "Knowledge a Prime Requisite in Art." *Brush and Pencil* 12, no. 1 (April 1903): 14–16.

Naef, Weston J. *Era of Exploration: The Rise of Landscape Photography in the American West, 1860–1885.* Buffalo, N.Y.: Albright-Knox Art Gallery, 1975.

Nicolai, Richard R. *Centennial Philadelphia.* Bryn Mawr: Bryn Mawr University Press, 1976.

Nicolson, Marjorie Hope. *Mountain Gloom and Mountain Glory: The Development of the Aesthetics of the Infinite.* Ithaca: Cornell University Press, 1959.

Nobles, Gregory H. *American Frontiers: Cultural Encounters and Continental Conquest.* New York: Hill and Wang, 1991.

Noll, Keith. Oral History Interview, September 11, 2003.

Noll, Keith, et al. "Continuation of the HST Heritage Project," 2003.

———. "The HST Heritage Project," 1997.

Novak, Barbara. *Nature and Culture: American Landscape and Painting, 1825–1875* [1980]. Oxford: Oxford University Press, 1995.

Nye, David E. *American Technological Sublime.* Cambridge: MIT Press, 1996.

O'Dell, C. R. "The Large Space Telescope Program." *Sky and Telescope* 44 (December 1972): 369–71.

———. "The Space Telescope." In *Telescopes for the 1980s,* edited by G. Burbidge and A. Hewitt, 129–93. Palo Alto: Annual Reviews, 1981.

O'Dell, C. R., and Shui Kwan Wong. "Hubble Space Telescope Mapping of the Orion Nebula. I. A Survey of Stars and Compact Objects." *Astronomical Journal* 111 (February 1996): 846–55.

O'Dell, C. R., et al. "Knots in Nearby Planetary Nebulae." *Astronomical Journal* 123 (June 2002): 3329–47.

Parks, Lisa. *Cultures in Orbit: Satellites and the Televisual.* Durham, N.C.: Duke University Press, 2005.

Patterson, J. N. "The Magic Mountain." *National Geographic* 19, no. 7 (July 1908): 457–68.

Pioneering the Space Frontier: Report of the National Commission on Space. New York: Bantam Books, 1986.

Problems at National Aeronautics and Space Administration, Senate Hearing before the Committee on Appropriations, One Hundred First Congress, Second Session, July 18, 1990.

Raleigh, Henry P. "Johannes Itten and the Background of Modern Art Education." *Art Journal* 27 (Spring 1968): 284–302.

Rector, Travis A., et al. "Image-Processing Techniques for the Creation of Presentation-Quality Astronomical Images." *Astronomical Journal* 133, no. 2 (2007): 598–611.

Rindge, Debora. "Science and Art Meet in the Parlor: The Role of Popular Magazine Illustration in the Pictorial Record of the 'Great Survey.'" In *Surveying the Record: North American Scientific Exploration to 1930,* edited by Edward C. Carter II, 173–93. Philadelphia: American Philosophical Society, 1999.

Ringle, Ken. "Political Correctness; Art's New Frontier: At NMAA a Revisionist Prism at Work." *Washington Post,* March 31, 1991, final ed., G1.

Ritchin, Fred. *In Our Own Image: The Coming Revolution in Photography—How Technology Is Changing Our View of the World.* New York: Aperture, 1990.

Rosenblum, Robert. "The Abstract Sublime." In *The Sublime,* edited by Simon Morley, 108–12. Cambridge: MIT Press, 2010.

———. *Modern Painting and the Northern Romantic Tradition: Friedrich to Rothko.* New York: Harper and Row, 1975.

Rosler, Martha. "Image Simulations, Computer Manipulations: Some Considerations." In *Photography after Photography: Memory and Representation in the Digital Age,* edited by Hubertus V. Amelunxen, Stefan Iglhaut, and Florian Rötzer, 36–56. Amsterdam: G+B Arts, 1996.

Rydell, Robert W. *All the World's a Fair: Visions of Empire at American International Expositions, 1876–1916.* Chicago: University of Chicago Press, 1987.

Sandweiss, Martha A. *Print the Legend: Photography and the American West.* New Haven: Yale University Press, 2002.

Sawyer, Kathy. "Big Storm on Saturn Scrutinized." *Washington Post,* November 21, 1990, final ed., A5

———. "Defect Ruins Focus of Space Telescope; Astronauts to Try Repairs in 1993." *Washington Post,* June 28, 1990, final ed., A1, A26–27.

———. "Early Release of Telescope Data Set." *Washington Post,* April 10, 1990, final ed., A9.

———. "Given New Focus, Hubble Can Almost See Forever." *Washington Post,* January 14, 1994, final ed., A1.

———. "House Panel Examines NASA's 'Midlife Crisis'; Witnesses Say Oversight of Contractors Is Lax." *Washington Post,* August 2, 1991, final ed., A4.

———. "Hubble Discovers Star Group." *Washington Post,* August 14, 1990, final ed., A3.

———. "Hubble Sends Images of Unborn Stars." *Washington Post,* November 3, 1995, final ed., A1, A10.

———. "Hunting the 'Blueprint of Eternity.'" *Washington Post,* April 8, 1990, final ed., A1.

———. "New Space Images Reflect Hubble Telescope's 'Glory and Tragedy.'" *Washington Post,* October 5, 1990, final ed., A3.

Schaaf, Larry J. *Out of the Shadows: Herschel, Talbot, and the Invention of Photography.* New Haven: Yale University Press, 1992.

Schafer, Charles E. *Play Therapy with Adults.* New York: John Wiley, 2003.

Schaffer, Simon. "The Leviathan of Parsonstown: Literary Technology and Scientific Representation." In *Inscribing Science: Scientific Texts and the Materiality of Communication,* edited by Timothy Lenoir, 182–222. Stanford: Stanford University Press, 1998.

———. "On Astronomical Drawing." In *Picturing Science, Producing Art,* edited by Caroline Jones and Peter Galison, 441–74. New York: Routledge, 1998.

Scientific Uses of the Large Space Telescope, Report of the Space Science Board ad hoc Committee on the Large Space Telescope. Washington, D.C.: National Academy of Sciences, 1969.

Scoville, N. Z., et al. "High Mass, OB Star Formation in M51: Hubble Space Telescope Hα and Paα Imaging." *Astronomical Journal* 122, no. 6 (2001): 3017–45.

"7,000 Light-Years Away, Stars Are Born." *U.S. News and World Report* 13 (November 1995): 29.

Smith, Henry Nash. *Virgin Land: The American West as Symbol and Myth.* Cambridge: Harvard University Press, 1950.

Smith, Robert W. *The Space Telescope: A Study of NASA, Science, Technology, and Politics.* Cambridge: Cambridge University Press, 1993.

Smith, Robert W., and Joseph N. Tatrewicz. "Replacing a Technology: The Large Space Telescope and CCDs." *Proceedings of the IEEE* 73, no. 7 (1985): 1221–35.

Smithsonian Institution. *Report of the Explorations in 1873 of the Colorado of the West and Its Tributaries, by Professor J. W. Powell, under the direction of the Smithsonian Institution.* Washington, D.C.: Government Printing Office, 1874.

Sobchack, Vivian. "The Scene of the Screen: Envisioning Photographic, Cinematic, and Electronic 'Presence.'" In *Carnal Thoughts: Embodiment and Moving Image Culture,* 135–62. Berkeley: University of California Press, 2004.

———. *Screening Space: The American Science Fiction Film.* New Brunswick, N.J.: Rutgers University Press, 1987.

"Special Section: Parables of the Space Age—The Ideological Basis of Space Exploration." *Western Folklore* 46, no. 4 (October 1987): 227–93.

Spitzer, Lyman. "Astronomical Advantages of an Extra-Terrestrial Observatory." *Astronomical Quarterly* 7 (1990): 131–42.

Stafford, Barbara Maria. *Good Looking: Essays on the Virtue of Images.* Cambridge: MIT Press, 1996.

"STSDAS." Space Telescope Science Institute, October 18, 2004, http://www.stsci.edu/resources/software_hardware/stsdas.

Talbot, William Henry Fox. "The Pencil of Nature." In *Henry Fox Talbot: Selected Texts and Bibliography,* edited by Mike Weaver, 75–104. Santa Barbara, Calif.: ABC-Clio, 1992.

Trachtenberg, Alan. "Contesting the West." *Art in America* (September 1991): 118–23, 152.

———. *The Incorporation of America.* New York: Hill and Wang, 1982.

Truettner, William H. *The West as America: Reinterpreting Images of the Frontier, 1820–1920.* Washington, D.C.: Smithsonian Institution Press, 1991.

Tuan, Yi-Fu. *Space and Place: The Perspective of Experience.* Minneapolis: University of Minnesota Press, 1977.

Tucker, Jennifer. *Nature Exposed: Photography as Eyewitness in Victorian Science.* Baltimore: Johns Hopkins University Press, 2005.

Tufte, Edward. *Envisioning Information.* Cheshire, Conn.: Graphics Press, 1990.

Turner, Frederick Jackson. "The Significance of the Frontier in American History." *Frontier and Section: Selected Essays of Frederick Jackson Turner,* edited by Ray Allen Billington, 37–62. Englewood Cliffs, N.J.: Prentice-Hall, 1961.

Underhill, Anne B. "The Large Space Telescope Instrumentation." *Publication of the Astronomical Society of the Pacific* 84 (February 1972): 84–90.

Urry, John. *The Tourist Gaze: Leisure and Travel in Contemporary Society,* 2nd ed. Thousand Oaks, Calif.: Sage Publications, 2002.

Vertesi, Janet. "Seeing Like a Rover: Images in Interaction on the Mars Exploration Rover Mission." Ph.D. diss., Cornell University, 2009.

Villard, Ray. "HST News and Information Services: Continuously Bringing Hubble Science Down to Earth, to a Worldwide Audience." *STScI Newsletter* 14, no. 4 (October 1997): 6–7.

———. Oral History Interview, October 8, 2003.

Villard, Ray, and Zoltan Levay. "Creating Hubble's Technicolor Universe." *Sky and Telescope* (September 2002): 28–34.

Wallach, Albert. "Making a Picture of a View from Mount Holyoke." In *American Iconology: New Approaches to Nineteenth-Century Art and Literature,* edited by David C. Miller, 80–91. New Haven: Yale University Press, 1995.

West, Paul. *Master Class: Scenes from a Fiction Workshop.* San Francisco: Harcourt, 2001.

Westphal, James. Oral History Interview, August 12, 1982. Space History Project, National Air and Space Museum.

Westphal, James A., et al. *Wide Field/Planetary Camera for Space Telescope.* Pasadena: California Institute of Technology.

Westwick, Peter J. *Into the Black: JPL and the American Space Program, 1976–2004.* New Haven: Yale University Press, 2007.

Wheeler, George M. *Progress Report upon the Geographical and Geological Explorations and Surveys West of the One-Hundredth Meridian, in 1872.* Washington, D.C.: Government Publishing Office, 1874.

"Who Art in Heaven?" *Harper's* (April 1996): 23.

Wilford, John Noble. "First Hubble Findings Bring Delight." *New York Times,* August 30, 1990, final ed., B10.

———. "NASA Pronounces Space Telescope Cured." *New York Times,* January 14, 1994, final ed., A1.

———. "A Stunning View Inside an Incubator for Star." *New York Times,* November 3, 1995, final ed., D19.

Wilton, Andrew, and Tim Barringer. *American Sublime: Landscape Painting in the United States, 1820–1880.* Princeton, N.J.: Princeton University Press, 2002.

Zachary, G. Pascal. *Endless Frontier: Vannevar Bush, Engineer of the American Century.* New York: Free Press, 1997.

Zimmerman, Robert. *The Universe in a Mirror: The Saga of the Hubble Space Telescope and the Visionaries Who Built It.* Princeton, N.J.: Princeton University Press, 2008.

INDEX

ACS (Advanced Camera for Surveys), 21, 24, 32, 60, 109, 111, 145, 236–37n3, 239n46, 247n46

Adams, Ansel, 55, 130, 156, 225, 246n3; *Clearing Winter Storm, Yosemite National Park, California,* 55–56; *Monolith, the Face of Half-Dome, Yosemite National Park,* 55

Advanced Camera for Surveys. *See* ACS

aesthetics: and astronomy, 8–9, 73–74, 163, 176, 197; and depictions of the American West, 45, 182, 188; and Hubble Heritage Project, 7, 17, 50–54, 114–17, 121, 124–25, 166, 167–70; and Hubble images, 4, 6, 7, 15, 16, 28, 50, 61, 227; in image processing, 136, 146, 149, 156, 164; modernist, 176; and numeric data, 73; and science, 6, 10, 17, 100, 105, 108–9, 114, 138. *See also* agreeable, the; beautiful, the; Burke, Edmund; Kant, Immanuel; pretty pictures; sublime, the

agreeable, the, 72–73, 89

ambivalence: toward astronomical images, 16, 72, 74, 90, 99, 109, 111, 125; and digital imaging, 133, 135; about role of senses in gaining knowledge, 84; toward scientific images, 11, 70–71, 187–89; and technologies that enhance senses, 81, 84

American West: and Ansel Adams, 55–56; and the frontier, 181, 207–8, 210–11; and Hollywood westerns, 56–57; and nineteenth-century American painters and photographers, 16, 28, 33–37, 40–41, 43, 45–46, 183–95; relationship of Hubble images to, 5, 10, 15, 17, 28–46, 175, 181; and science fiction, 57–59; scientific exploration of, 17, 28, 182–96, 251n8; as site for astronomical observatories, 17, 197–204; and space art, 57; and the sublime, 29; symbolic significance of, 175, 181, 196–97, 207–10

Andromeda Galaxy, 78–79, 88, 90

Apollo, 75, 112, 214, 254n75

Association of Universities for Research in Astronomy (AURA), 248n30

astrometry, 142

astronomers: and Ansel Adams, 55; adoption of digital detectors, 131–33; and aesthetics, 4, 11, 54, 71–73, 136; attitudes toward images, 6, 16, 71, 74, 90, 186; and Cepheid variables, 78; and data, 86–87, 91, 247n26; and digital image processing, 5, 15, 17, 37–38, 103, 111, 127–29, 133, 137–66, 176; efforts to improve seeing, 19, 24; and guaranteed observing time, 245n68; and history of Hubble Space Telescope, 84, 91, 94, 96–97,

267

Elizabeth A. Kessler teaches at Stanford University. She has been awarded fellowships by the Smithsonian Institution National Air and Space Museum and Stanford University.